ECHOES
OF THE FUTURE

RATIONAL GRAPHIC DESIGN & ILLUSTRATION

gestalten

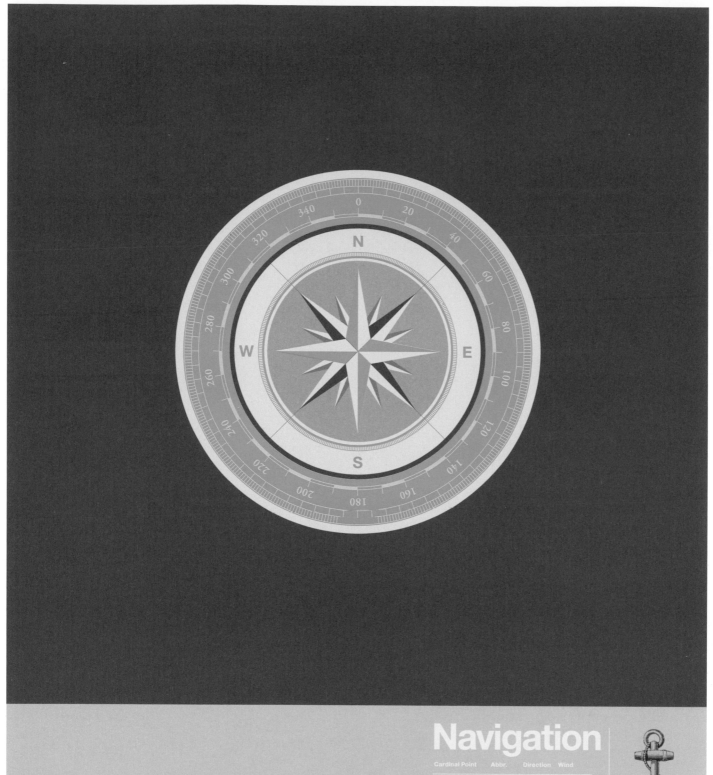

Navigation

Cardinal Point	Abbr.	Direction	Wind
North	N	0°	Tramontane
North-East	NE	45°	Gregale
East	E	90°	Levante
South-East	SE	135°	Sirocco
South	S	180°	Austro
South-West	SW	225°	Libeccio
West	W	270°	Ponente
North-West	NW	315°	Mistral

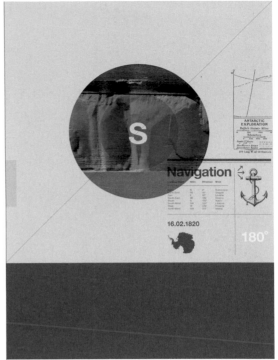

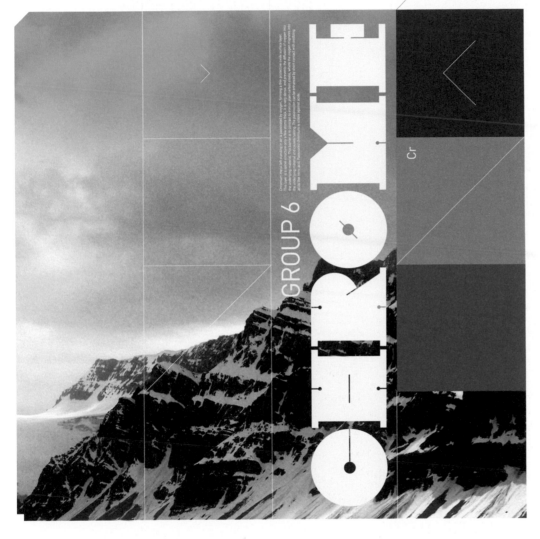

Astronaut Design

Navigation, Chrome
2010, Personal Project

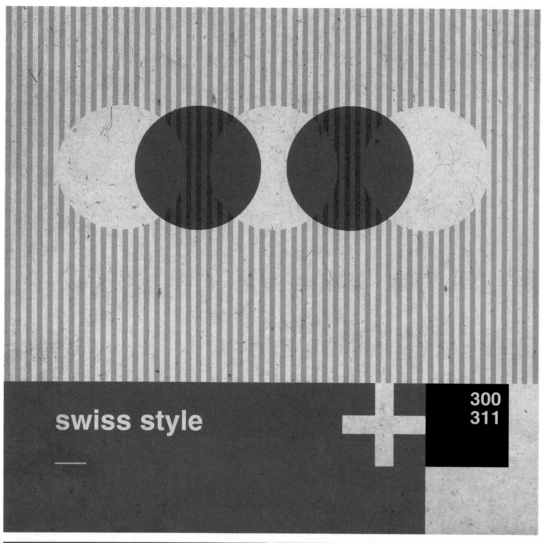

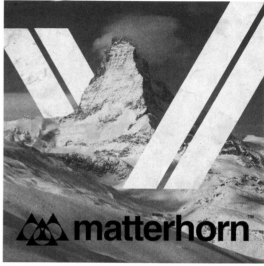

Duane Dalton

Swiss Style, Swiss Plus, Matterhorn
Switzerland *(right page)*
2011, Personal Project

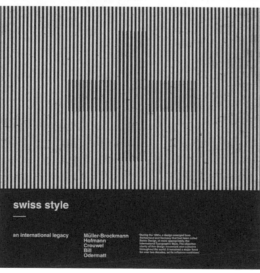

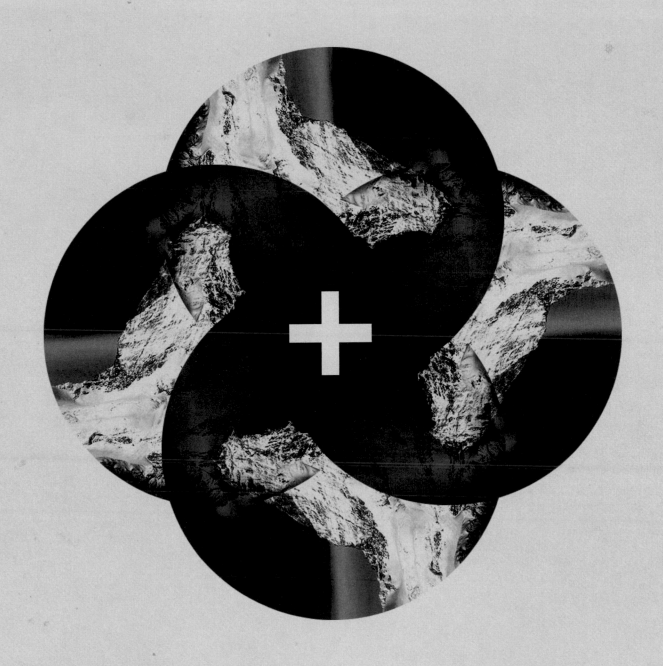

Switzerland

**Suisse
Svizzera
Schweiz**

41,285 km²

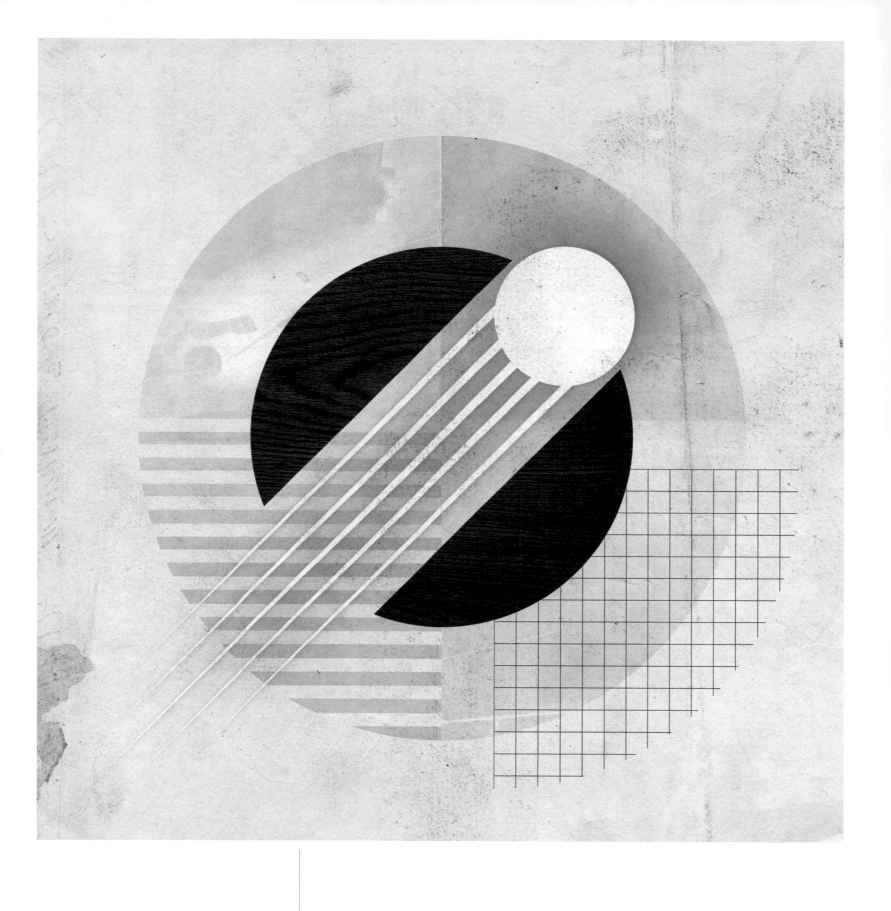

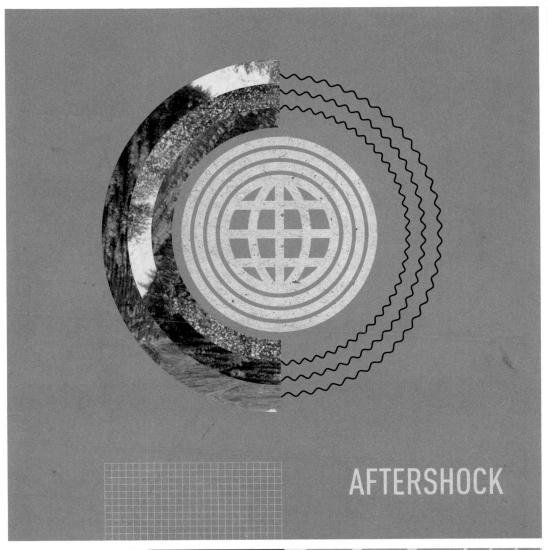

AFTERSHOCK

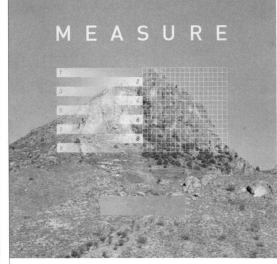

MEASURE

Duane Dalton

Speed *(left page)*
Aftershock, Supersonic, Measure
2011, Personal Project

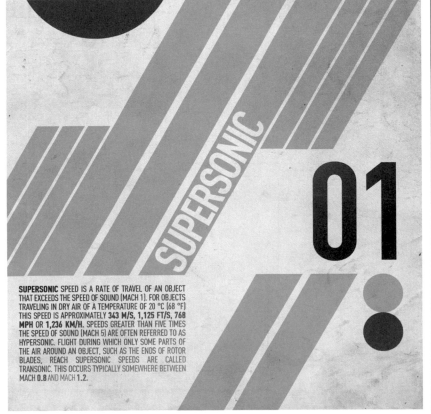

SUPERSONIC

01

SUPERSONIC SPEED IS A RATE OF TRAVEL OF AN OBJECT THAT EXCEEDS THE SPEED OF SOUND (MACH 1). FOR OBJECTS TRAVELING IN DRY AIR OF A TEMPERATURE OF 20 °C (68 °F) THIS SPEED IS APPROXIMATELY 343 M/S, 1,125 FT/S, 768 MPH OR 1,236 KM/H. SPEEDS GREATER THAN FIVE TIMES THE SPEED OF SOUND (MACH 5) ARE OFTEN REFERRED TO AS HYPERSONIC. FLIGHT DURING WHICH ONLY SOME PARTS OF THE AIR AROUND AN OBJECT, SUCH AS THE ENDS OF ROTOR BLADES, REACH SUPERSONIC SPEEDS ARE CALLED TRANSONIC. THIS OCCURS TYPICALLY SOMEWHERE BETWEEN MACH **0.8** AND MACH **1.2.**

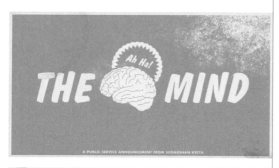

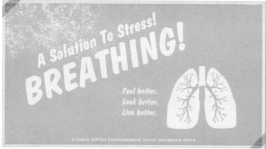

Jonathan Mutch

The Mind, Breathing, Sudarshan Kriya,
Brain Under Stress, Neurotransmitters
2010/11, Personal Project

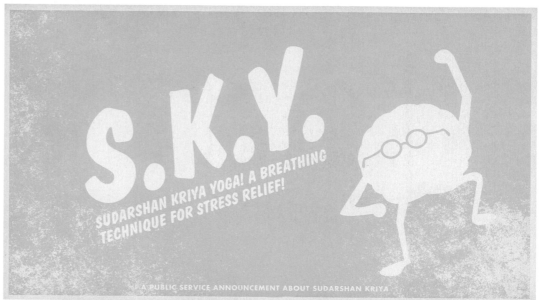

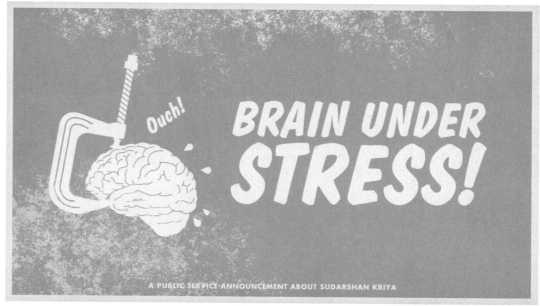

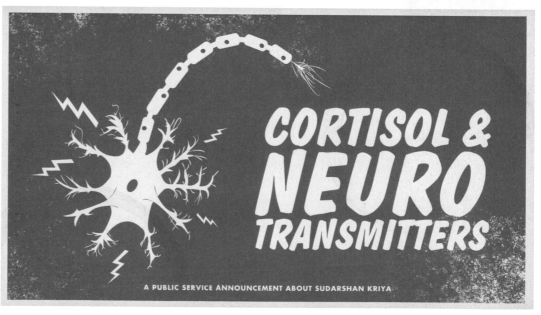

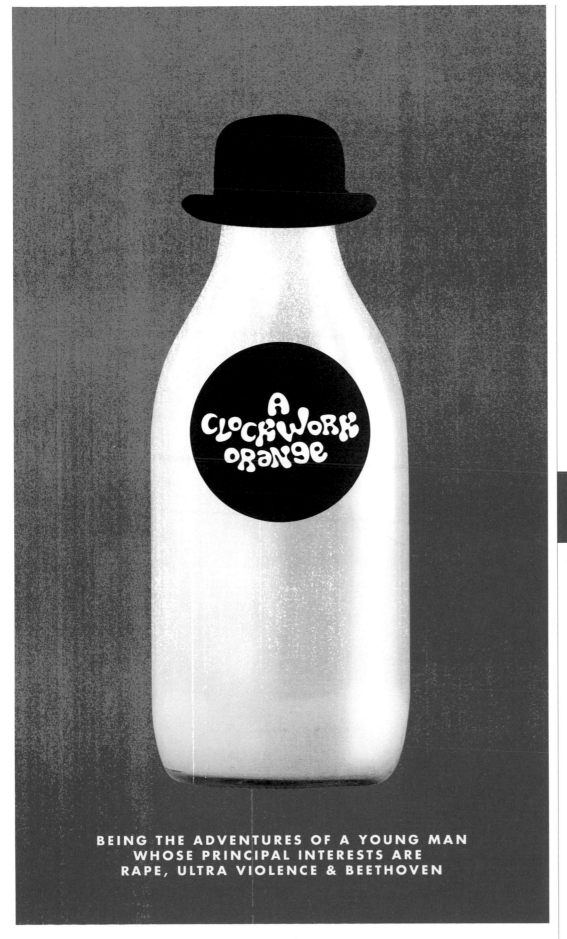

Heath Killen

A Clockwork Orange
2010, Personal Project

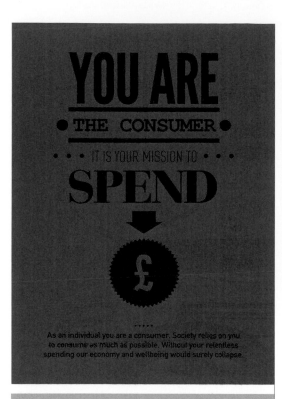

YOU ARE
• THE CONSUMER •
•••• IT IS YOUR MISSION TO ••••
SPEND
↓
£

As an individual you are a consumer. Society relies on you to consume as much as possible. Without your relentless spending our economy and wellbeing would surely collapse.

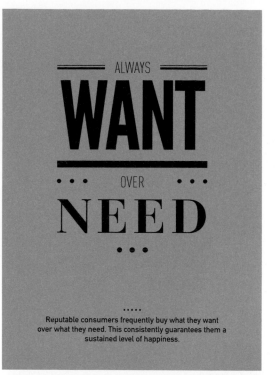

ALWAYS
WANT
••• OVER •••
NEED
•••

Reputable consumers frequently buy what they want over what they need. This consistently guarantees them a sustained level of happiness.

•••**BUY**•••
NOW
—— PAY LATER ——

Not working hard enough can often result in a lack of funds needed for consumption. However, a clever consumer will always borrow money to keep up.

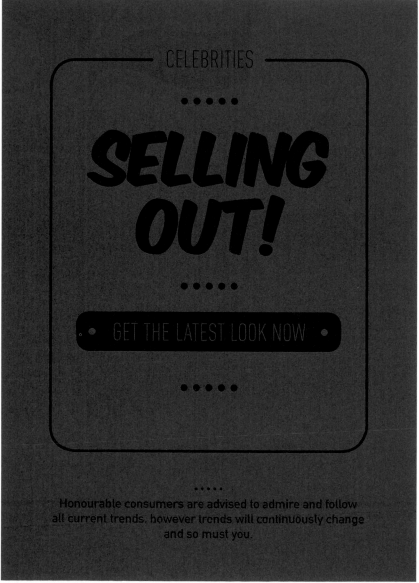

CELEBRITIES
•••••
SELLING OUT!
•••••
GET THE LATEST LOOK NOW
•••••

Honourable consumers are advised to admire and follow all current trends. however trends will continuously change and so must you.

*STRESS
ANXIETY
DISMAY

AVAILABLE HERE →

.

Consumerism can sometimes conclude with feelings of stress, anxiety and dismay. Do not worry, these are typical symptoms. To overcome such feelings we propose more spending to ensure endless fulfilment.

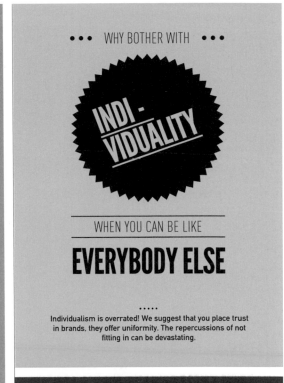

INDI-VIDUALITY

WHEN YOU CAN BE LIKE

EVERYBODY ELSE

.

Individualism is overrated! We suggest that you place trust in brands, they offer uniformity. The repercussions of not fitting in can be devastating.

Andy Penny

Consumerism

2010, Personal (Student) Project

THE CONSUMER CYCLE

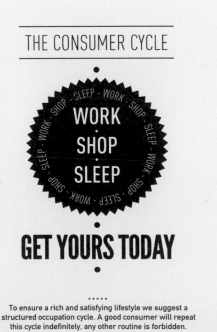

WORK
SHOP
SLEEP

GET YOURS TODAY

.

To ensure a rich and satisfying lifestyle we suggest a structured occupation cycle. A good consumer will repeat this cycle indefinitely, any other routine is forbidden.

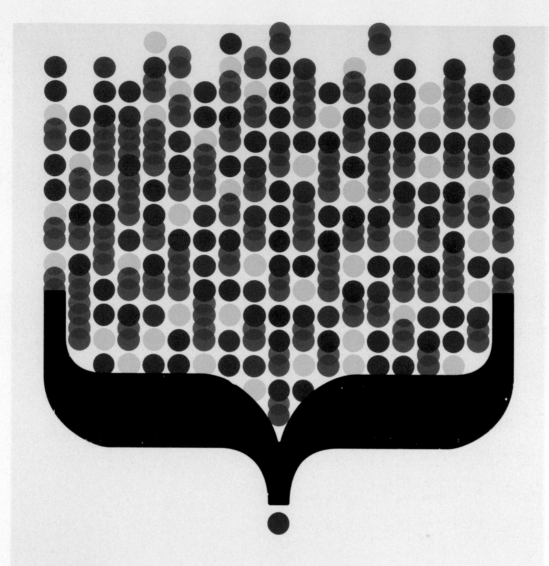

Expertise

The postmodernists told us there was no objective truth. Reality, they said, was an infinite number of multiple stories that we tell ourselves about ourselves – and this meant that everyone could be an artist, a critic or a philosopher.

As a theoretical position this was intriguing and empowering, but these advocates were not living in a time when the expansion of the media meant that everyone's art, expertise and philosophies could be self-published. In the age of the blog, the podcast, the self-designed website and the self-published 'zine, this multiplicity overwhelms us and engenders new desires and feelings. We find it hard to maintain concentration, and struggle with a new condition of Continuous Partial Attention. Thanks to interactive technology and new media, everyone is a critic – and in truth, most of them are dull, badly-informed and good only at unqualified attack or unintelligent celebration.

The trouble is, everyone these days thinks they're an expert. But they're not. Sure, everyone can blog and many can use Photoshop – but is everyone then a writer and designer? Research by Wiki and Google produces information, but it doesn't teach you how to apply that information and turn it into meaningful knowledge. The world where everybody does everything creates middling results. It's time to embrace real expertise and experts again.

Depressingly, teachers of design now find that for some students 'research' has become a collation of sources of information gathered online. This creates a body of data and an awareness of what has gone before, but the question is, how does someone create new work using those sources? How does he or she develop a vision, and create something new? How do they turn their knowledge into inspiring products and services that relate to people's lives in the modern world? To author a work, to turn data into knowledge, requires intuition and a comprehension that involves a sense of practical experience and vision. Without that, we just have amateurish pastiche, which is why so much creative work today feels like a crass, empty rehash of an old idea.

When in doubt, investigate the language. The root of the English word 'knowledge' is cnawan, a Germanic word meaning to recognise or identify. Interestingly, it is highly unusual in sharing a root with Latin gnoscere, and the Greek gignoskein (meaning 'to know by the senses'). The word knowledge thus signifies a combination of ways of knowing - knowing as fact, recognising from memory, and identifying through the senses.

In a world in which data is often used to justify poor decisions, this type of knowing should be regarded as more valuable than platinum. And you can't have wise and instinctive thinking without experience. While this depth of thought came to be undervalued during the boom, in design it is now being fostered. The last decade has seen a growth in multi-disciplinary working, whereby practitioners are asked to apply learning from one field of expertise to several others. It is an acknowledgement that only knowing the facts and data of a discipline is insufficient to produce work good enough to meet the new demands of a changing world. Also essential are insight and intuition, those priceless combinations of instinct and rich experience.

In this world where skill and intention matter, age comes before beauty. When youth is fetishised, skills are lost. People are starting to value long-term knowledge over the anything-goes ethos of the internet, and realising that depth and intuition aren't things you instinctively do or don't have. They come from all you know and from living and working with a subject for years.

Expertise doesn't mean that you no longer take risks during the process. But there's a high return on the results. And it means you don't add to the ignorant crap and clutter that gets in the way of good design and human progress.

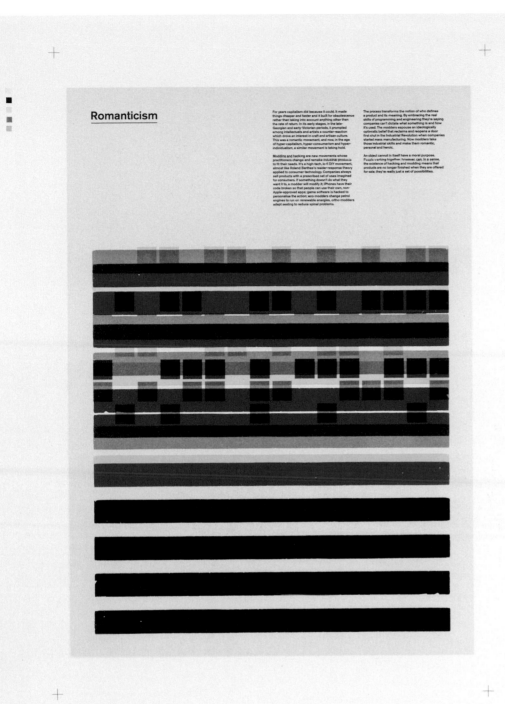

Romanticism

For years capitalism did because it could. It made things cheaper and faster and it built for obsolescence rather than taking into account anything other than the rate of return. In its early stages, in the late-Georgian and early-Victorian periods, it prompted among intellectuals and artists a counter-reaction which drove an interest in craft and artisan culture. This was a romantic movement, and now, in the age of hyper-capitalism, hyper-consumerism and hyper-individualism, a similar movement is taking hold.

Modding and hacking are new movements whose practitioners change and remake industrial products to fit their needs. It's a high-tech, lo-fi DIY movement, almost like Roland Barthes's reader-response theory applied to consumer technology. Companies always sell products with a prescribed set of uses imagined for consumers. If something doesn't do what they want it to, a modder will modify it; iPhones have their code broken so that people can use their own, non-Apple-approved apps; game software is hacked to personalise the action; eco-modders change petrol engines to run on renewable energies, ortho-modders adapt seating to reduce spinal problems.

The process transforms the notion of who defines a product and its meaning. By embracing the real skills of programming and engineering they're saying companies can't dictate what something is and how it's used. The modders espouse an ideologically optimistic belief that reclaims and reopens a door first shut in the Industrial Revolution when companies started mass manufacturing. Now modders take those industrial skills and make them romantic, personal and heroic.

An object cannot in itself have a moral purpose. People working together, however, can, in a sense, the existence of hacking and modding means that products are no longer finished when they are offered for sale; they're really just a set of possibilities.

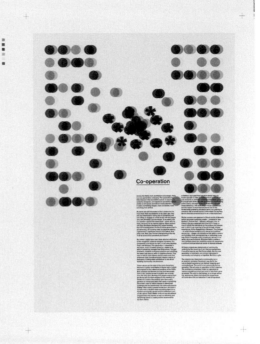

Co-operation

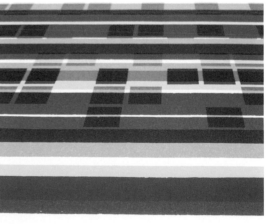

Tom Hingston Studio

Tænker 001 Edition
2011, Æsir Copenhagen
Tænker first edition is a publication, Tænker 001, edited by Suki Larson and Martyn Evans. It was designed and produced by Tom Hingston Studio at a Copenhagen-based lithographic workshop in a limited edition of 100 copies.

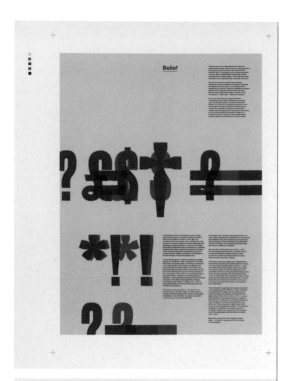

Tom Hingston Studio

Tænker 001 Edition

2011, Æsir Copenhagen

Tænker first edition is a publication, Tænker 001, edited by Suki Larson and Martyn Evans. It was designed and produced by Tom Hingston Studio at a Copenhagen-based lithographic workshop in a limited edition of 100 copies.

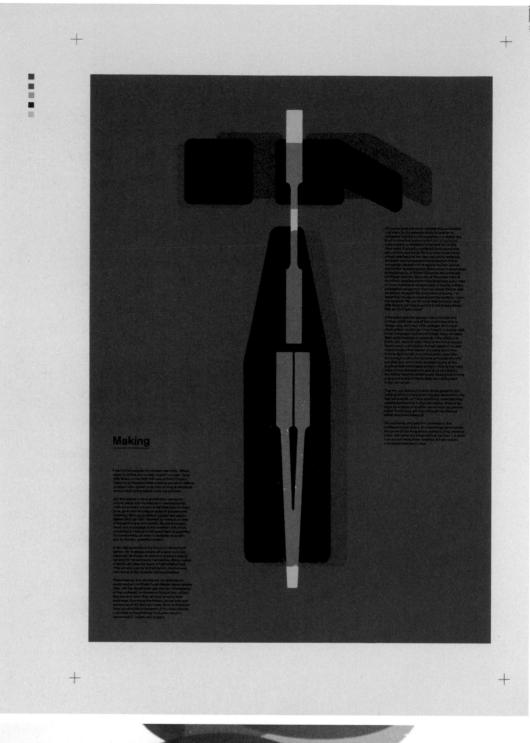

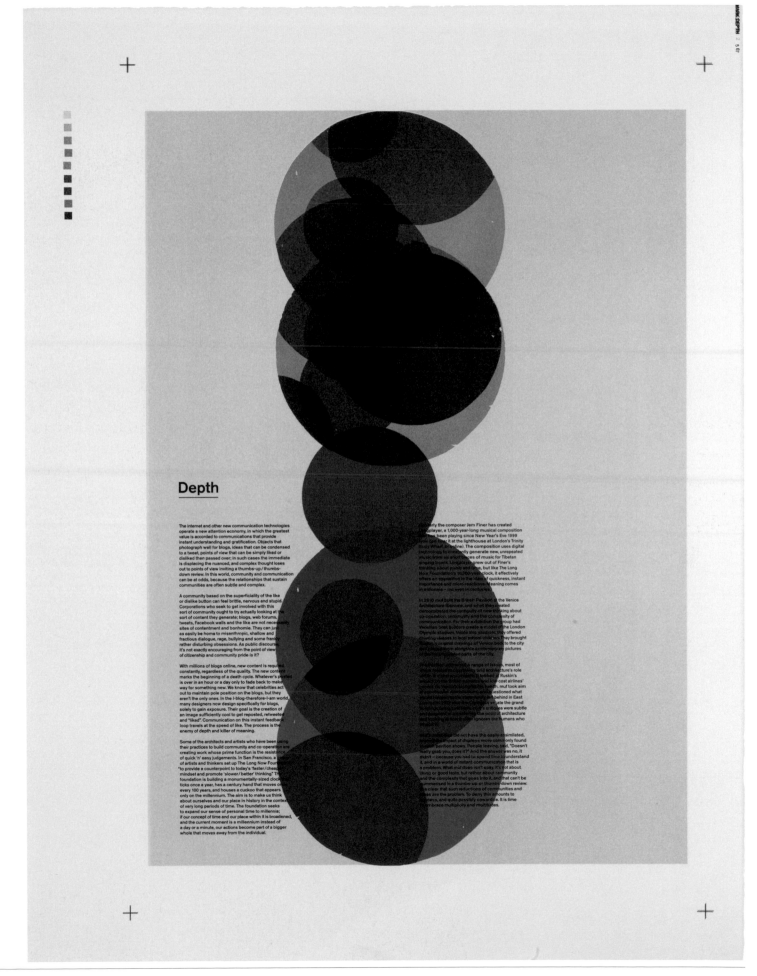

Depth

The internet and other new communication technologies operate a new attention economy, in which the greatest value is accorded to communications that provide instant understanding and gratification. Objects that photograph well for blogs, ideas that can be condensed to a tweet, points of view that can be simply liked or disliked then passed over; in such cases the immediate is displacing the nuanced, and complex thought loses out to points of view inviting a thumbs-up/thumbs-down review. In this world, community and communication can be at odds, because the relationships that sustain communities are often subtle and complex.

A community based on the superficiality of the like or dislike button can feel brittle, nervous and stupid. Corporations who seek to get involved with this sort of community ought to try actually looking at the sort of content they generate; blogs, web forums, tweets, Facebook walls and the like are not necessarily sites of contentment and bonhomie. They can just as easily be home to misanthropic, shallow and fractious dialogue, rage, bullying and some frankly rather disturbing obsessions. As public discourse, it's not exactly encouraging from the point of view of citizenship and community pride is it?

With millions of blogs online, new content is required constantly, regardless of the quality. The new content marks the beginning of a death cycle. Whatever's posted is over in an hour or a day only to fade back to make way for something new. We know that celebrities act out to maintain pole position on the blogs, but they aren't the only ones. In the I-blog-therefore-I-am world, many designers now design specifically for blogs, solely to gain exposure. Their goal is the creation of an image sufficiently cool to get reposted, retweeted and "liked". Communication on this instant feedback loop travels at the speed of like. The process is the enemy of depth and killer of meaning.

Some of the architects and artists who have been using their practices to build community and co-operation are creating work whose prime function is the resistance of quick 'n' easy judgements. In San Francisco, a group of artists and thinkers set up The Long Now Foundation "to provide a counterpoint to today's 'faster/cheaper' mindset and promote 'slower/better' thinking." The foundation is building a monumentally-sized clock that ticks once a year, has a century hand that moves on every 100 years, and houses a cuckoo that appears only on the millennium. The aim is to make us think about ourselves and our place in history in the context of very long periods of time. The foundation seeks to expand our sense of personal time to millennia; if our concept of time and our place within it is broadened, and the current moment is a millennium instead of a day or a minute, our actions become part of a bigger whole that moves away from the individual.

...rly the composer Jem Finer has created ...player, a 1,000-year-long musical composition ...been playing since New Year's Eve 1999 ...(or hear it at the lighthouse at London's Trinity ...Buoy Wharf, or online). The composition uses digital ...technology to constantly generate new, unrepeated ...music from six sources of music for Tibetan ...singing bowls. Longplayer grew out of Finer's ...thinking about pace and time, but like The Long ...Now Foundation's 10,000-year clock, it effectively ...takes an opposition to the ideas of quickness, instant ...importance and micro-reactions. Meaning comes ...in millennia – not even in centuries.

In 2010 muf built the British Pavilion at the Venice Architecture Biennale, and what they created demonstrated the complexity of new thinking about co-operation, community and the complexity of communication. For their exhibition the group had Venetian boat builders create a model of the London Olympic stadium. Inside this stadium, they offered drawing classes to local school children. They brought the physical drawings of Venice back to the city and juxtaposition alongside contemporary pictures of the less-visited parts of the city.

...a range of issues, most of ...and architecture's role ...looked at Ruskin's ...and low-cost airlines' ...muf took aim ...questioned what ...left behind in East ...create the grand ...critiques were subtle ...the point of architecture ...ignores the humans who ...

...did not have this easily-assimilated, ...impact of displays more commonly found ...pavilion shows. People leaving, said, "Doesn't ...grab you, does it?" And the answer was no, it ...– because you had to spend time to understand ...it, and in a world of instant communication that is a problem. What muf does isn't easy. It's not about ...bang or good taste, but rather about community ...and the complexity that goes into it, and that can't be ...summarised in a thumbs-up or thumbs-down review. ...clear that such reductions of communities and ...ideas are the problem. To deny this amounts to ...cowardice. It is time ...to embrace multiplicity and multitudes.

Park the Van presents

DAVID VANDERVELDE
CADDYWHOMPUS
CARTER TANTON of Tulsa & Lower Dens

Friday October 14th
Chickie Wah Wah
2828 Canal St.
doors at 9pm
$10

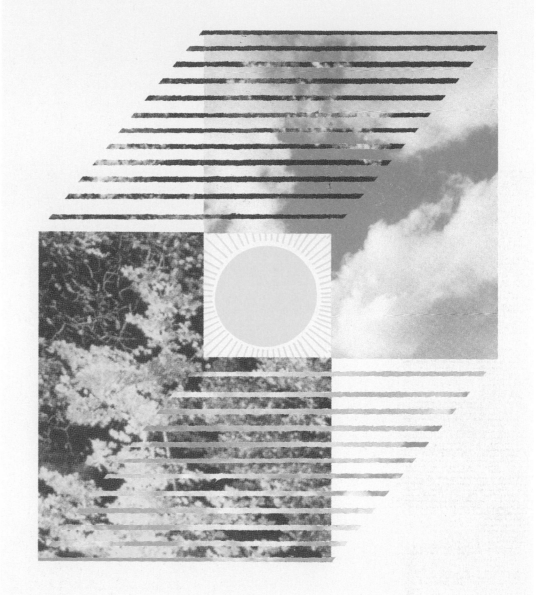

Scott Campbell

Gas Food & Lodging Festival
2009, Bullhorn Bandits

David Vandervelde
2011, Park the Van Records
16 x 24 in., three-color screen print.

BULLHORN BANDITS PRESENT
GAS FOOD & LODGING FEST
WEEK ONE

SPANISH MOON

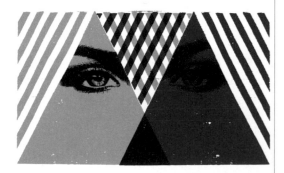

SATURDAY MARCH 14	MONDAY MARCH 16	TUESDAY MARCH 17
ANATHALLO	MARNIE STERN	THESE ARMS ARE SNAKES
SAM AMIDON	MILES BENJAMIN - ANTHONY ROBINSON	YOUNG WIDOWS
	TITUS ANDRONICUS	MASERATI
	THE SUBJECTS	

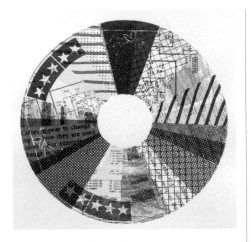

BULLHORN
BANDITS
PRESENT

the national

JUNE 4TH & 5TH // PHILADELPHIA • PA // ELECTRIC FACTORY // WITH THE ANTLERS

RA RA RIOT
MAPS & ATLASES
PRINCETON

SAT SEP 26
SPANISH MOON

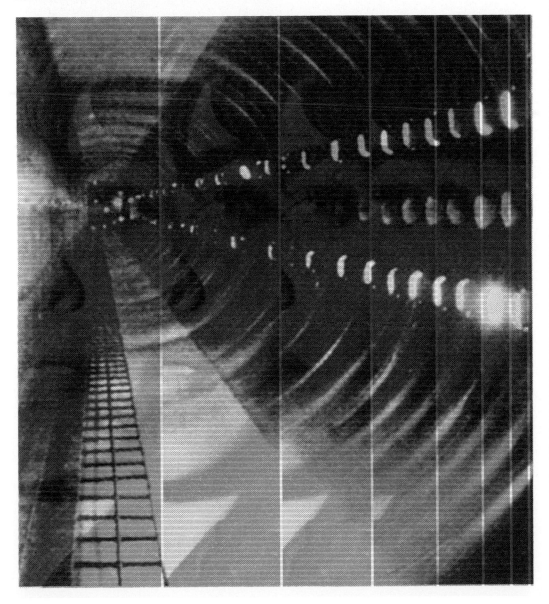

Scott Campbell

The National
2010, The National
18 x 22 in., three-color screen print.

Colors Appear to Change
2008, Personal Project
18 x 18 in., three-color screen print.

Ra Ra Riot
2009, Bullhorn Bandits

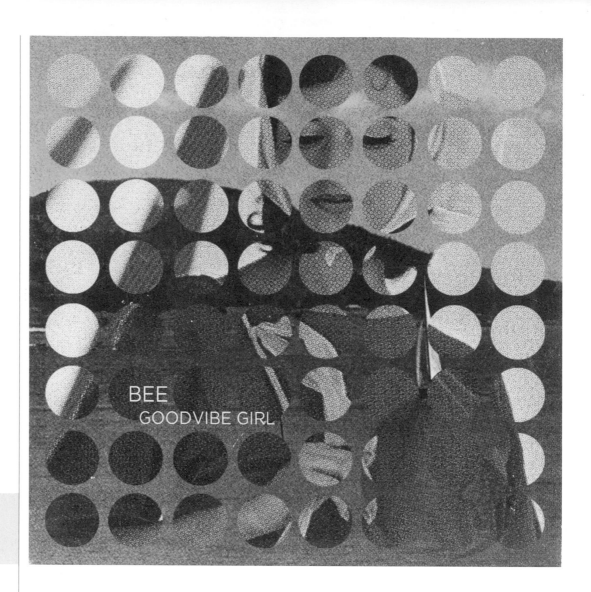

Brandon Schaefer

Goodvibe Girl
 2009, Bee
Album art for the single "Goodvibe Girl" by the musician Bee.

Scott Campbell

Caddywhompus
 2010, Bullhorn Bandits
17 x 23 in., four-color screen print.

BULLHORN
BANDITS
PRESENT

FRI JAN 22
SPANISH
MOON

CADDYWHOMPUS
MAN PLUS BUILDING
SMILEY WITH A KNIFE

BRANDON SCHAEFER, SCOTT CAMPBELL

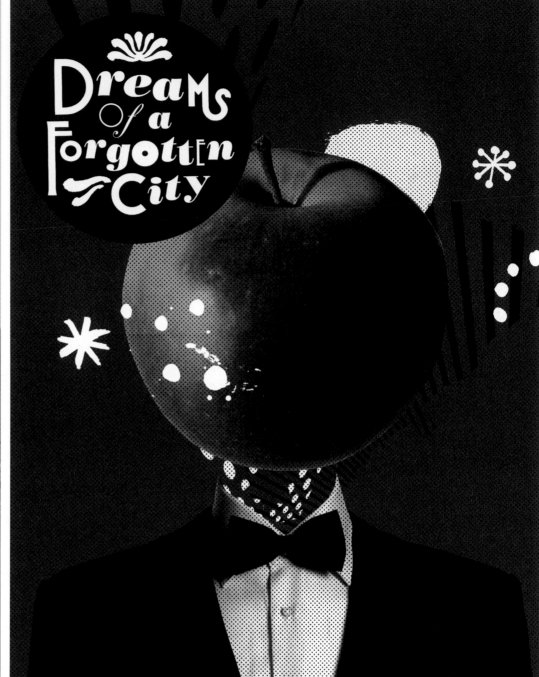

Heath Killen

2039, Dreams of a Forgotten City
2010, Tantrum Theatre
*Tantrum Theatre is an independent theater
company based in Newcastle, Australia.*

Processed Harp Works Volume 1
2011, New Weird Australia
Record cover for Kris Keogh

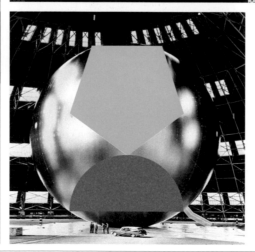

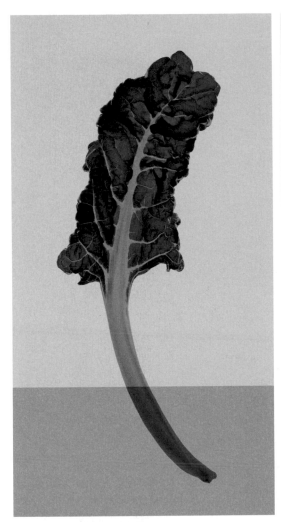

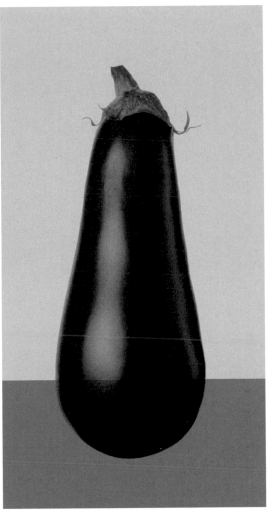

Concrete Design Communications

Exterior poster
2010, Fabbrica
Designer: Edmond Ng → Poster for the restaurant
Fabbrica.

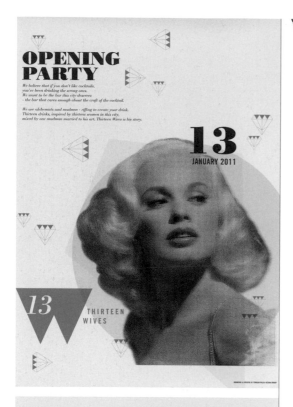

Foreign Policy Design Group

13 Wives
2011, 13 Wives

13 Wives is the story of 13 ladies and their man behind the bar. This tucked-away special little cocktail bar mixes up potent one-of-a-kind concoctions inspired by each of the femme fatale protagonists.

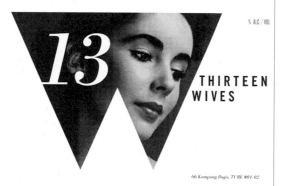

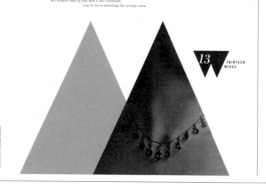

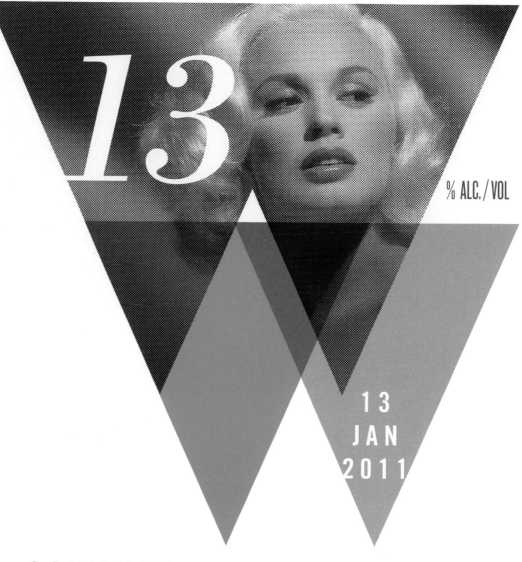

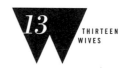

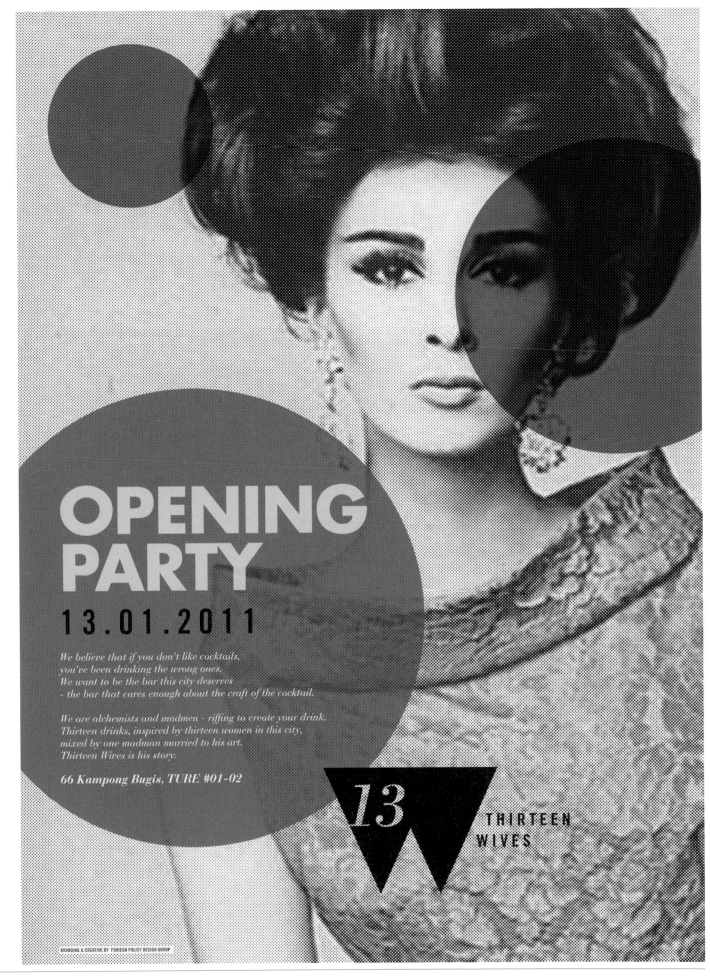

OPENING PARTY

13.01.2011

We believe that if you don't like cocktails,
you've been drinking the wrong ones.
We want to be the bar this city deserves
- the bar that cares enough about the craft of the cocktail.

We are alchemists and madmen - riffing to create your drink.
Thirteen drinks, inspired by thirteen women in this city,
mixed by one madman married to his art.
Thirteen Wives is his story.

66 Kampong Bugis, TURE #01-02

13 W THIRTEEN WIVES

BRANDING & CREATIVE BY FOREIGN POLICY DESIGN GROUP

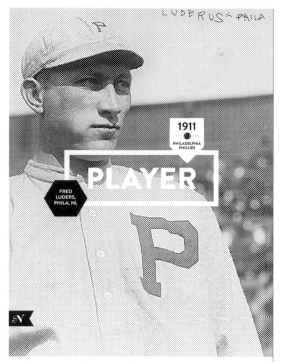

LUDERUS PHILA

1911
PHILADELPHIA
PHILLIES

PLAYER

FRED
LUDERS,
PHILA, NL

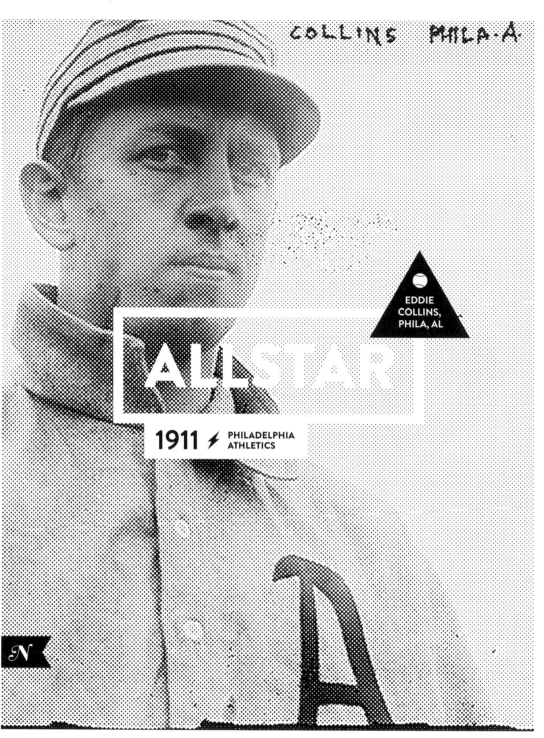

COLLINS PHILA·A·

EDDIE
COLLINS,
PHILA, AL

ALLSTAR

1911 ⚡ PHILADELPHIA ATHLETICS

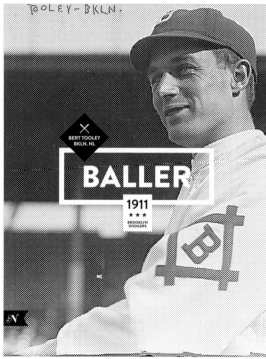

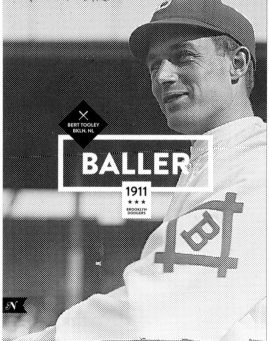

TOOLEY-BKLN.

BERT TOOLEY
BKLN, NL

BALLER

1911
★★★
BROOKLYN
DODGERS

Neuarmy

Victory League | Player
2011, Personal Project
*Photos: Library of Congress → A collection of
champion athletes from various sports and eras.*

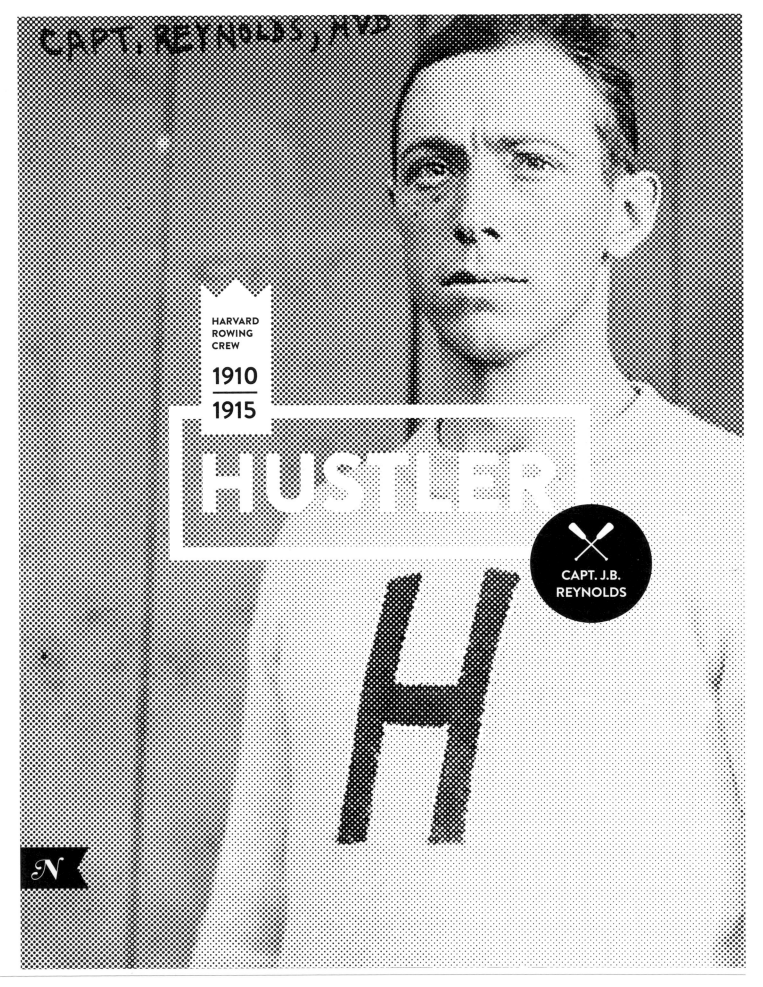

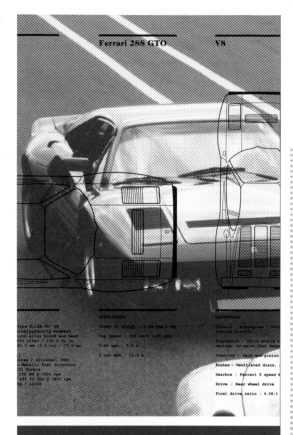

Ferrari 288 GTO V8

Jonathan Mutch

GTO, Miura, 78, 911 Carrera, 3 Series
2010/11, Personal Project

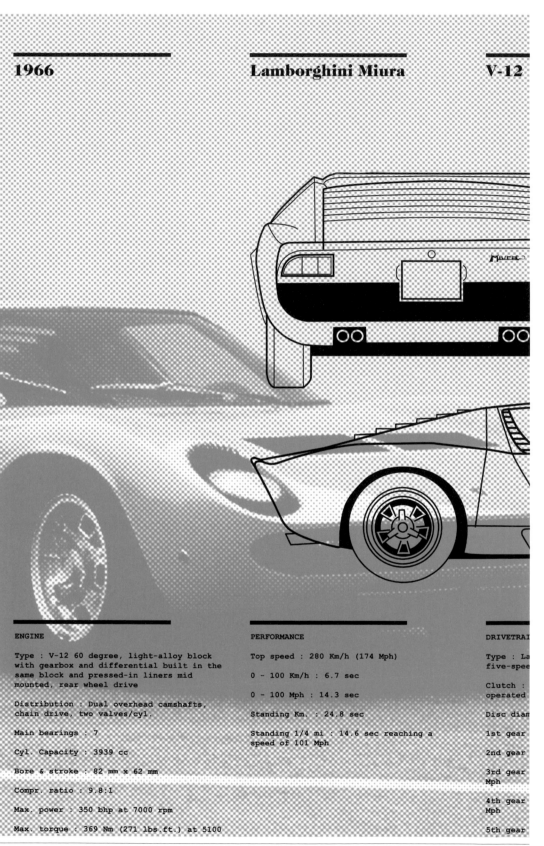

1966 **Lamborghini Miura** **V-12**

ENGINE

Type : V-12 60 degree, light-alloy block
with gearbox and differential built in the
same block and pressed-in liners mid
mounted, rear wheel drive

Distribution : Dual overhead camshafts,
chain drive, two valves/cyl.

Main bearings : 7

Cyl. Capacity : 3939 cc

Bore & stroke : 82 mm x 62 mm

Compr. ratio : 9.8:1

Max. power : 350 bhp at 7000 rpm

Max. torque : 369 Nm (271 lbs.ft.) at 5100

PERFORMANCE

Top speed : 280 Km/h (174 Mph)

0 - 100 Km/h : 6.7 sec

0 - 100 Mph : 14.3 sec

Standing Km. : 24.8 sec

Standing 1/4 mi : 14.6 sec reaching a
speed of 101 Mph

DRIVETRAI

Type : La
five-spee

Clutch :
operated

Disc diam

1st gear

2nd gear

3rd gear
Mph

4th gear
Mph

5th gear

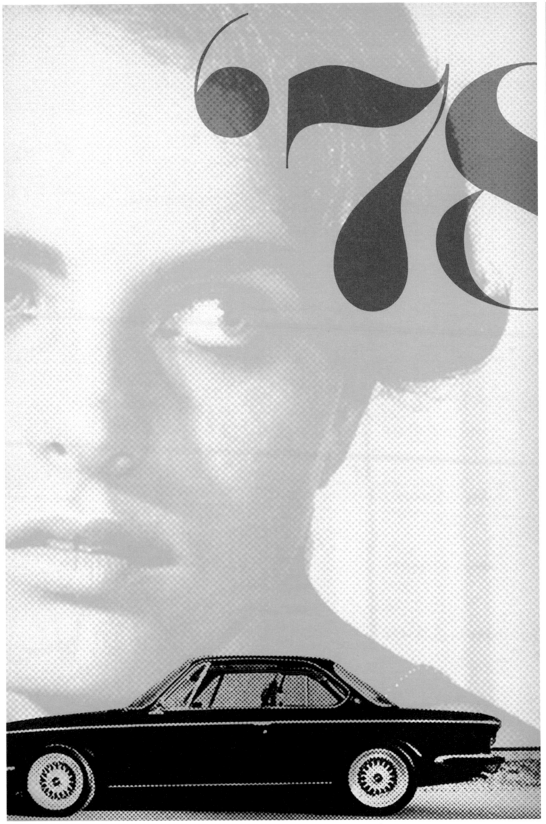

'78

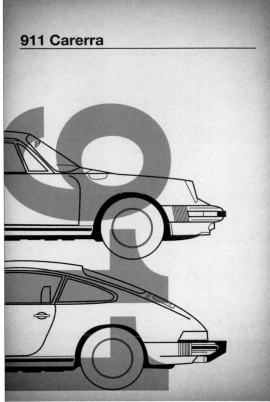

911 Carerra

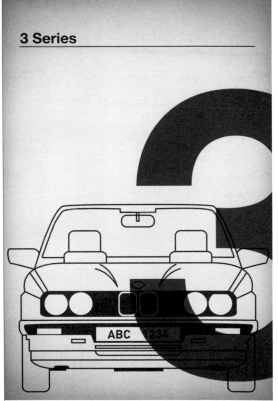

3 Series

JONATHAN MUTCH

NOTHING
TODAY SAY

Andaur Studios

17, Nothing, Both
2011, Personal Project
*Part of my daily graphic project "Everyday",
going on since June 2011.*

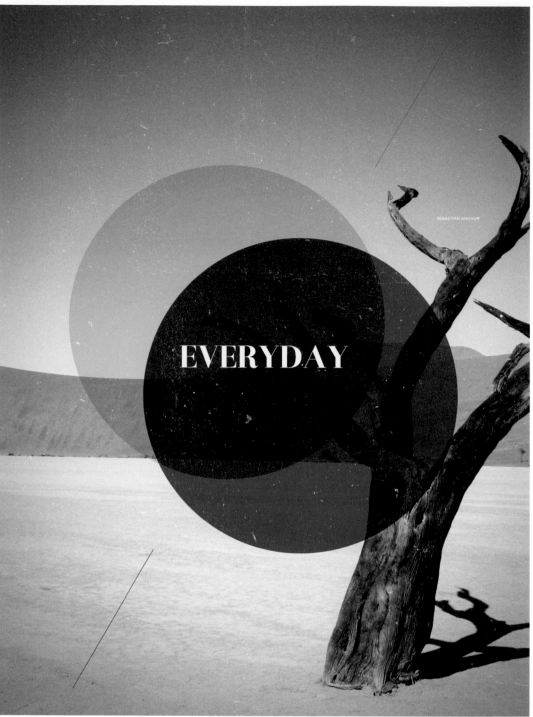

EVERYDAY

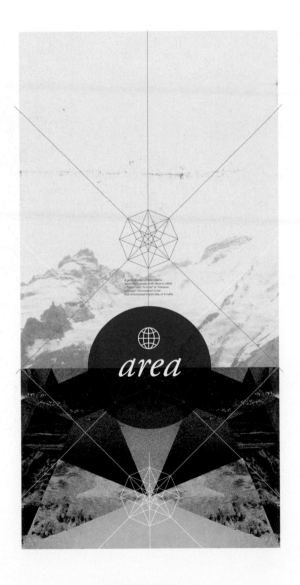

In geometry, the tesseract, also called an 8-cell or regular octachoron or cubic prism, is the four-dimensional analog of the cube. The tesseract is to the cube as the cube is to the square. Just as the surface of the cube consists of 6 square faces, the hypersurface of the tesseract consists of 8 cubical cells. The tesseract is one of the six convex regular 4-polytopes.

Astronaut Design

Astronaut Design Identity
2010, Personal Project

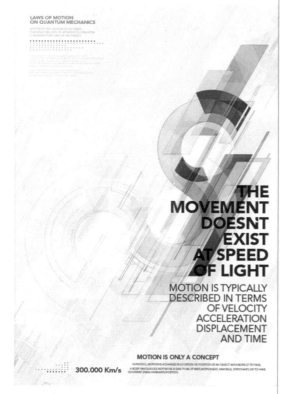

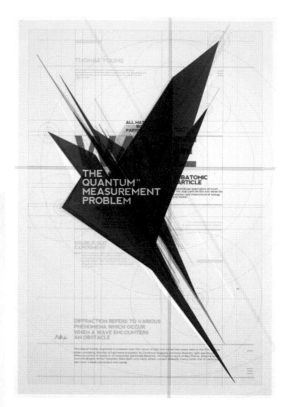

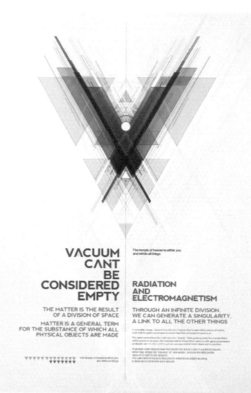

THE MOVEMENT DOESNT EXIST AT SPEED OF LIGHT

MOTION IS TYPICALLY DESCRIBED IN TERMS OF VELOCITY ACCELERATION DISPLACEMENT AND TIME

MOTION IS ONLY A CONCEPT

300.000 Km/s

VACUUM CANT BE CONSIDERED EMPTY

THE MATTER IS THE RESULT OF A DIVISION OF SPACE

MATTER IS A GENERAL TERM FOR THE SUBSTANCE OF WHICH ALL PHYSICAL OBJECTS ARE MADE

RADIATION AND ELECTROMAGNETISM

THROUGH AN INFINITE DIVISION, WE CAN GENERATE A SINGULARITY, A LINK TO ALL THE OTHER THINGS

THE QUANTUM MEASUREMENT PROBLEM

Metric72

19,47 – Father Sun, Smell Monkeys Lucky Dice Chaos, Vacuum Can't Be Considered Empty, The Quantum Measurement Problem, The Movement Doesn't Exist At The Speed Of Light
 2010, Universe
Designer: Jorge Marín.

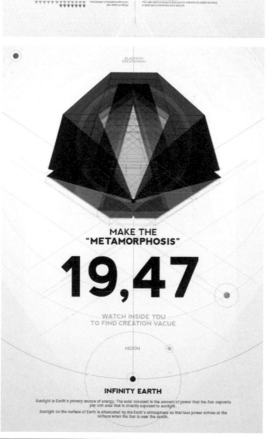

MAKE THE "METAMORPHOSIS"

19,47

WATCH INSIDE YOU TO FIND CREATION VACUE

MOON

INFINITY EARTH

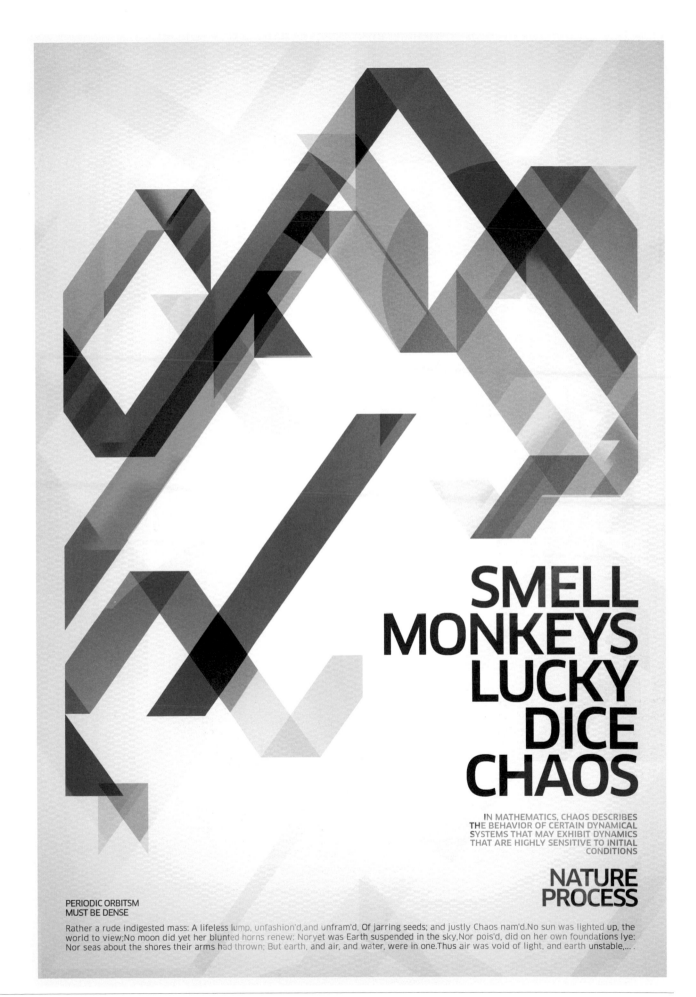

SMELL MONKEYS LUCKY DICE CHAOS

IN MATHEMATICS, CHAOS DESCRIBES THE BEHAVIOR OF CERTAIN DYNAMICAL SYSTEMS THAT MAY EXHIBIT DYNAMICS THAT ARE HIGHLY SENSITIVE TO INITIAL CONDITIONS

NATURE PROCESS

PERIODIC ORBITSM
MUST BE DENSE

Rather a rude indigested mass: A lifeless lump, unfashion'd,and unfram'd. Of jarring seeds; and justly Chaos nam'd.No sun was lighted up, the world to view;No moon did yet her blunted horns renew: Noryet was Earth suspended in the sky,Nor pois'd, did on her own foundations lye: Nor seas about the shores their arms had thrown; But earth, and air, and water, were in one.Thus air was void of light, and earth unstable,.... .

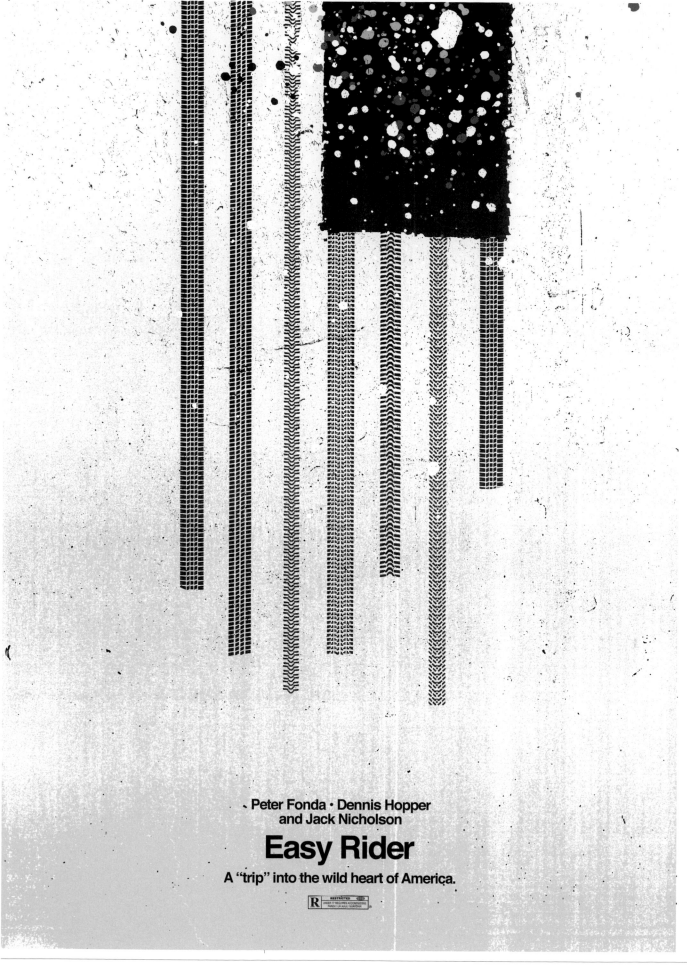

Peter Fonda · Dennis Hopper
and Jack Nicholson

Easy Rider

A "trip" into the wild heart of America.

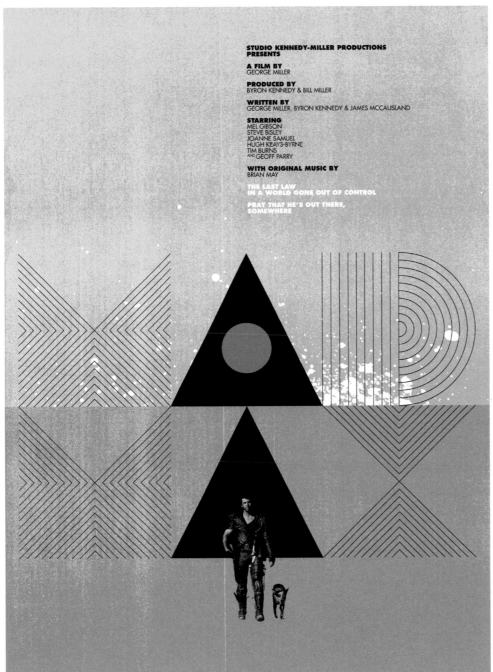

STUDIO KENNEDY-MILLER PRODUCTIONS
PRESENTS

A FILM BY
GEORGE MILLER

PRODUCED BY
BYRON KENNEDY & BILL MILLER

WRITTEN BY
GEORGE MILLER, BYRON KENNEDY & JAMES MCCAUSLAND

STARRING
MEL GIBSON
STEVE BISLEY
JOANNE SAMUEL
HUGH KEAYS-BYRNE
TIM BURNS
AND GEOFF PARRY

WITH ORIGINAL MUSIC BY
BRIAN MAY

THE LAST LAW
IN A WORLD GONE OUT OF CONTROL

PRAY THAT HE'S OUT THERE,
SOMEWHERE

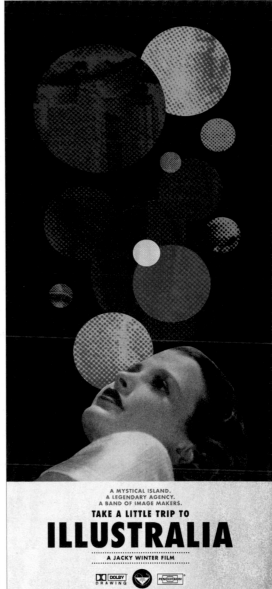

A MYSTICAL ISLAND.
A LEGENDARY AGENCY.
A BAND OF IMAGE MAKERS.

TAKE A LITTLE TRIP TO

ILLUSTRALIA

A JACKY WINTER FILM

The
N3CKS

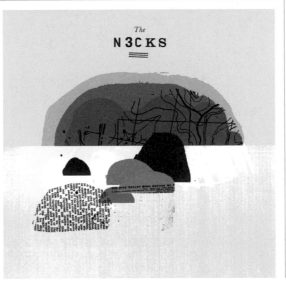

Heath Killen

Easy Rider, Mad Max
 2010, Personal Project

Illustralia
 2010, Jacky Winter Group
 Promotional image.

The Necks
 2011, Jazz & Draw
 Blog illustration.

FRAMED: ART ON FILM
THE BRATTLE THEATRE · SEPT 25-30

THE MYSTERY OF PICASSO · VERTIGO · LAURA · STOLEN · THE ART OF THE STEAL · THE HORSES MOUTH
FOR MORE INFO, VISIT WWW.BRATTLEFILM.ORG

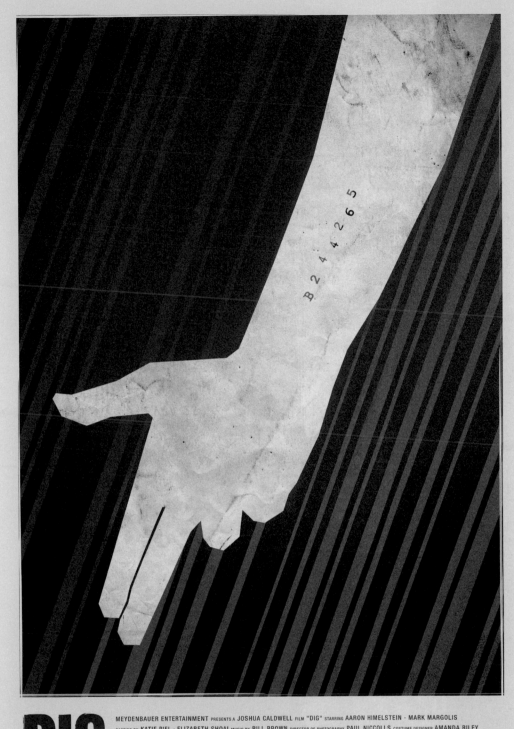

Brandon Schaefer

Framed: Art on Film, Dig
2010/11, The Brattle Theatre
*Poster for a series of film screenings
that deal with the subject of art.*

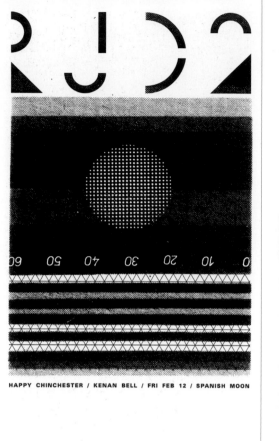

HAPPY CHINCHESTER / KENAN BELL / FRI FEB 12 / SPANISH MOON

Scott Campbell

RJD2
2010, Bullhorn Bandits

Matt & Kim / Velcro
2009, Bullhorn Bandits

Why?
2009, Why?
17 x 23 in., three-color screen print.

Reception is Suspected
2008, Reception is Suspected

Club of the Sons
2008, Bullhorn Bandits

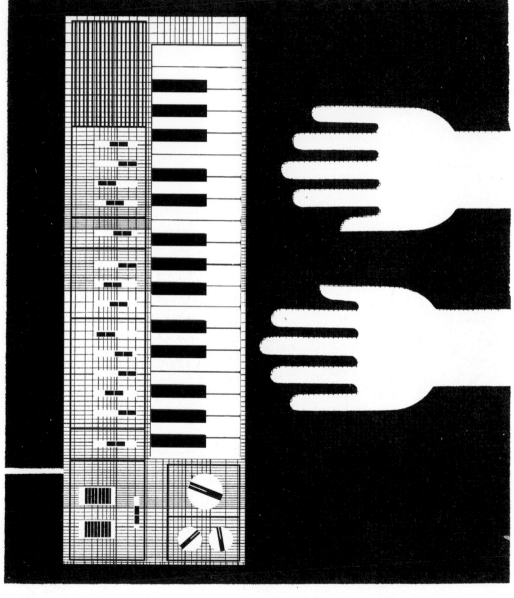

BULLHORN BANDITS PRESENT
VELCRO
WITH VERY SPECIAL GUESTS
MATT+KIM
WED MAR 4TH SPANISH MOON

WHY?

SERENGETI & POLYPHONIC

SEPTEMBER 24 • 2009

NORTHSIDE TAVERN

CINCINNATI • OH

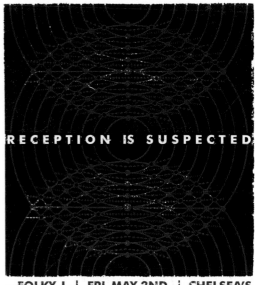

RECEPTION IS SUSPECTED

w/ FOLKY J | FRI MAY 2ND ¡ CHELSEA'S

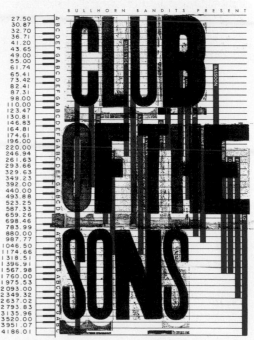

PRETTY & NICE | SAT AUG 30 | SPANISH MOON

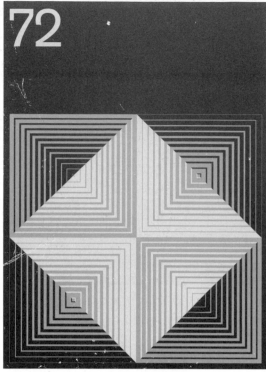

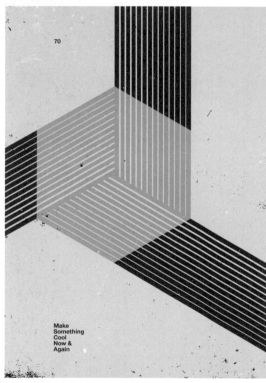

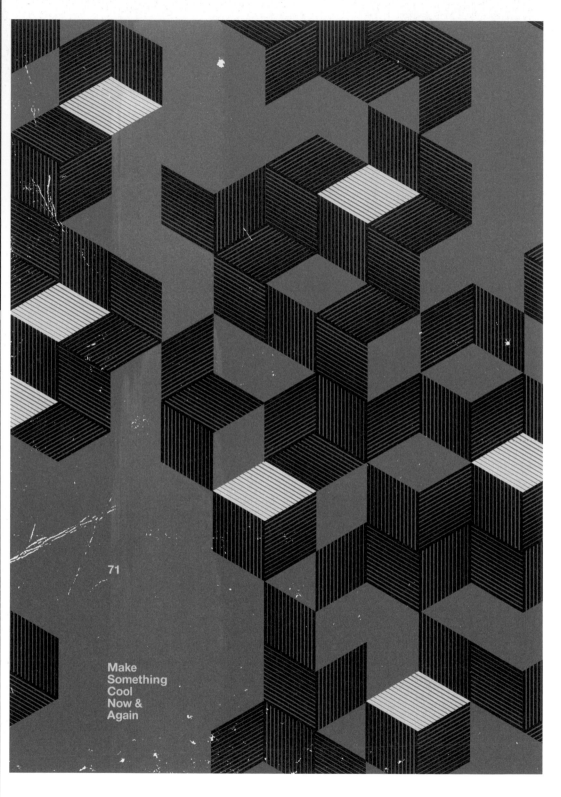

Marius Roosendaal

70, 71, 72, Skewed Space
2011, Personal Project
Part of a self-initiated "make something every day" project.

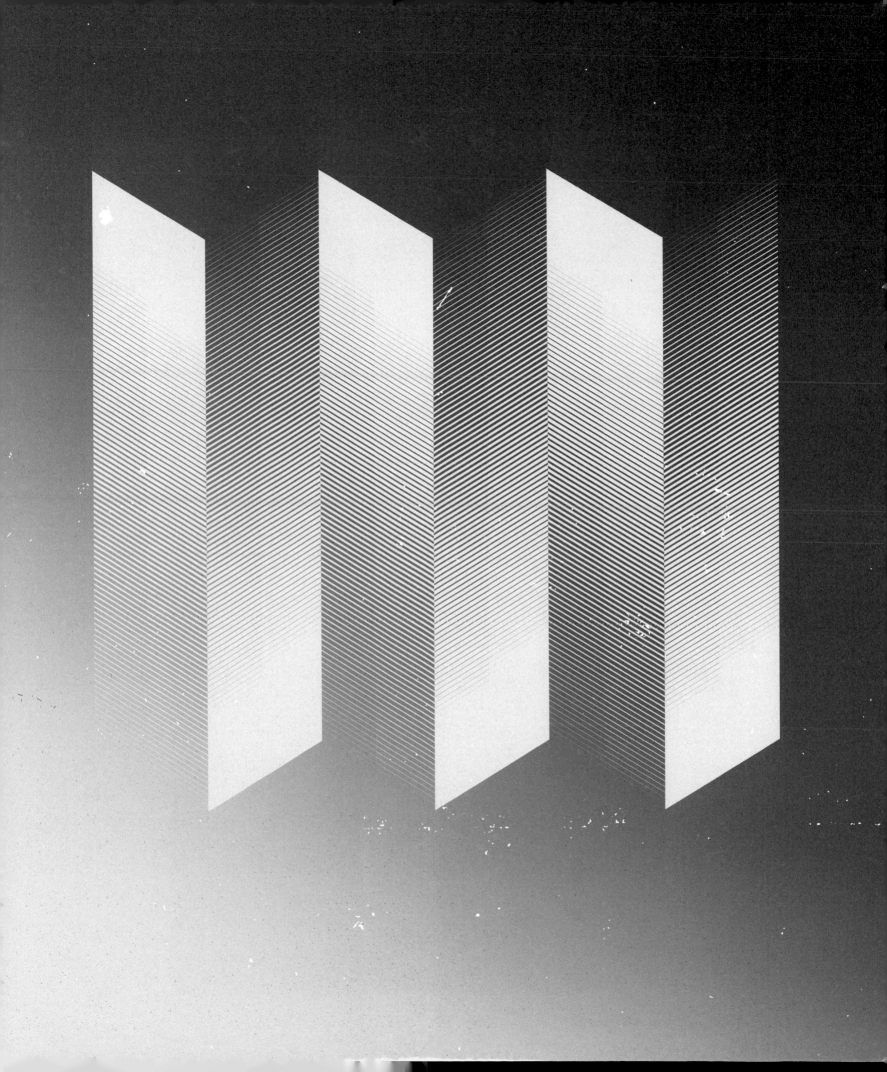

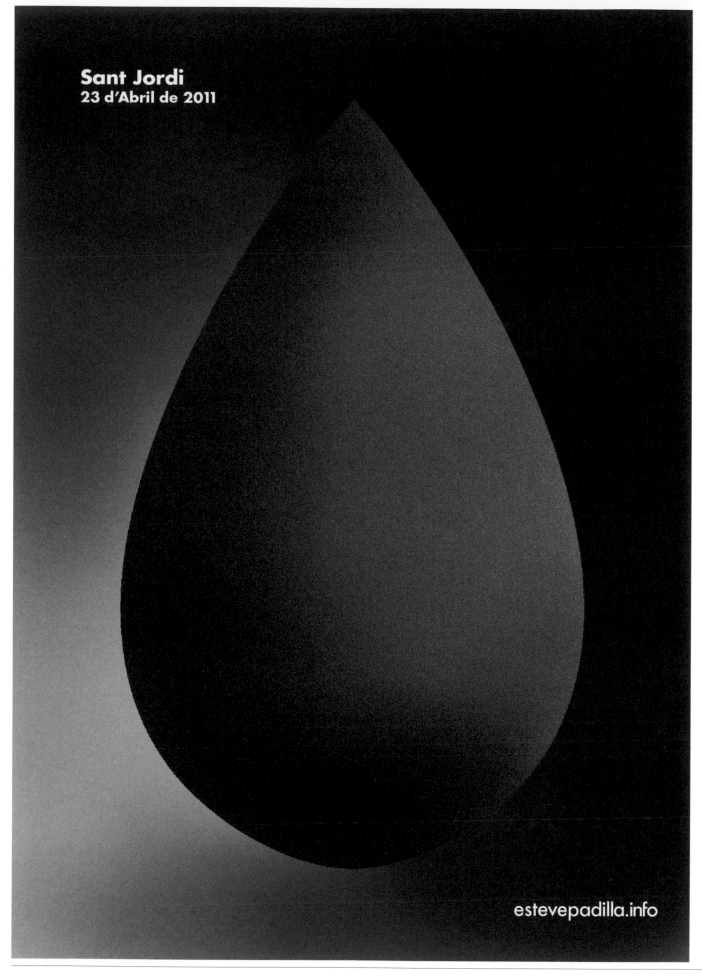

Sant Jordi
23 d'Abril de 2011

estevepadilla.info

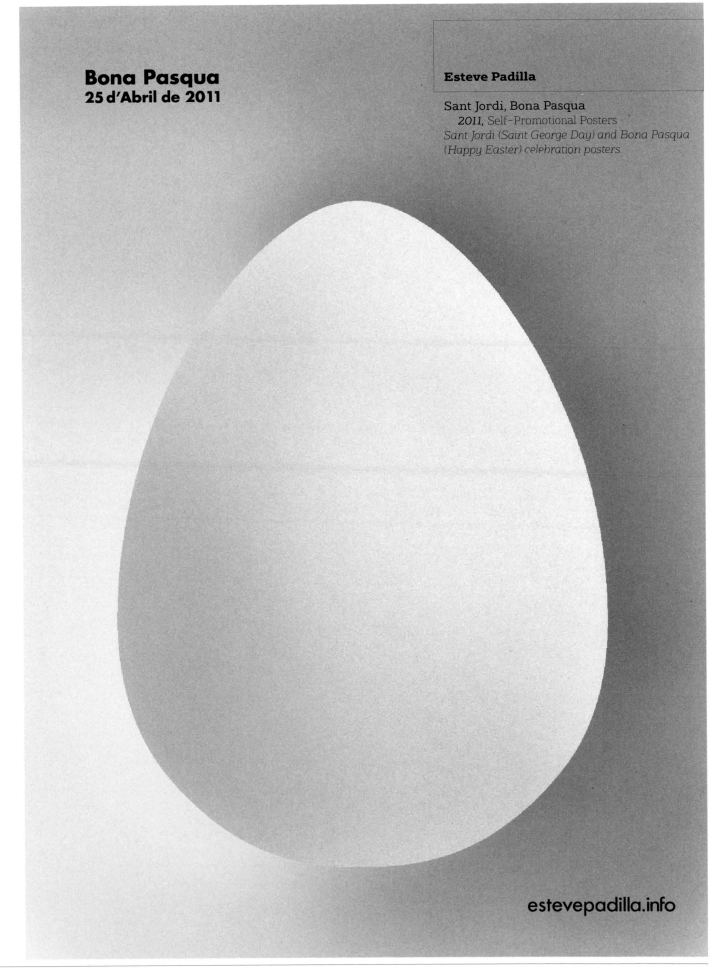

Bona Pasqua
25 d'Abril de 2011

estevepadilla.info

Esteve Padilla

Sant Jordi, Bona Pasqua
2011, Self-Promotional Posters
*Sant Jordi (Saint George Day) and Bona Pasqua
(Happy Easter) celebration posters.*

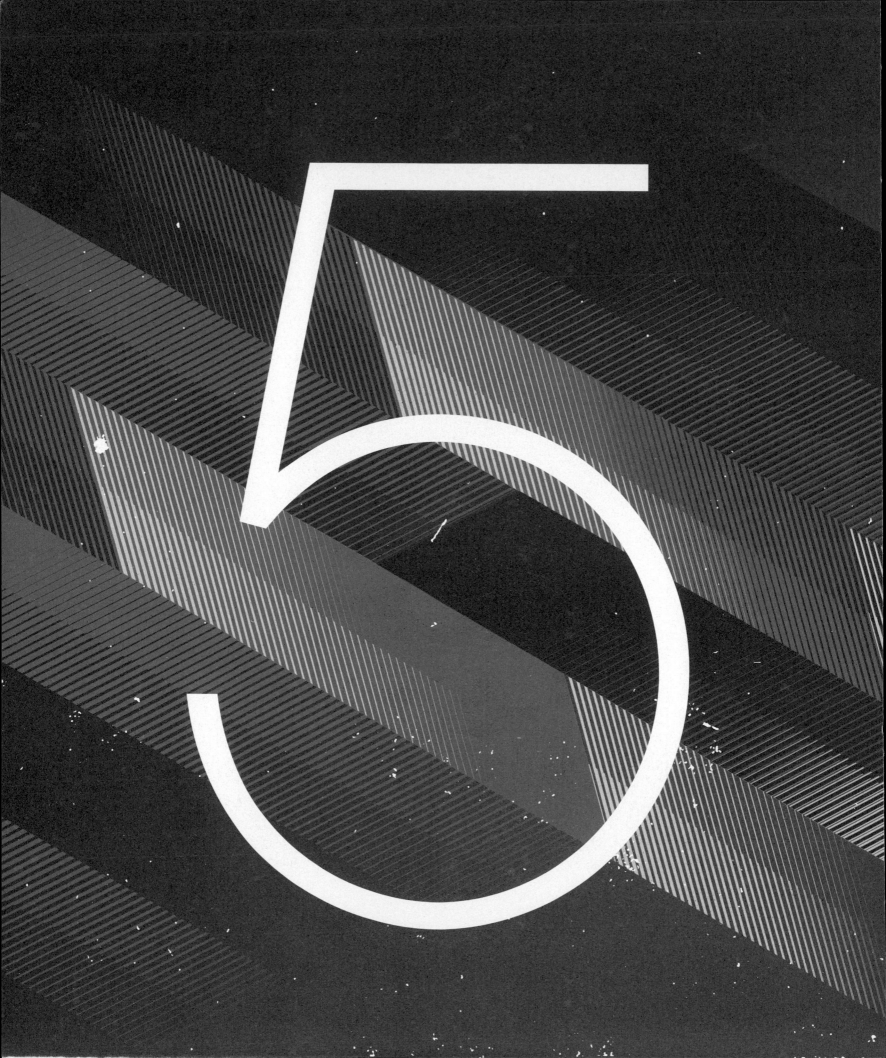

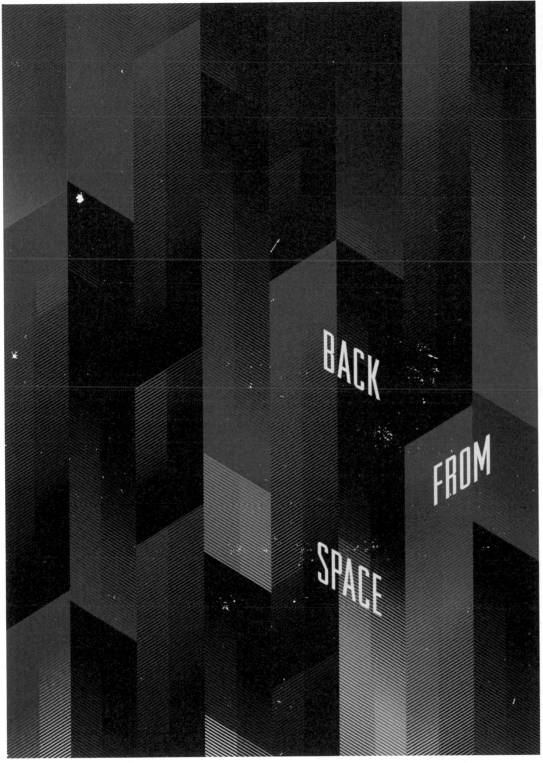

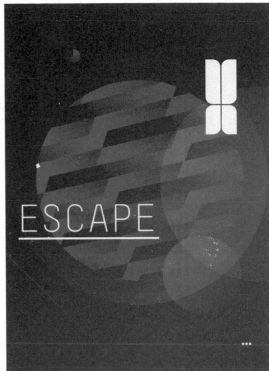

ESCAPE

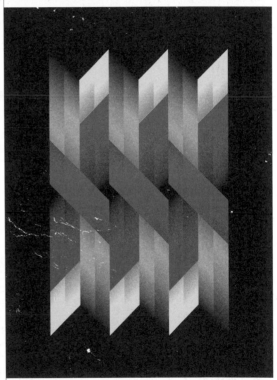

Marius Roosendaal

5, Back From Space, Escape, 65
2011, Personal Project
Part of a self-initiated "make something every day" project.

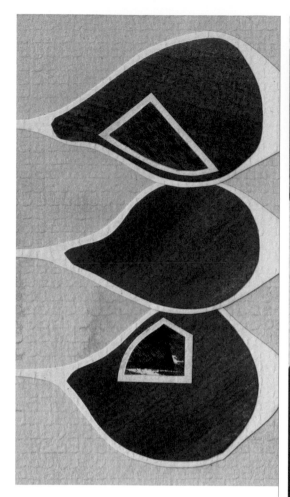

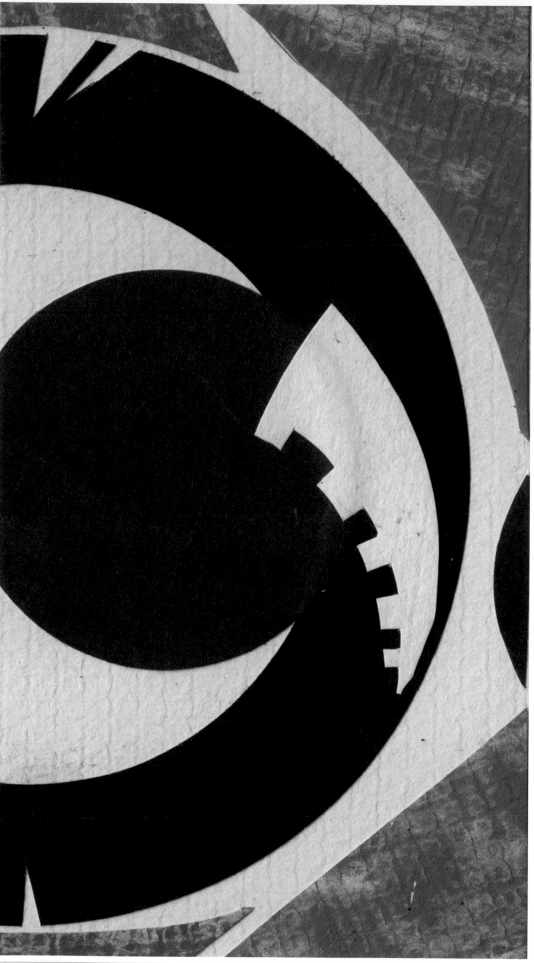

ECHOES OF THE FUTURE

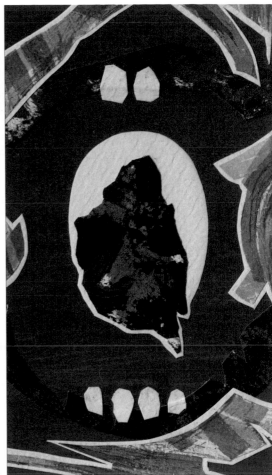

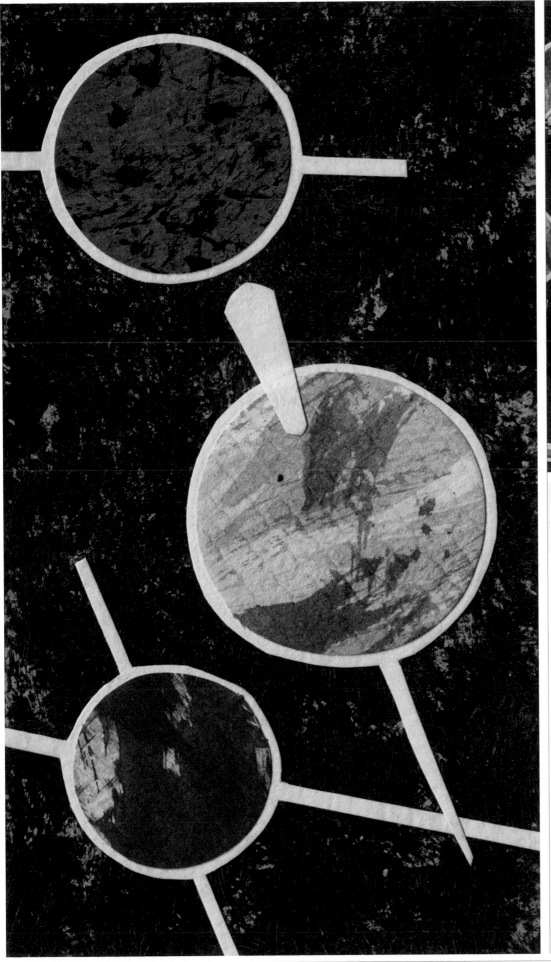

Chyrum Lambert

Paper Tiles

2011, Personal Project

The Paper Tile Game: A creative idea game used for generating new thoughts and ideas, strengthening creative functions and solving creative dilemmas.

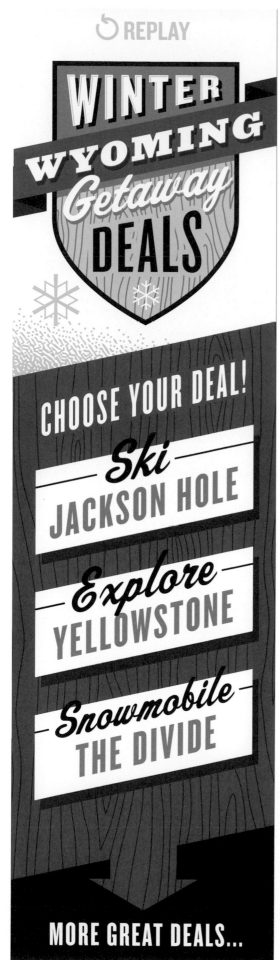

WINTER WYOMING Getaway DEALS

CHOOSE YOUR DEAL!

Ski JACKSON HOLE

Explore YELLOWSTONE

Snowmobile THE DIVIDE

MORE GREAT DEALS...

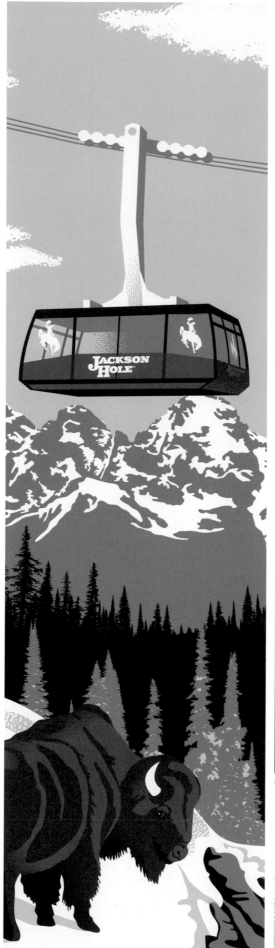

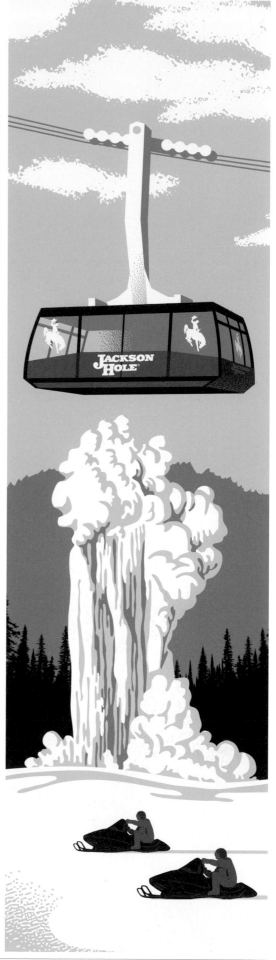

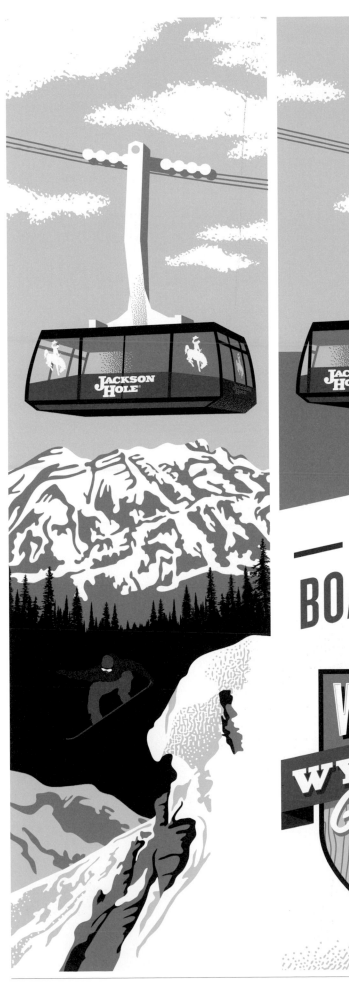
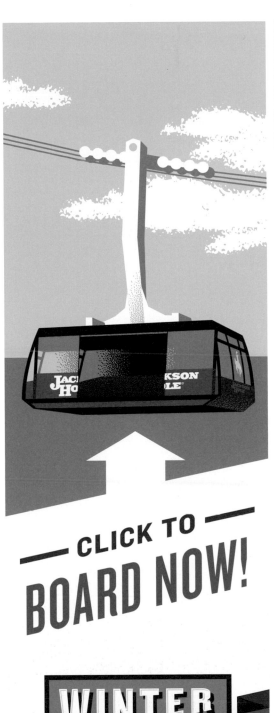

Winter Wyoming Banners
2010, Wyoming Tourism
Design & Illustration: Josh Emrich → Advertising banners for the internet.

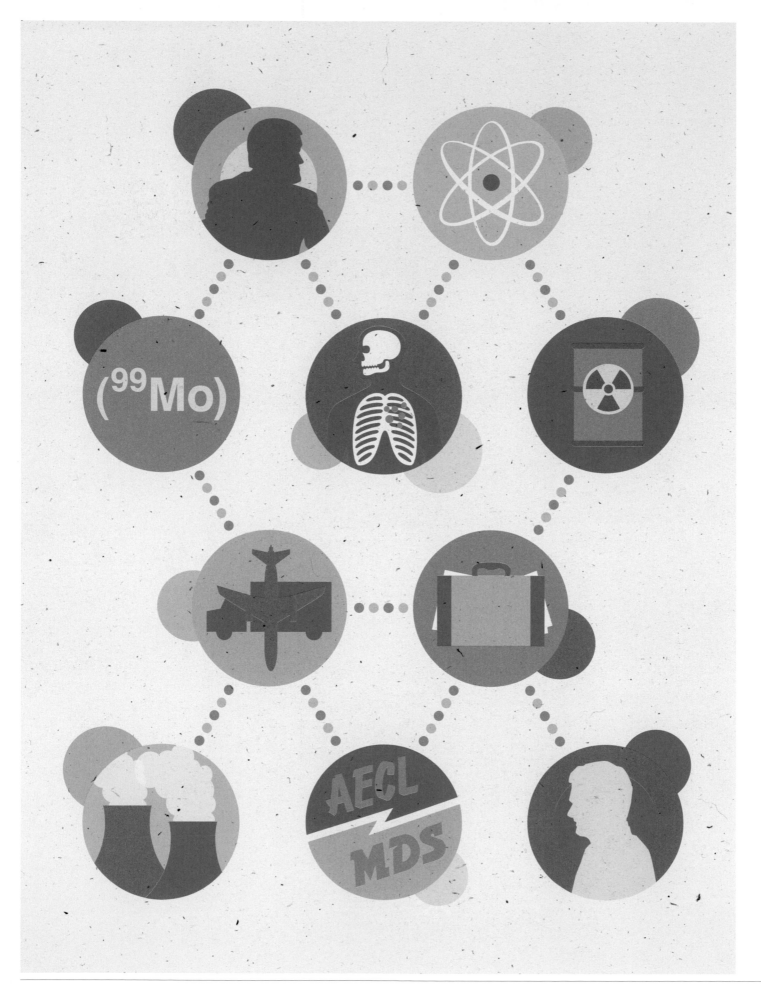

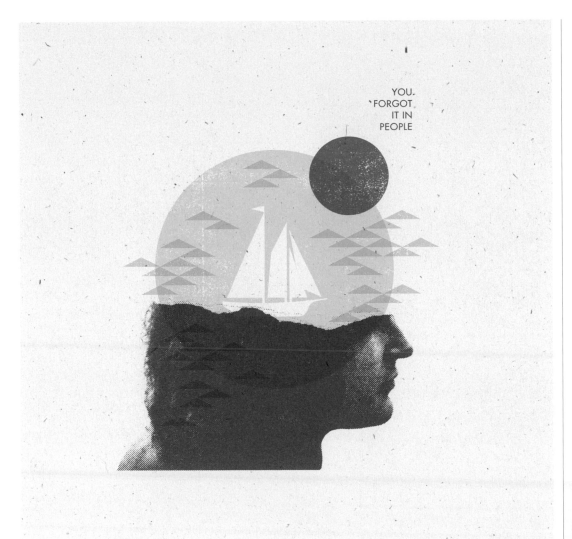

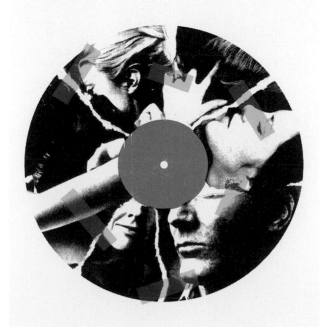

Doublenaut

Untitled
2011, The Walrus Magazine
*Designer: Andrew McCracken → Article about
the Canadian isotope crisis.*

Sights and Sounds Series
2011, The Fox is Black
*Designer: Matt McCracken → Desktop, iPhone
and iPad wallpaper. The wallpaper pays tribute
to Broken Social Scene's album "You Forgot It In
People".*

Broken Social Scene–Forgiveness
2010, Polaris Music Prize
*Designer: Matt McCracken → Commemorational
poster for the 2010 Polaris Music Prize.
A screen printed poster was created and
presented to each nominee.*

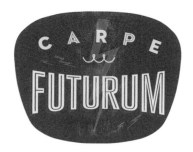

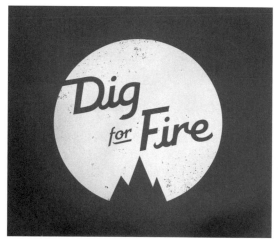

Kelli Anderson

Carpe Futurum

2011, Self-directed project for Tattly

An illustrated slogan for a temporary tattoo, playing off the old adage, "Carpe Diem."

Dig for Fire

2010, Dig for Fire

Logo for music video production company.

Wired Content Farm

2011, Wired UK

Infographic about the massive quantity of books made by content farms at Amazon.com.

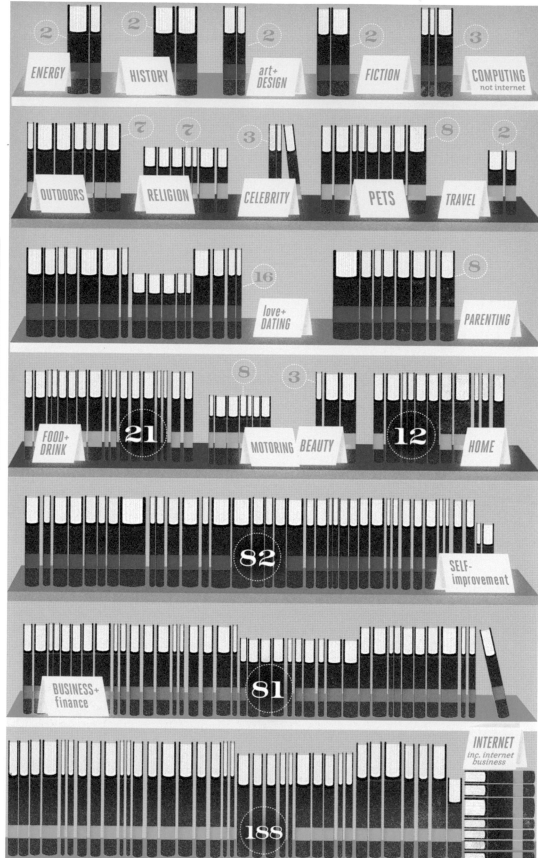

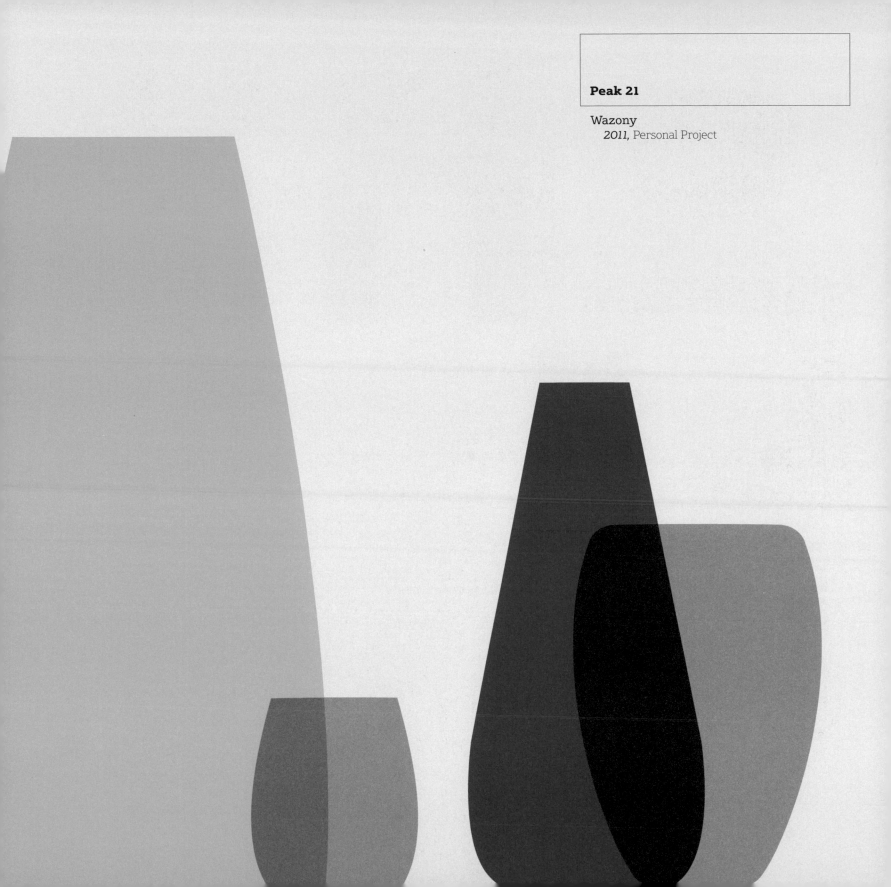

Peak 21

Wazony
2011, Personal Project

EDWARD SHARPE & THE MAGNETIC ZEROS
EDWARD SHARPE & *the* MAGNETIC ZEROS

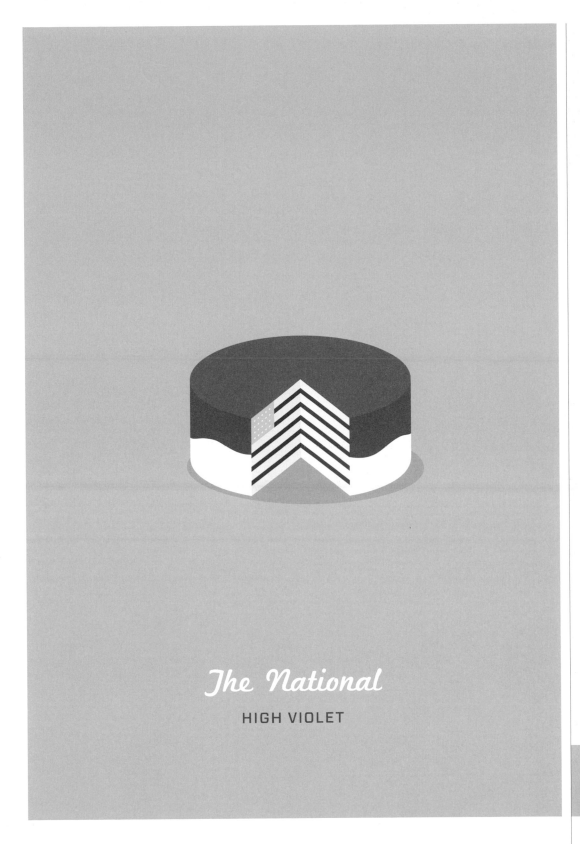

The National

HIGH VIOLET

MAPS & ATLASES
PERCH PATCHWORK

kxt91.7
MUSIC TO THE CORE

Dev Gupta

Edward Sharpe, The National,
Maps & Atlases
2010, Personal Project

KXT
2010, 91.7 KXT Radio Station
Limited edition poster.

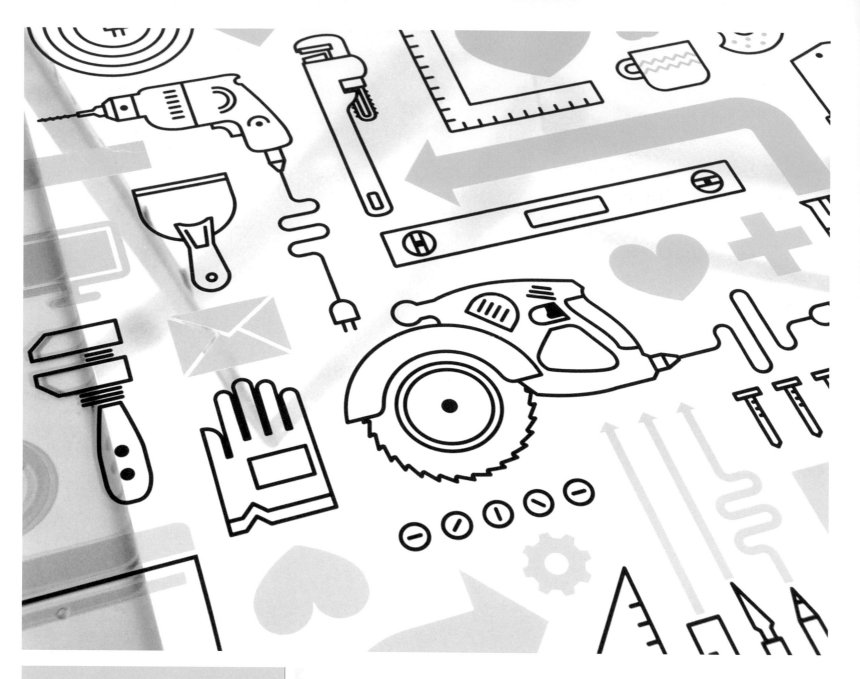

Mikey Burton

Facebook F8

2010, Facebook

Designer: Mikey Burton, Art director: Ben Barry → Limited edition glass table for Facebook's F8 Conference. The theme of the conference was rolling up your sleeves and getting the job done... hence all the tools.

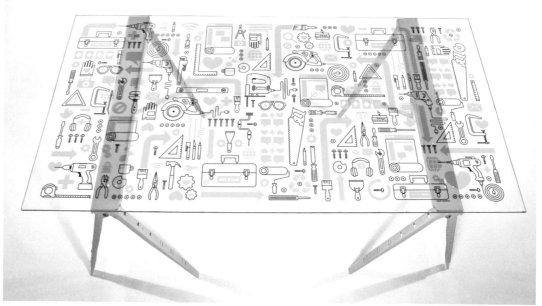

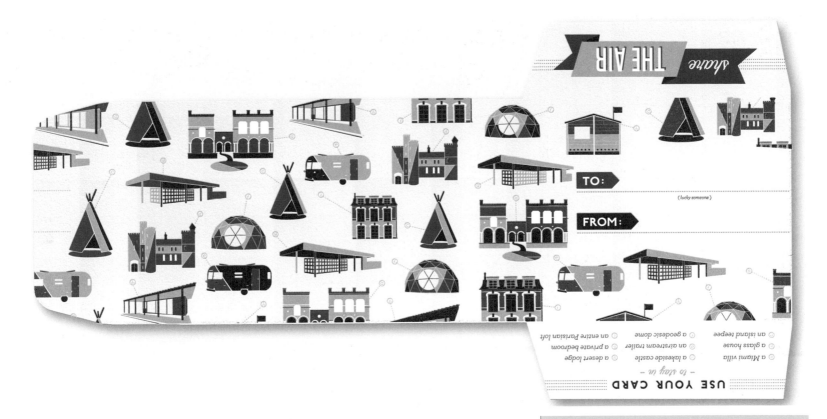

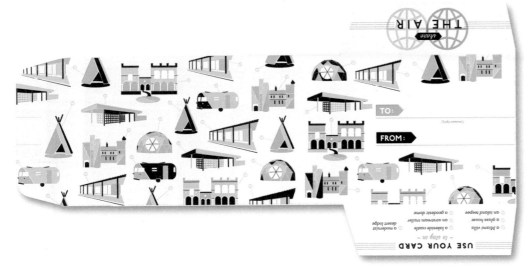

Kelli Anderson

Little Buildings

2010, Airbnb

Little illustrations of igloos, geodesic domes, boats, airstream trailers, castles, and villas for Airbnb, an internet company that allows people to rent any space/lodging to travelers. They were used in a variety of places, including these letterpressed gift cardholders.

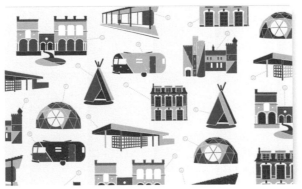

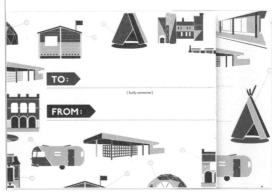

THE THINK ROOM®

Nick Brue

Olson: Think Room Logo, Brand Anthropology Icons & Logo
 2011, Olson
*Designer: Nick Brue, Creative Director:
Dan Olson, Design Director: Robb Harskamp →
Logo created for Olson's official agency blog,
"The Think Room", a series of icons to be used for
Olson Brand Anthropology exercises, and a logo
created for Olson's strategy department.*

Primary Brewing Logo (right page)
 2010, Primary Brewing Co.
*Logo for a home brewing poster event titled
ARTENBRU in St. Paul, Minnesota.*

Rush River Icons (right page)
 2009, Rush River Brewing Company
*Creative Director: Dan West, Westwerk Design →
Icon set created for three flavors of Rush River
beer during a rebrand.*

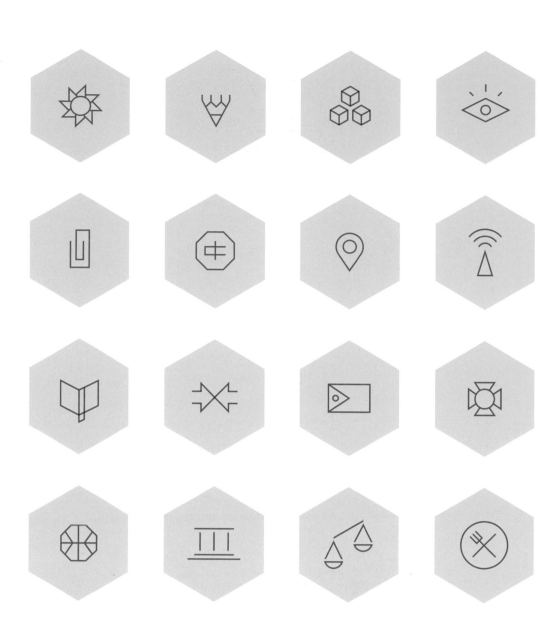

OLSON BRAND
ANTHROPOLOGY℠

TRADE · MARK

PRIMARY

BREWING CO.

MINN · U.S.A.

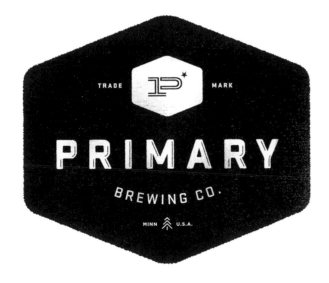

BUBBLE JACK

INDIA PALE ALE

FLUID · 12 · OUNCE

SMALL AXE

Golden Ale

FLUID · OUNCE

LOST ARROW

PORTER

FLUID · 12 · OUNCE

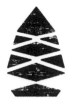

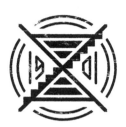

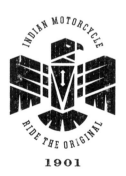

INDIAN MOTORCYCLE

RIDE THE ORIGINAL

1901

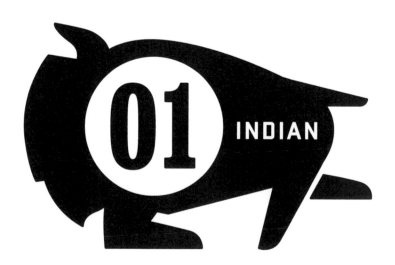

MOTORIGINAL

EST. 1901

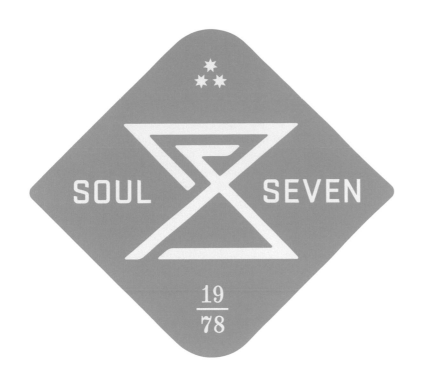

Arrowhead, Eagle, Shield, Bison *(left page)*
 2011, Indian Motorcycle
Designer: Sam Soulek, Creative Director: Ann Bauer, Olson + Co. → Logo concepts proposed for an Indian Motorcycle brand update.

High 5 Tribe Logo *(left page)*
 2011, Olson + Company

EcoFreako Icons *(left page)*
 2008, FAME – A Retail Brand Agency
Designer: Sam Soulek, Creative Director: Julie Feyerer, FAME.

Soulseven Logo
 2011, Soulseven

Smead Icons (*Specialty Products*)
 2008, Smead
Designer: Sam Soulek, Creative Director: Cheryl Meyer, FAME → For an office supply company.

True O2 Logo
 2008, True O2
Logo for a residential air purification company.

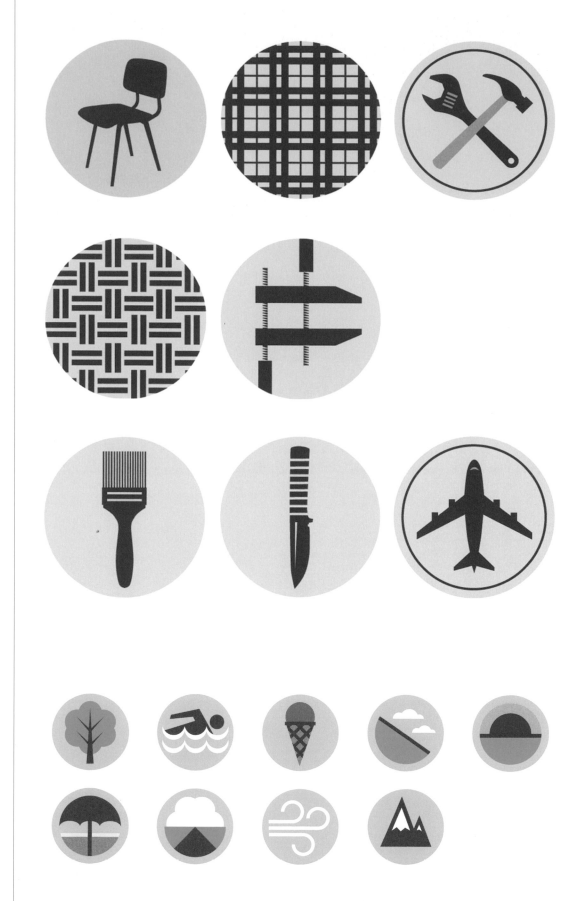

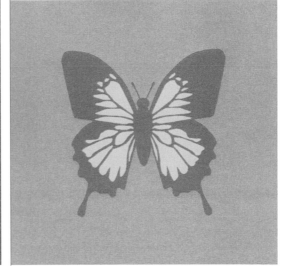

Jason Hill

Poland Icons, Craft Icons *(left page)*
2010, Monocle Magazine

Quality of Life Icons
2009, Monocle Magazine

Honeybee, Butterfly
2008, Personal
Two of twenty prints from "Open Your Eyes" solo exhibition, Art Detour, Phoenix, Arizona.

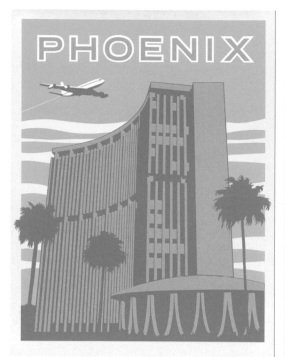

PHOENIX

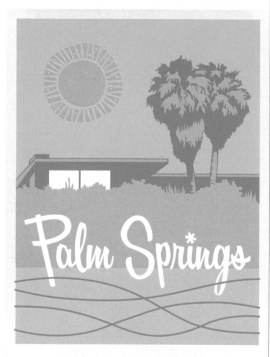

Palm Springs

Jason Hill

Phoenix, Palm Springs
2005/6, Personal Project

Retro-Futurism Exhibition
2004, Personal Project

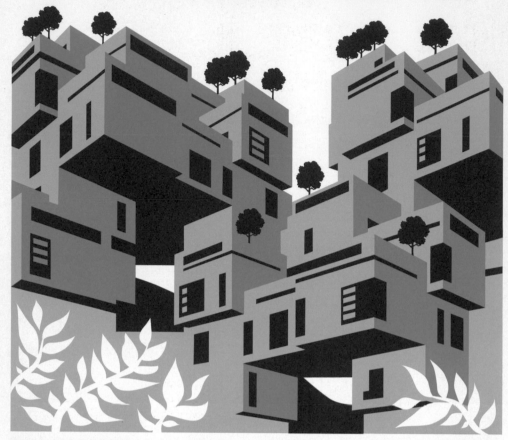

SHADE PROJECTS PRESENTS

RETRO-FUTURISM

THE ART AND DESIGN OF JASON HILL

AUGUST 6th - 27th 2004

MonOrchid Gallery

214 E. Roosevelt St • Phoenix Arizona

OPENING RECEPTION | FIRST FRIDAY | AUGUST 6TH | 7 PM

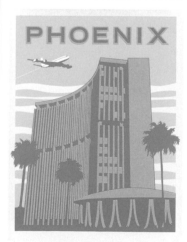

PHOENIX

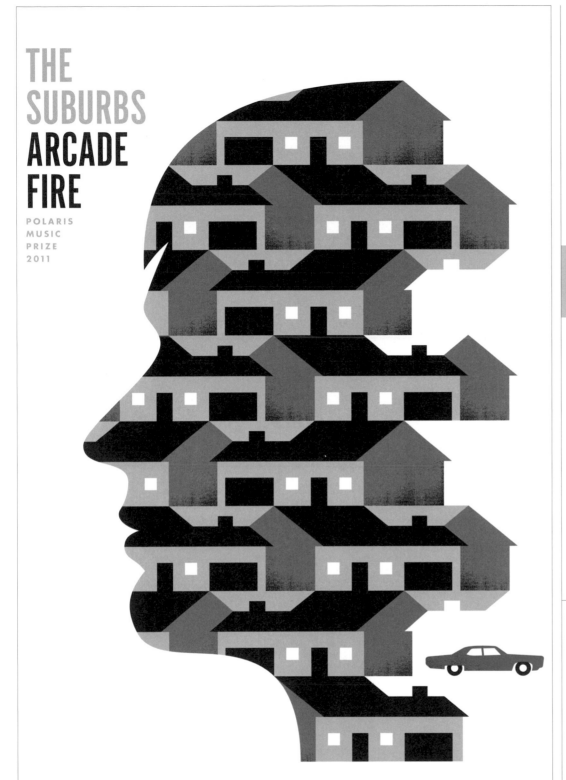

THE
SUBURBS
ARCADE
FIRE

POLARIS
MUSIC
PRIZE
2011

Arcade Fire

2011, Polaris Music Prize
Designer: Matt McCracken → Poster to com-memorate Arcade Fire's album "The Suburbs" which was nominated for the 2011 Polaris Music Prize. A screen printed poster was created and presented to each nominee.

Mogwai

2011, Mogwai
Designer: Matt McCracken → Screen printed poster commissioned by Mogwai to sell at their Toronto show in April 2011.

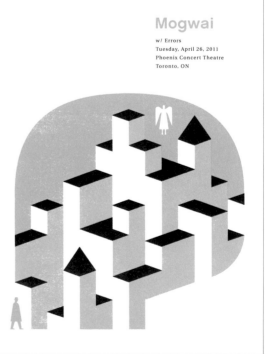

Mogwai

w/ Errors
Tuesday, April 26, 2011
Phoenix Concert Theatre
Toronto, ON

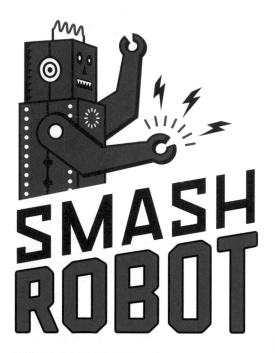

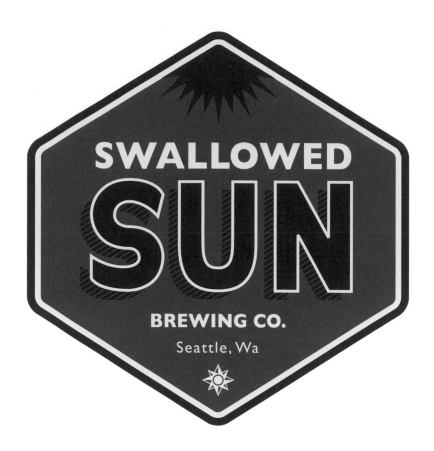

Riley Cran

Smash Robot
2011, Smash Robot
Logo for a search engine optimization firm.

Swallowed Sun Brewing Co.
2010, Swallowed Sun Brewing Co.
Logo for a Seattle-based microbrewery.

Shopaholla
2011, Shopaholla
Logo and secondary marks for a fabricator of high-end e-commerce websites.

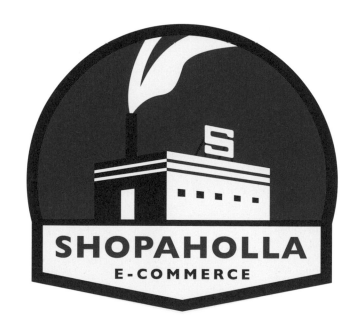

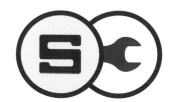

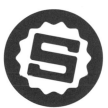

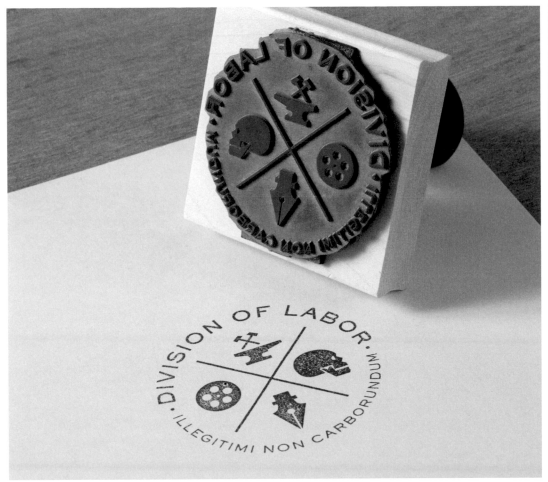

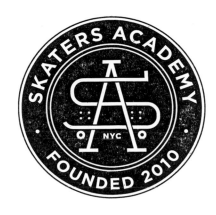

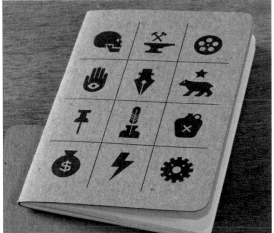

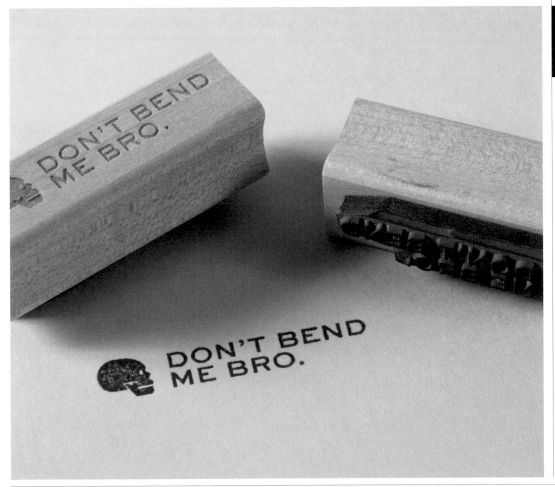

Mikey Burton

Division of Labor

2010, Division of Labor

Designer: Mikey Burton, Art Directors: Josh Denberg, Paul Hirsch → Identity system for a creative and strategic brand studio, created as a modern take on union membership cards, stamps, and seals. The Latin means "Don't let the bastards grind you down."

Skaters Academy Logo

2010, Skaters Academy

Designer: Mikey Burton, Art Director: Adam Goldstein → Seal for a Manhattan-based skate-boarding school.

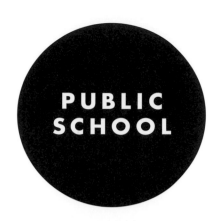

Cody Haltom

Public School
2009, Public School
Logo for an Austin-based creative collective of designers, illustrators, and photographers.

Austin Architectural Graphics
2009, Tommy Dunn
Logo for a studio focused on design, fabrication, and installation of large-scale signage.

Quiet Unique
2010, Chris Duty
Logo for an online store that sells a new and unique item each day.

Crimson & Whipped Cream
2010, Ashleigh Barnett
Logo for a bakery and coffee bar located near the University of Oklahoma.

Bake Sale
2011, Andrea Duty/Bake Sale
Logo for a bakery in Austin, Texas.

Ryann Ford
2008, Ryann Ford
Logo for an architectural photographer.

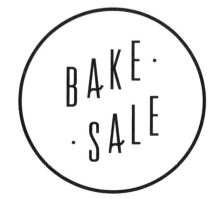

R Y A

N N F

O R D

CODY HALTOM

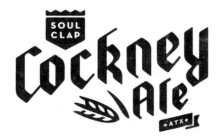

Simon Walker

Dirty Jeans Co., Soul Clap Cockney Ale,
Quality Seafood, Nat's New York Pizza,
Electric Company
2010/11, Personal Project
Logos for self-promotion.

Hega
2011, Hega
*Designer: Simon Walker & Marc Ferrino → Logo
for a digital design studio in Portland, Oregon.*

A Bit Of Crumpet *(5 images, right page)*
2010, A Bit Of Crumpet
*Signage for an English-style tea and bakery
shop in Chicago, Illinois.*

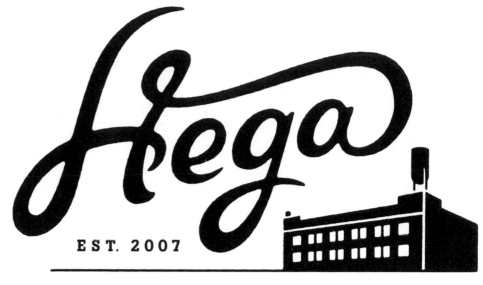

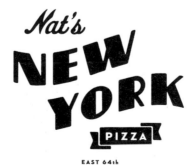

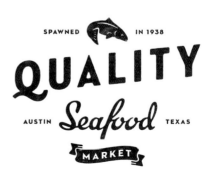

The Electric
ELECTRIC
Company
ON PBS

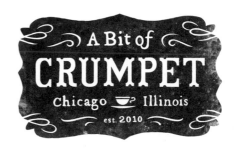

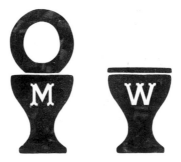

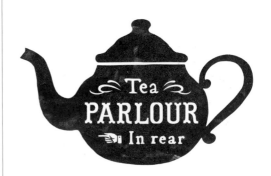

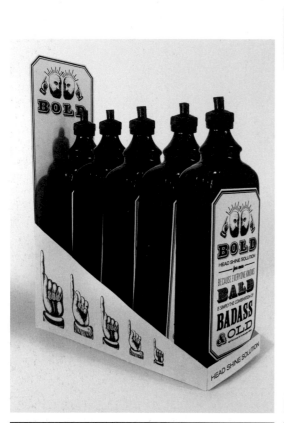

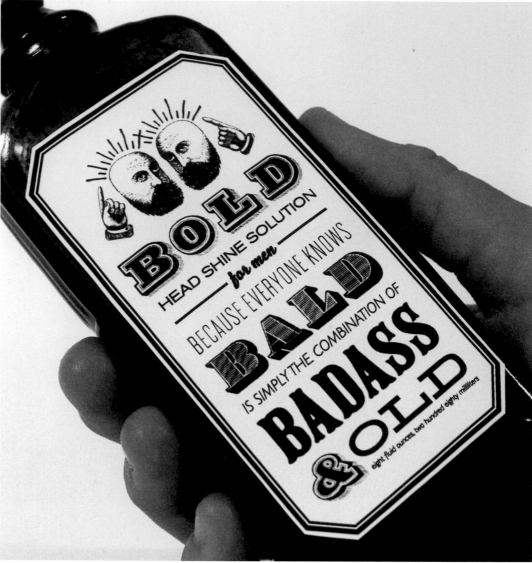

Steph Davlantes

Bold

2011, Personal Project

Designed for the early senior citizen market, this head-shine product label and campaign assures men that they can be badass and balding at the same time. The logo sends the message that two balding heads are better than one with hair.

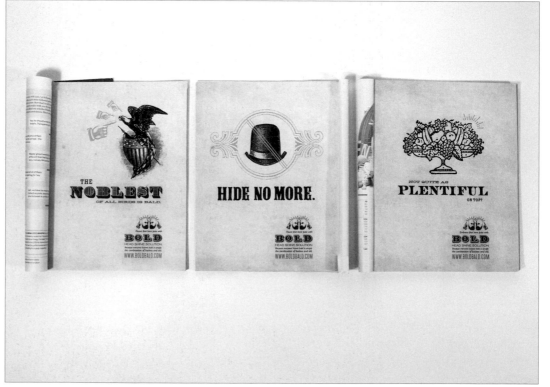

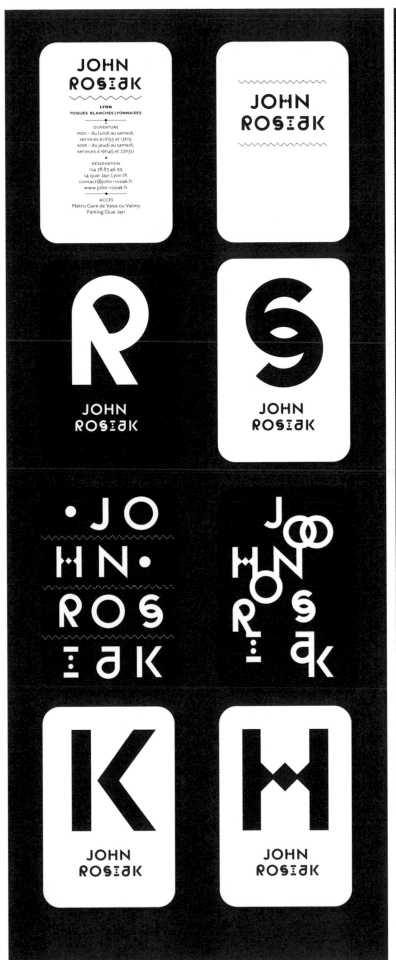

Atelier Müesli

Restaurant John Rosiak
2010, John Rosiak
Visual identity for a French restaurant.

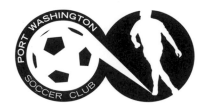

Mark Brooks

Port Washington Soccer Club
2010, Bill Goodspeed
Logo for the Port Washington Soccer Club.

Permissive Records
2010, Permissive Records
Logo for an electronic music record label.

BICC
2011, Brooklyn Inkognito Creative Collektive
Logo for an artistic collective in Brooklyn.

Remenart
2010, Remenart / Carles Yagüe
Logo design for an event production company.

Dorada & Morena
2011, SantaMonica
Catalan beer label design.

The Northerner
2011, The Northerner
Logo design for a logistics company specializing in farmer's products.

Carabiners BCN
2011, Ludobike
Logo Design for a fixed-gear bicycle association in Barcelona.

Dead Troyans
2011, Sean Vogarde
Logo for a skateboarding blog.

New York State Baseball Championship
2011, Michael Macchine Sr
Logo design for the 2012 American Legion New York State Baseball Championship.

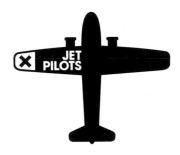

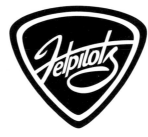

Silence Television

Sixty Watts, Killers, Scuderia Magnani,
Films, Jetpilots, STV, Riders,
The Trees Community
2009/10, Personal Projects
Designer: Gianmarco Magnani.

SYMBOLS MARQUES & MONOGRAMS

At its core, identity design begins and ends with a logo - the logotype, marque or monogram. A symbol that distils a sense of identity. A simple, discernable icon that contains meaning, personality and association.

Identity informs everything we do - it's what we're about. By starting from scratch or re-inventing the past, we seek to define the essence of a brand or organisation.

This search for identity is central to our practice and forms the basis of our mission - to create symbols that are recognisable, particulars that feel whole and concepts that are complete in and of themselves.

Things that work on multiple levels - sometimes direct, often discreet, always interconnected - through a rich system and hierarchy of information and aesthetics.

Quite a few of the logos we've developed have been published in design books and magazines in recent years. But they've never been assembled as a single body of work.

So here they are - some (but not all) of our favourites from the last six years. (Only symbols, marques and monograms this time around - we're saving logotypes for later).

Admittedly, several were rescued from the cutting room floor (CRF), and as the saying goes, 'the best horse doesn't always win the race'.

But our work is much more than just designing a logo. We collaborate with clients directly - perhaps through photography, language or structure. And any other discipline that successfully gets their message across.

Because a logo alone isn't an identity - it's merely an asset, a unit of communication, a device that functions beyond words.

Graphical House is a design consultancy.

We assist clients with visual communication through innovative and effective design. We ask them simple questions to solve complex problems. We investigate how their audiences should be addressed and help shape the voice with which they speak.

Project to project, things may differ - the people, the process or the media. But our aims remain constant - to transmit ideas, inspire interaction and exceed expectations - so clients can fully achieve their goals.

Our identity lies in the work we create for others.

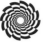

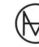

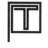
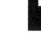
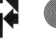

Graphical House

GH Edition 4:
Symbols Marques & Monograms
2011, Personal Projects

Self-initiated poster/brochure detailing some of the symbols, marques, and monograms that Graphical House has produced in the past few years.

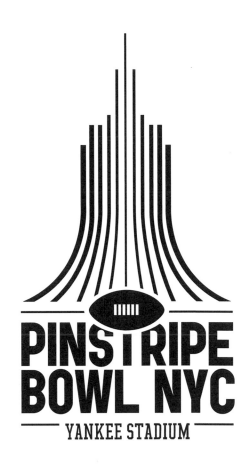

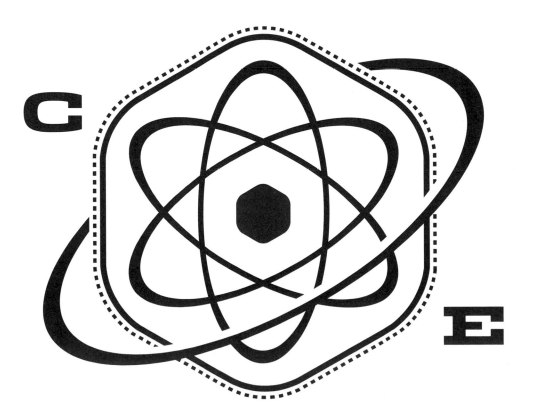

Mark Brooks

Xanadu
2011, Xanadu / Isako Baba
Logo design for an arts event promoter.

Palta Bar
2011, Bibiana Chamarro
Logo design for a snack bar.

Multiple Gates
2011, Arts Media People / Lorna Palmer
Designer: Mark Brooks.

Craftanese
2011, Yuko Mizuno
*Logo design for a video game programming
studio based in the UK.*

CE
2011, Cristian Escola
Logo design for a physicist investigation lab.

Pinstripe Bowl NYC
2010, Catch NYC
*Logo design for the Pinstripe Bowl NYC, held at
Yankee Stadium.*

Atelier Müesli

Amalgame Müesli Card
2011, Personal Project
*Home made two-color screen-printed greeting
card, business card, mini-card, etc.*

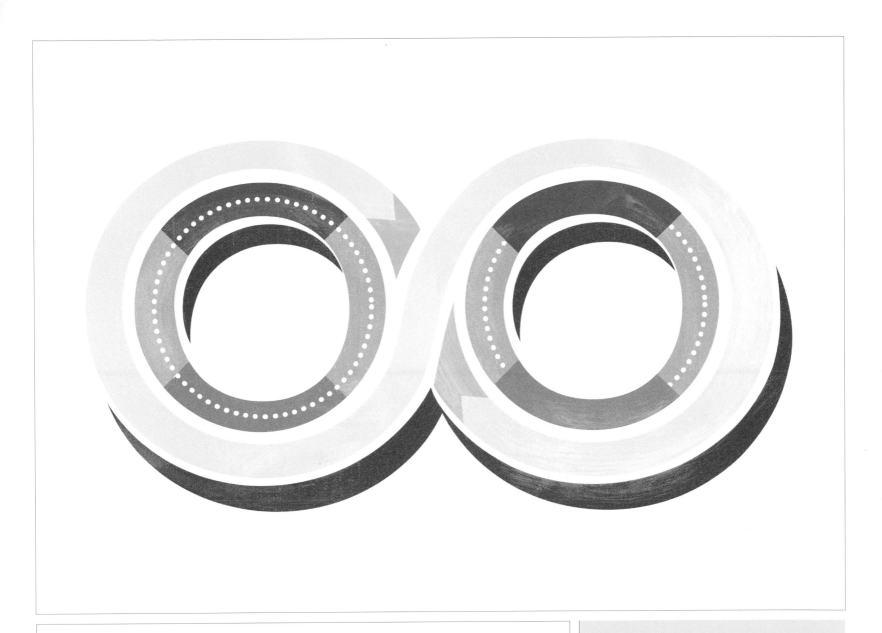

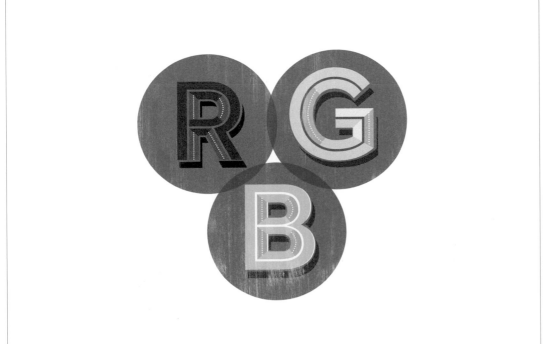

Kelli Anderson

Infinity
2011, Self-directed project for Tatt.ly
An ironic design for a temporary tattoo: the symbol for forever. Created from paper cutouts and then manipulated on the computer.

RGB
2011, Personal Project
Typography experiment employing cut paper shapes and scanned textures.

◫ ● ●

ABCDEFGHIJK
LMNOPQRST
UVWXYZ
abcdefghijklmn
opqrstuvwxyz

Baskerville 4pt

John Baskerville

◐ ● ●

ABCDEFGHIJK
LMNOPQRST
UVWXYZ
abcdefghijklmn
opqrstuvwxyz

Bodoni 4pt

Giambattista Bodoni

◐ ● ●

ABCDEFGHIJK
LMNOPQRST
UVWXYZ
abcdefghijklmn
opqrstuvwxyz

Garamond 4pt

Claude Garamond

◐ ● ●

ABCDEFGHIJK
LMNOPQRST
UVWXYZ
abcdefghijklmn
opqrstuvwxyz

Bembo 4pt

Francesco Griffo

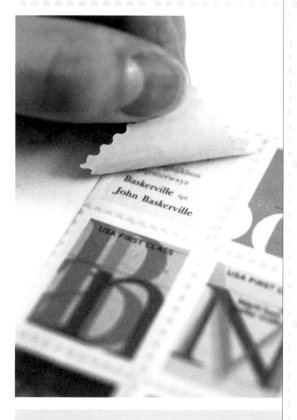

Jung Min

Typographic Stamps

2010, School of Visual Arts
*Thanks to Alli Truch → These stamps represent
18 important typefaces–under each image some
general information about each typeface is
revealed.*

USA FIRST CLASS — short x-height — tall ascender

USA FIRST CLASS — ascender

USA FIRST CLASS — similar x-height

USA FIRST CLASS

USA FIRST CLASS — M&N have similar width

USA FIRST CLASS — Big x-height

USA FIRST CLASS — taller x-height than other sans-serif

USA FIRST CLASS — Based on geometric shape

USA FIRST CLASS — Alp abe — short ascender short descender

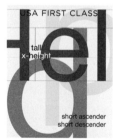

onsUSA FIRST CLASSre,t
atecumquas voloris exc
um arum il inia parum
hagniet et latum volupt
eum hard toditaquam,
doluptus a read on om
nt. long text eius nones
nt ommo iundi doluptu
e nat dolum voluptae m
tem. Igni aborepe rferc
a imilianis autempe rfe

USA FIRST CLASS — Hel — tall x-height — short ascender short descender

USA FIRST CLASS — humanist typeface — short x-height

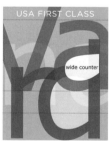

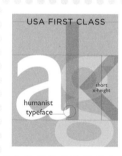

USA FIRST CLASS — wide counter

USA FIRST CLASS — standard typeface for engeenring and technology

USA FIRST CLASS — WHITN — tne — broad x-height

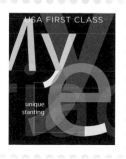

USA FIRST CLASS — geometric structure — AR

USA FIRST CLASS — monotone stroke weight

USA FIRST CLASS — My — unique stanting

Kelli Anderson

City Identities

2011, Airbnb

Identities celebrating cities from around the world, created for the website of travel startup Airbnb.

Albin Holmqvist

EF Destinations
2011, EF International Language Centers
Typographic logotypes for EF's destinations worldwide.

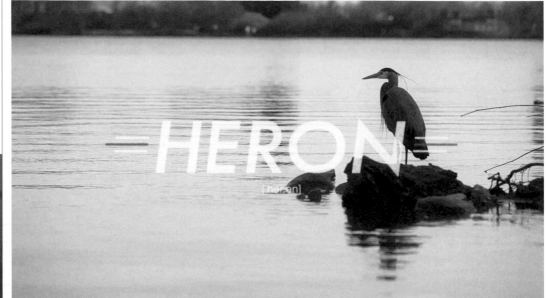

Albin Holmqvist

Live The Language
 2011
Client: EF International Language Centers
Designer: Albin Holmqvist, Director: Gustav Johansson, Director of photography: Niklas Johansson, Production company: Camp David Films. → Travel promotion film series.

LESSON 1

The Button-Down

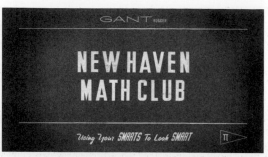

NEW HAVEN
MATH CLUB

Using Your SMARTS To Look SMART

LESSON 2

The Jacket Lapel

Albin Holmqvist

Gant – New Haven Math Club

2010, Gant Rugger
Designer: Albin Holmqvist, Directed by NEW-NEW Agency → Typography for a Gant film.

Brought to You in Part by GANT RUGGER

IN ASSOCIATION WITH

NEW HAVEN
HIGHER LEARNING

"The Kinship for Moral Fiber"

With the Advice of Dr. Ross Thompson, Ph.D

LESSON 3

The Cuff Vent

NEW HAVEN ⊼ MATH CLUB

*Proving Good Genes and Good Looks
Can Provide You with Answers to Problems
Others May be Unable to Solve!*

LESSON 4

The Collar Back Button

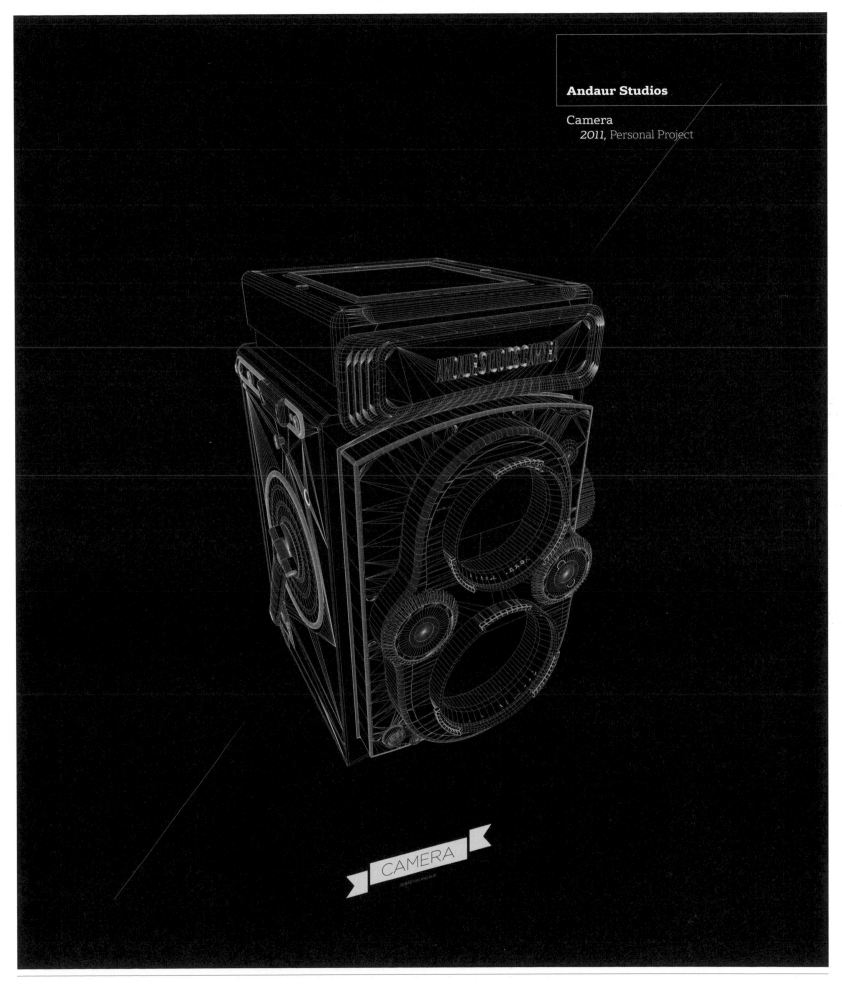

CAMERA

ALBIN HOLMQVIST, ANDAUR STUDIOS

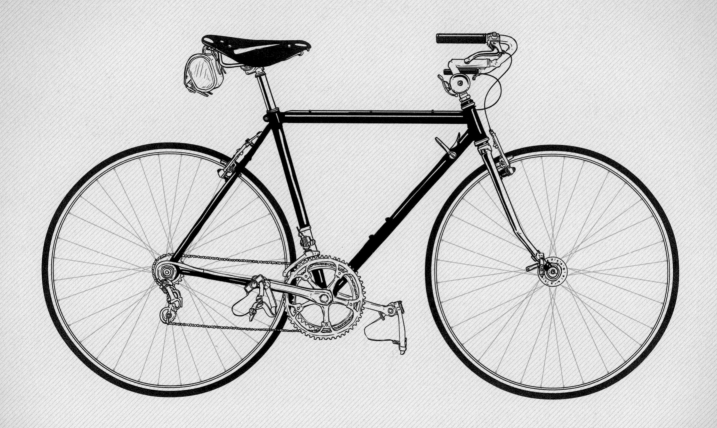

SILENCE TELEVISION
ILLUSTRATIONS & PRINTS

icons

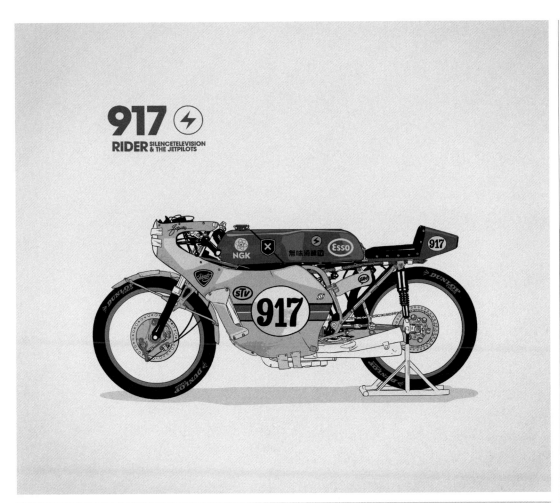

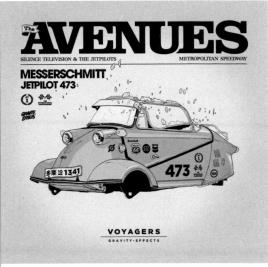

Silence Television

Icons
2009/10/11, Personal Project
Designer: Gianmarco Magnani → Series of digital illustrations.

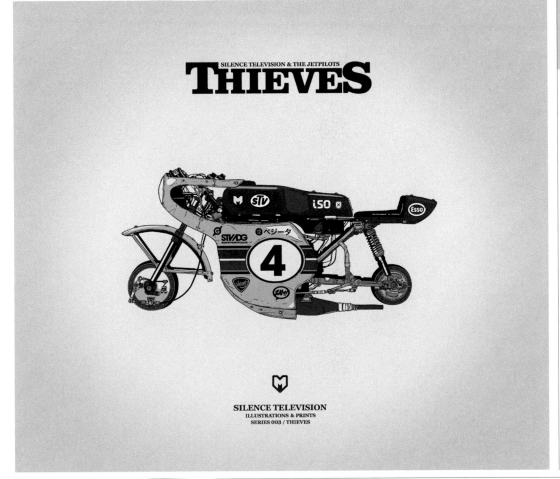

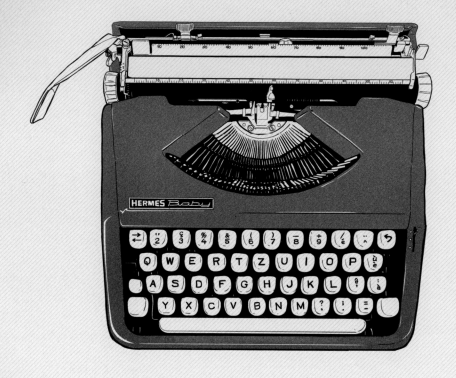

SILENCE TELEVISION
ILLUSTRATIONS & PRINTS

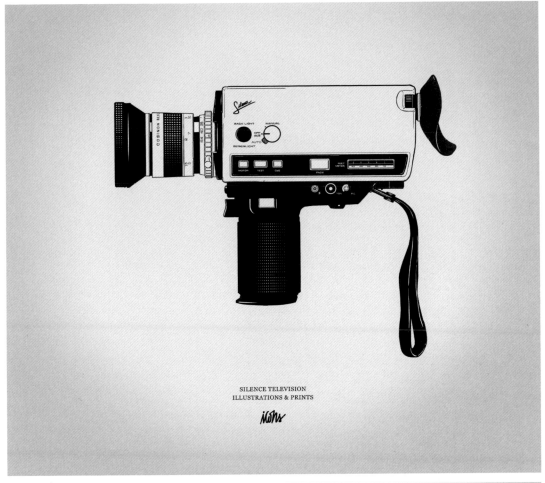

SILENCE TELEVISION
ILLUSTRATIONS & PRINTS

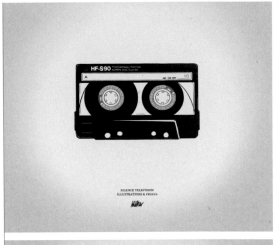

SILENCE TELEVISION
ILLUSTRATIONS & PRINTS

SILENCE TELEVISION
ILLUSTRATIONS & PRINTS

Silence Television

Icons, Illogic

2009/10/11, Personal Project
Designer: Gianmarco Magnani → Series of digital illustrations.

SILENCE TELEVISION
ILLUSTRATIONS & PRINTS

SILENCE TELEVISION
ILLUSTRATIONS & PRINTS

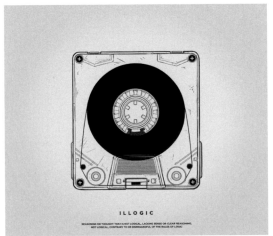

ILLOGIC

REASONING OR THOUGHT THAT IS NOT LOGICAL, LACKING SENSE OR CLEAR REASONING,
NOT LOGICAL, CONTRARY TO OR DISREGARDFUL OF THE RULES OF LOGIC

Neuarmy

The Warfare of Deception
2010, Personal Project
The Warfare of Deception is a basic field guide consisting of six individual sections: Survival, Objective, Protocol, Safety, First Aid, and Communication.

(L)Earn
2010, Personal Project
Knowledge is money. Learn & Earn.

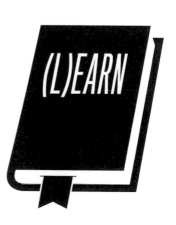

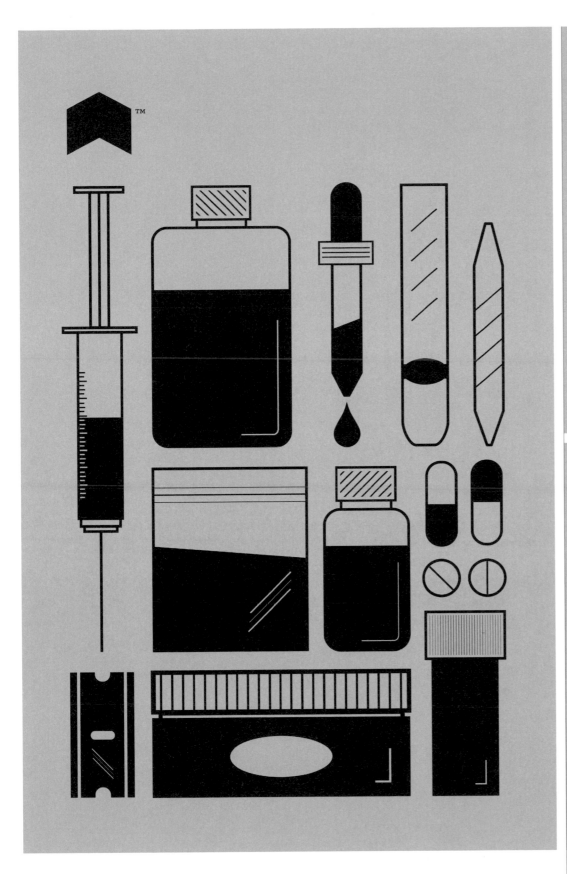

ABOVE ALL, KEEP YOUR HANDS & FEET DRY.

NEUARMY

BASIC FIELD GUIDE

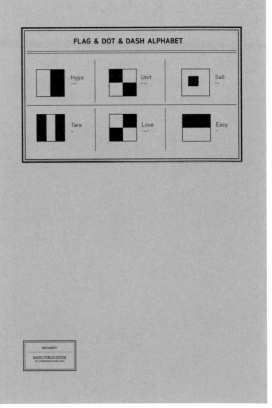

FLAG & DOT & DASH ALPHABET

Hypo	Unit	Sail
Tare	Love	Easy

NEUARMY

BASIC FIELD GUIDE

지구를
지켜라
save
the earth

2010.
5. 7–
8. 22

김현준 박혜수
도영준 이경석
박지훈 이장섭

이현진
천대광
퍼니페이퍼

Kim, Hyunjun
Do, Youngjun
Park, Jihoon

Park, Hyesoo
Lee, Kyungseog
Lee, Jangsub

Lee, Hyunjean
Chen, Daigoang
Funny Paper

지구를
지켜라
save
the earth

금호미술관

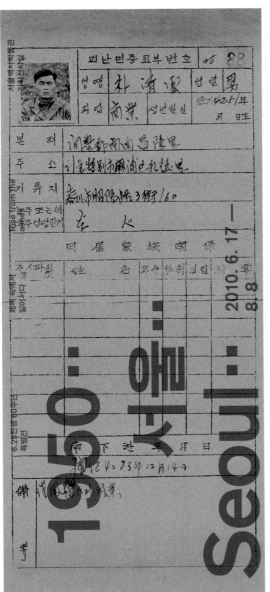

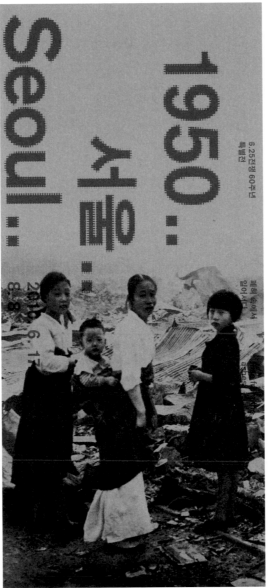

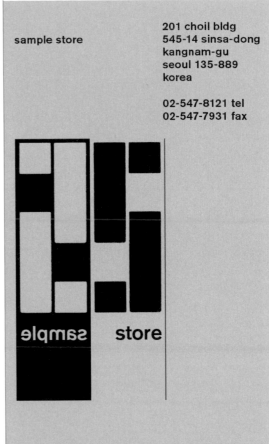

sample store

201 choil bldg
545-14 sinsa-dong
kangnam-gu
seoul 135-889
korea

02-547-8121 tel
02-547-7931 fax

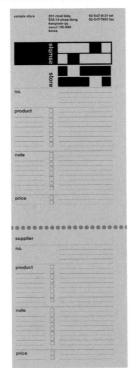

Workroom

Save the earth
2010, Kumho museum of art
Designer: Lee Kyeong-Soo → Exhibition poster.

1950. Seoul
2010, Seoul musuem of history
*Designer: Lee Kyeong-Soo → Seoul museum
of History exhibition invitation card.*

Sample store
2010, Flat m.
*Designer: Lee Kyeong-Soo → Sample store
name card & bill.*

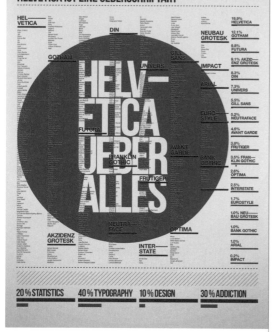

GROTESKLY BIASED. THE BIGOTRY OF DESIGN.

HELVETICA IST EINE UEBERSCHRIFTART

20% STATISTICS	40% TYPOGRAPHY	10% DESIGN	30% ADDICTION

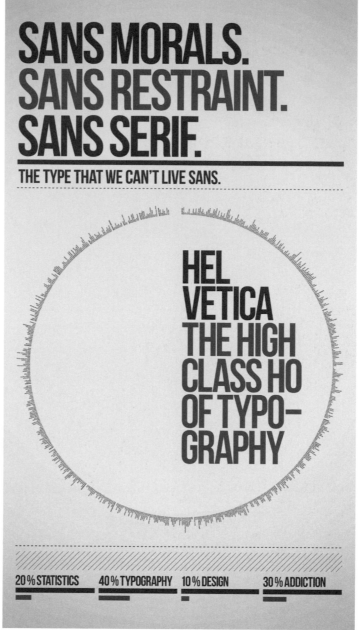

SANS MORALS. SANS RESTRAINT. SANS SERIF.

THE TYPE THAT WE CAN'T LIVE SANS.

HELVETICA THE HIGH CLASS HO OF TYPOGRAPHY

20% STATISTICS	40% TYPOGRAPHY	10% DESIGN	30% ADDICTION

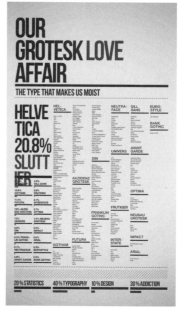

OUR GROTESK LOVE AFFAIR

THE TYPE THAT MAKES US MOIST

HELVETICA 20.8% SLUTTIER

20% STATISTICS	40% TYPOGRAPHY	10% DESIGN	30% ADDICTION

Ryan Atkinson

High Class Ho / Our Grotesk Love Affair
2011, Pesonal Project
Designer: Ryan Atkinson, Copywriter: Stephan de Lange → Experimental tpography posters.

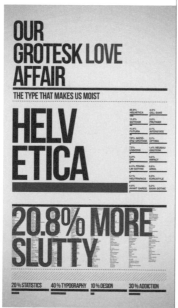

OUR GROTESK LOVE AFFAIR

THE TYPE THAT MAKES US MOIST

HELVETICA

20.8% MORE SLUTTY

20% STATISTICS	40% TYPOGRAPHY	10% DESIGN	30% ADDICTION

CALLING ALL TYPE OBSESSED ZEALOTS

A TYPOGRAPHIC EXPERIMENT

Un universe | He helvetica | Go gotham | Ak akzidenz

WE WANT YOUR NAME / YOUR FAVOURITE FONT HERE /

20% STATISTICS	40% TYPOGRAPHY	10% DESIGN	30% ADDICTION

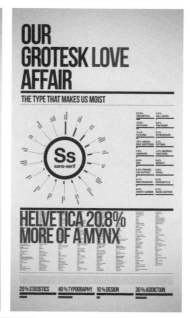

OUR GROTESK LOVE AFFAIR

THE TYPE THAT MAKES US MOIST

Ss sans-serif

HELVETICA 20.8% MORE OF A MYNX

20% STATISTICS	40% TYPOGRAPHY	10% DESIGN	30% ADDICTION

THE COMPETITION USED TO BE OTHER BRANDS.

NOW IT'S LADY GAGA, FARMVILLE AND A SLEEPY KITTEN.

FP7. THE EVOLUTION WILL NOT BE TELEVISED.
Visit http://www.promoseven.com

FP7. THE EVOLUTION WILL NOT BE TELEVISED.

Visit http://www.promoseven.com

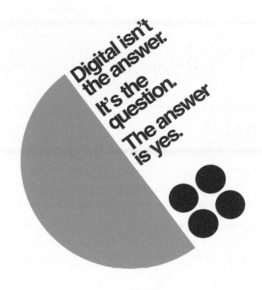

Digital isn't the answer. It's the question. The answer is yes.

FP7. THE EVOLUTION WILL NOT BE TELEVISED.
Visit http://www.promoseven.com

U WANT IN OVER EONE'S

IF YO TO W SOM MIND,

BEGIN B NNING O THEIR IN FINGER.

Y WI VER DEX

FP7. THE EVOLUTION WILL NOT BE TELEVISED.
Visit http://www.promoseven.com

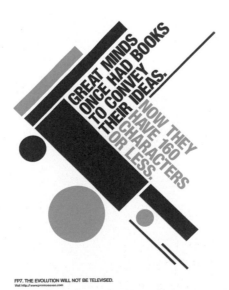

GREAT MINDS ONCE HAD BOOKS TO CONVEY THEIR IDEAS. NOW THEY HAVE 160 CHARACTERS OR LESS.

FP7. THE EVOLUTION WILL NOT BE TELEVISED.
Visit http://www.promoseven.com

Ryan Atkinson

The Evolution will not be televised
2011, Fortune Promoseven
Designer: Ryan Atkinson, Copywriter: Stephan de Lange, Creative Director: Fadi Yaish → Campaign for Fortune Promoseven Network (FP7).

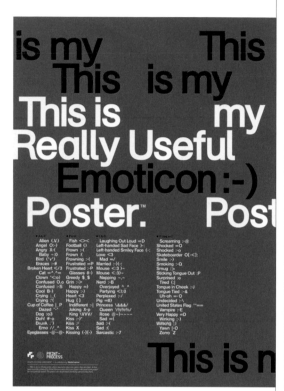

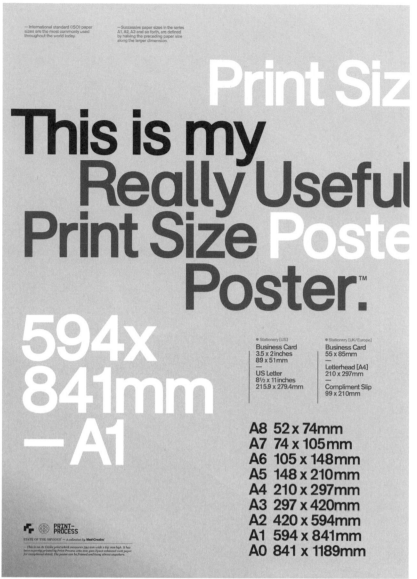

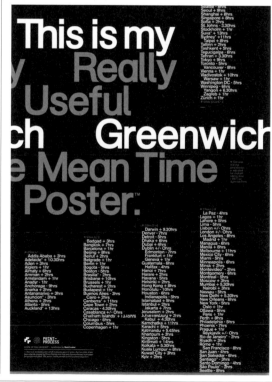

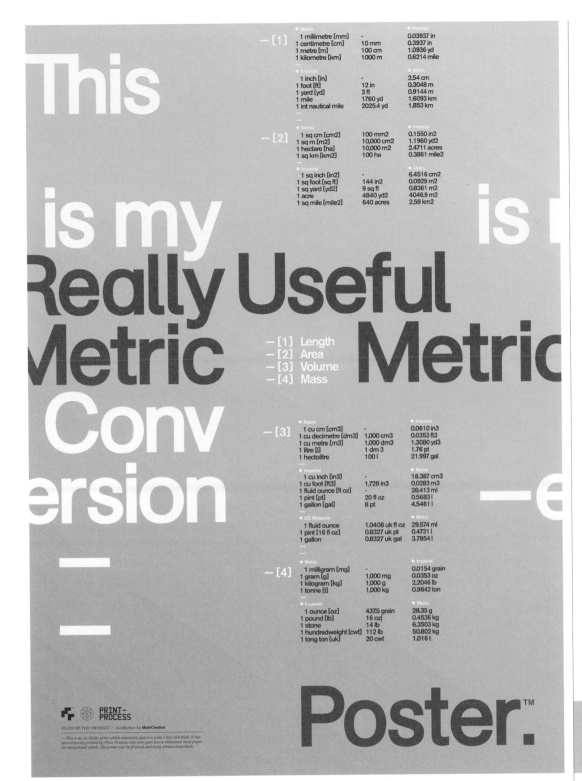

Really Useful
2011, Personal Project
Poster project.

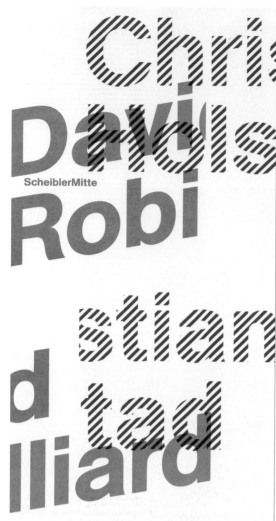

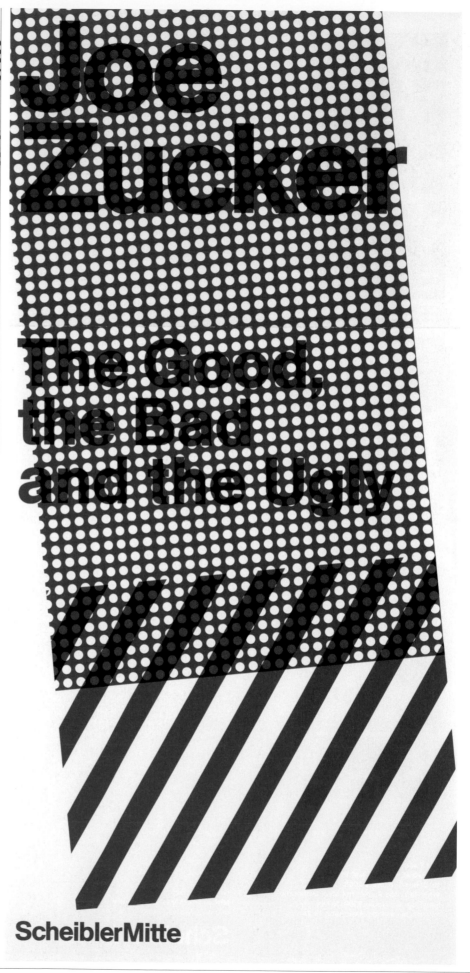

ScheiblerMitte

David Robilliard / Christian Holstad
14. März-18. April 2009
Eröffnung:
13. März 2009 / 18-21 Uhr

ScheiblerMitte

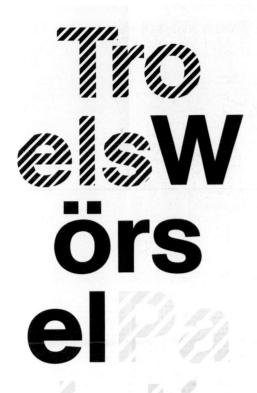

ScheiblerMitte

Charlottenstraße 2 (in der Durchfahrt), 10969 Berlin

ScheiblerMitte
6. Februar–1. April 2010
Eröffnung
5. Februar, 18–21 Uhr

Thomas Rentmeister
Der Staatsanwalt

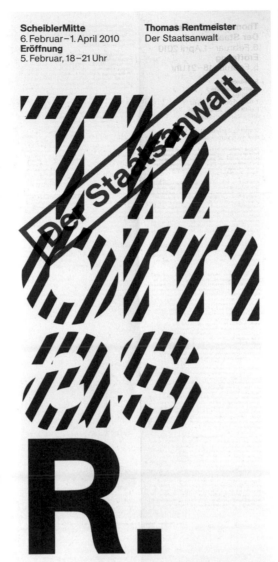

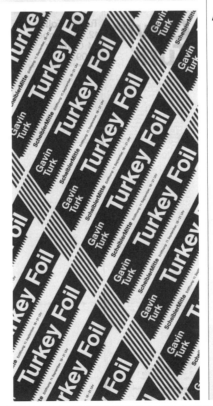

Studio Laucke

Diverse
2011, ScheiblerMitte
Art gallery posters.

Michel Auder
Heads of the Town

ScheiblerMitte
7. Februar-7. März 2009

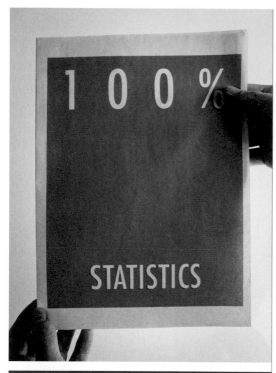

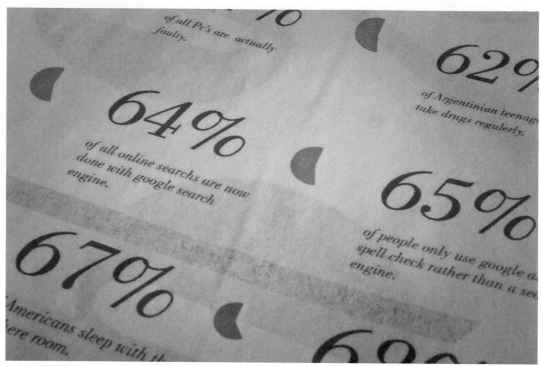

Ian Walsh

100%

2010, ISTD

100% shows 100 statistics through the medium of contemporary, innovative typography.

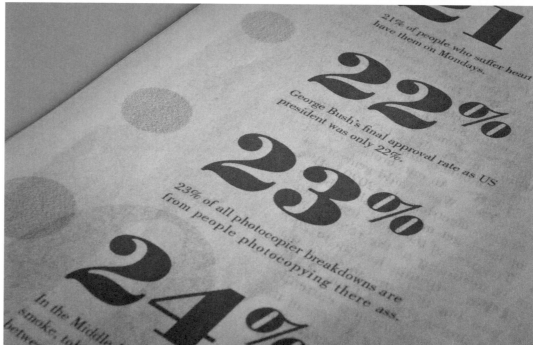

58%

of the worlds population will be obese by 2030 at the current rate.

59%

of the worlds population will be obese by 2030 at the current rate.

60%

of Irish population support the legalization of marijuana.

61%

of the worlds population will be obese by 2030 at the current rate.

62%

of the worlds population will be obese by 2030 at the current rate.

63%

of Irish population support the legalization of marijuana.

64%

of the worlds population will be obese by 2030 at the current rate.

65%

of the worlds population will be obese by 2030 at the current rate.

66%

of Irish population support the legalization of marijuana.

67%

of the worlds population will be obese by 2030 at the current rate.

68%

of the worlds population will be obese by 2030 at the current rate.

69%

of Irish population support the legalization of marijuana.

70%

of the worlds population will be obese by 2030 at the current rate.

71%

of the worlds population will be obese by 2030 at the current rate.

72%

of Irish population support the legalization of marijuana.

73%

of the worlds population will be obese by 2030 at the current rate.

74%

of the worlds population will be obese by 2030 at the current rate.

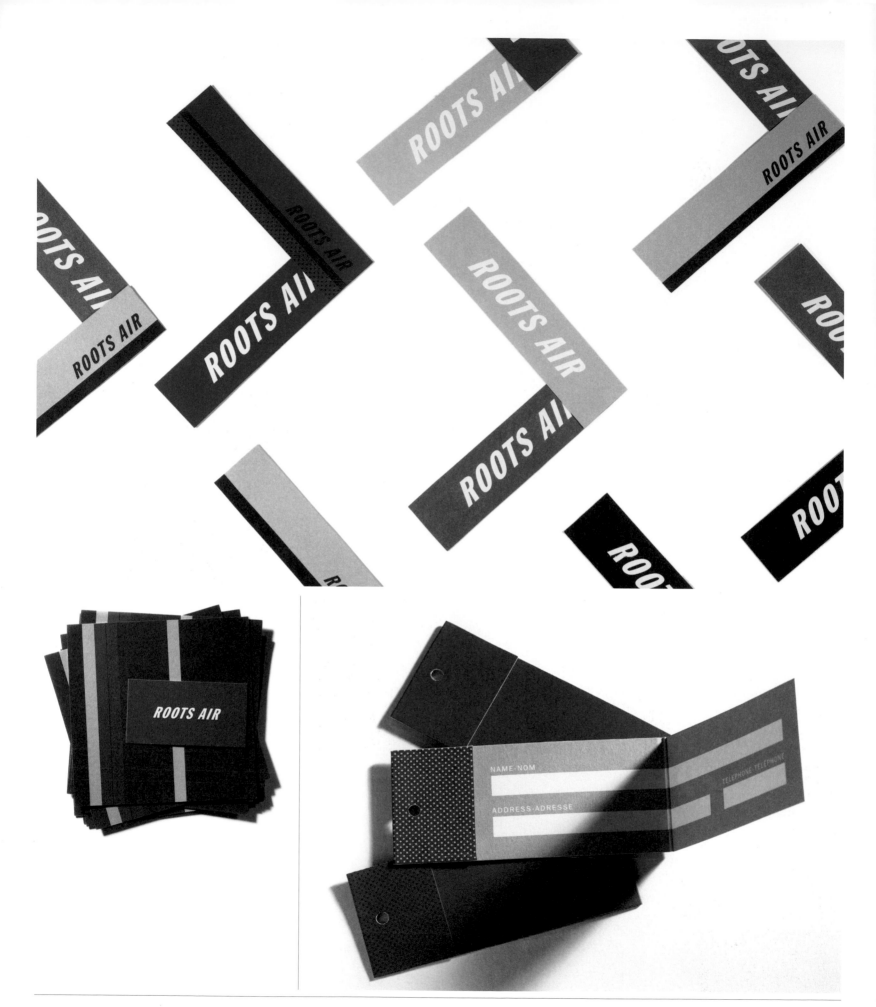

ECHOES OF THE FUTURE

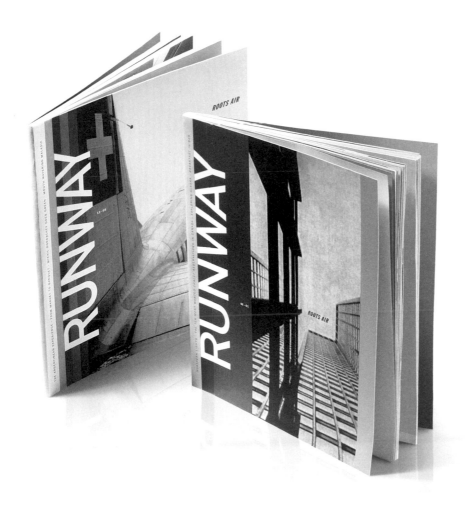

Roots
 2001, Roots Air
Designers: Vanessa Eckstein, Frances Chen→
Identity for the clothing company Roots who is entering of the airline travel business.

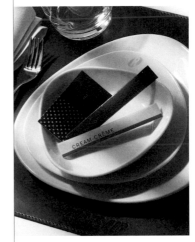

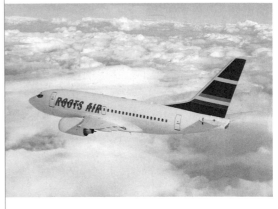

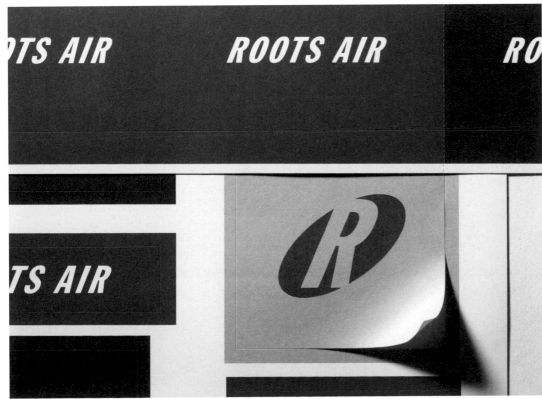

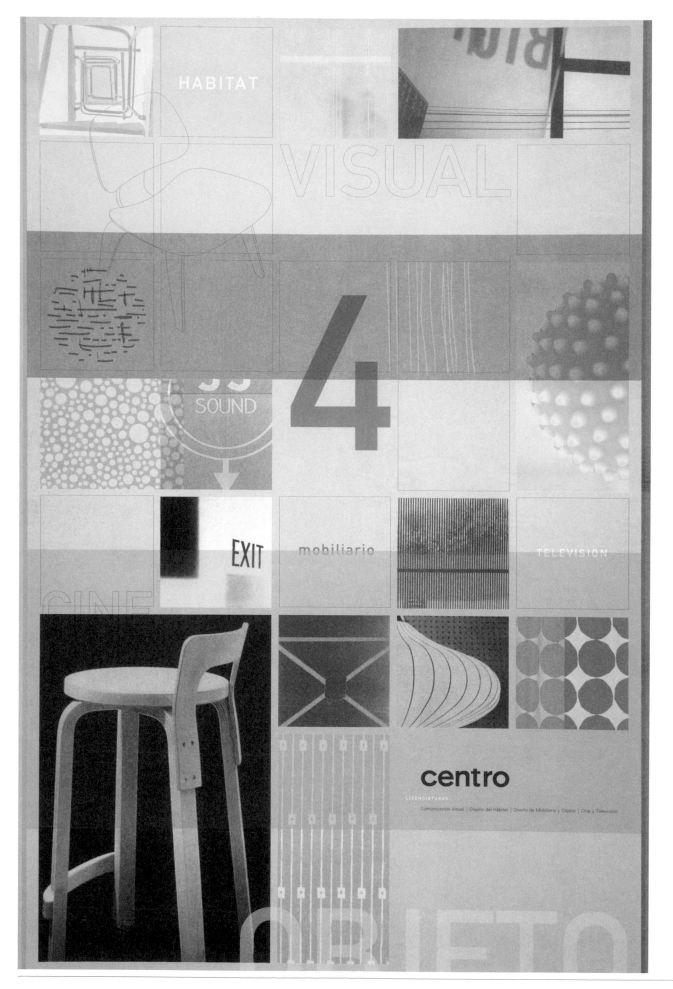

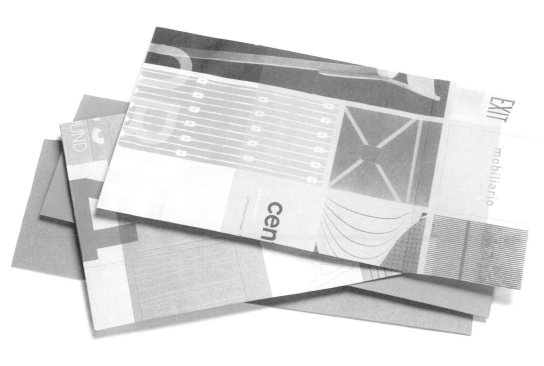

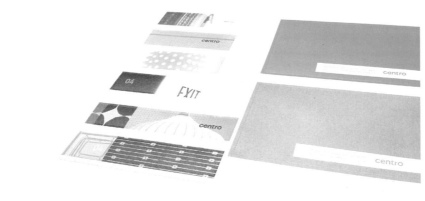

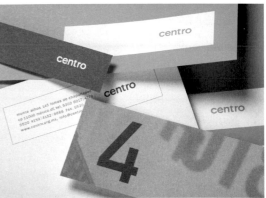

Centro Poster

2005, Centro

Designer: Vanessa Eckstein, Mariana Contegni, Photographer: Colin Faulkner → Identity for a new, contemporary arts university in Mexico City affiliated with the Art and Design Centre of Pasadena. The university offers four distinct career paths: film, industrial design, interior design and graphic design.

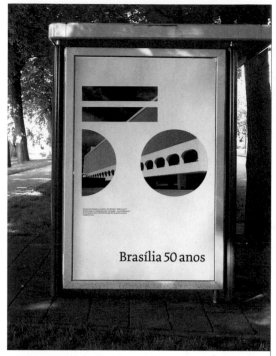

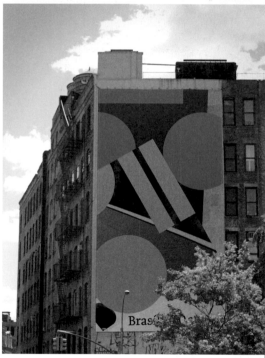

Rejane Dal Bello

50 years Celebration of Brasilia
2011, Personal Project
Event design. The shape of one of the more significant buildings in Brasília, the Palácio do Congresso Nacional, was translated into simple abstract forms whose arrangement formed the number 50.

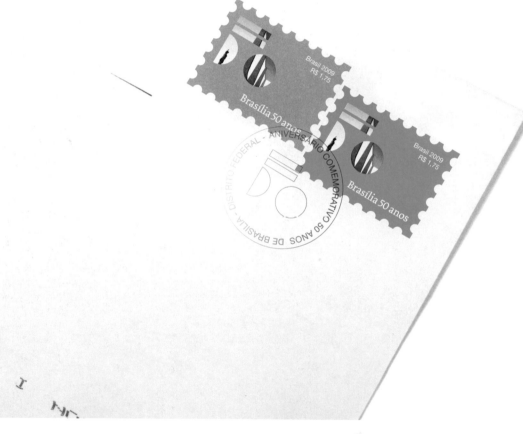

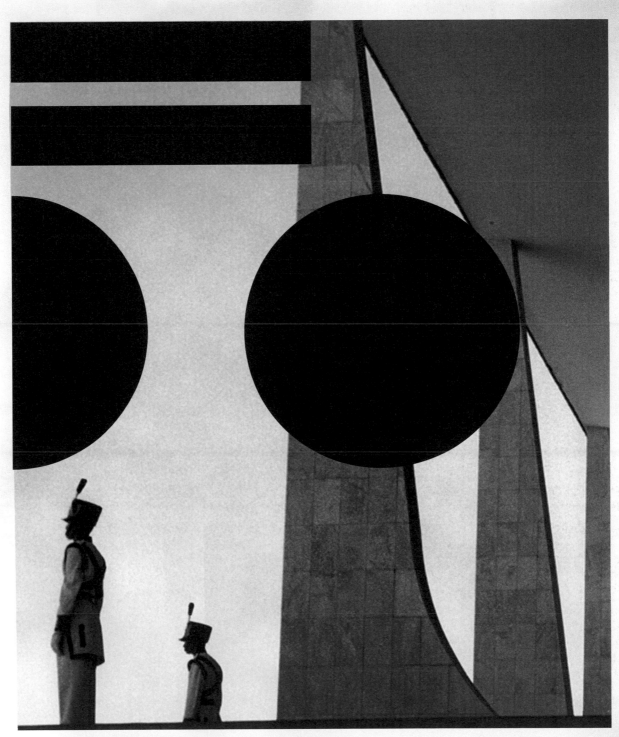

O poeta Ezra Pound, ao se referir a Brasília disse "Make it new!".
E é justamente a combinação entre essa utopia – traço fundamental
de seu projeto, marca tão profunda que não desapareceu nesses
cinqüenta anos.

Brasília 50 anos

REJANE DAL BELLO

Artiva

A D nothing to read *(2 images)*
2009, Personal Project
Journal-poster without text to reflect upon the meaning of communication.

Archphoto 2.0 n°00
2011, Plug in, Archphoto
Graphics, cover design, layout, and art direction of a 24 page black-and-white magazine.

Lettera 22
2010, Plug in
Packaging for a DVD collection about architecture, arts and design released at the fiftieth anniversary of Adriano Olivetti's death.

Quale Città *(right page, bottom, 2 images)*
2011, OBR-Architects
The project is focused on a series of lectures about the future of the cities and the architect's role in society. The illustration is a reference to Le Corbusier's architecture.

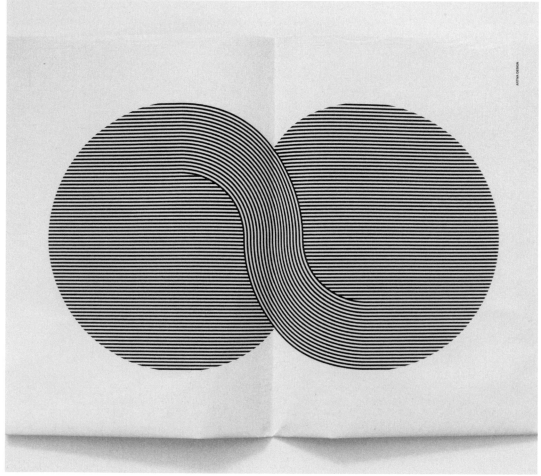

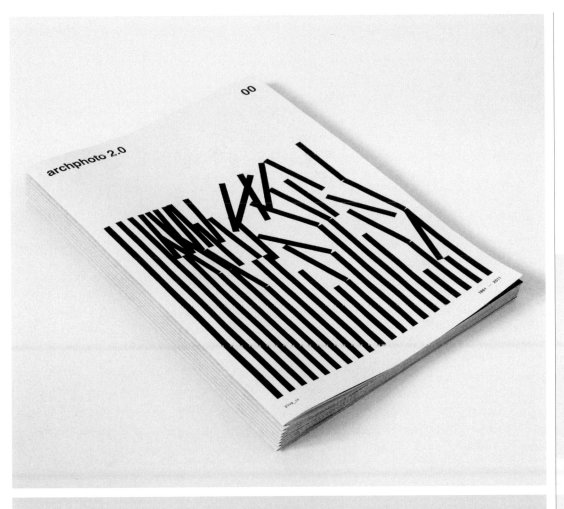

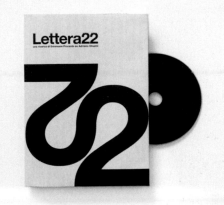

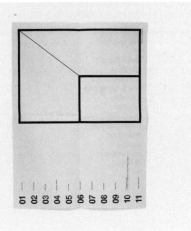

ARTIVA

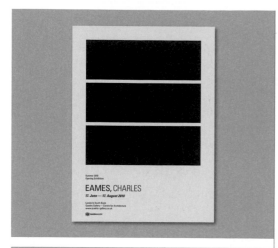

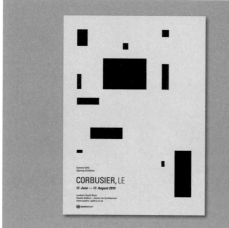

Donna Wearmouth

Quadra Gallery
2010, Northumbria University

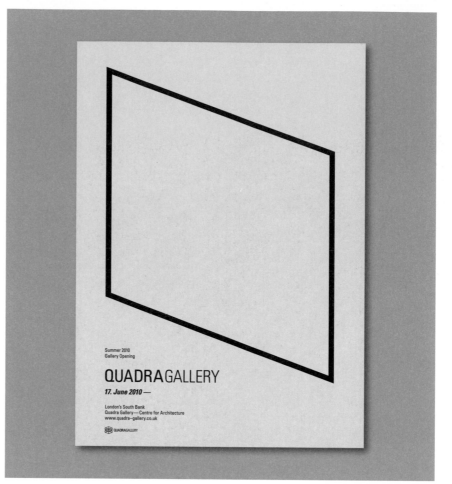

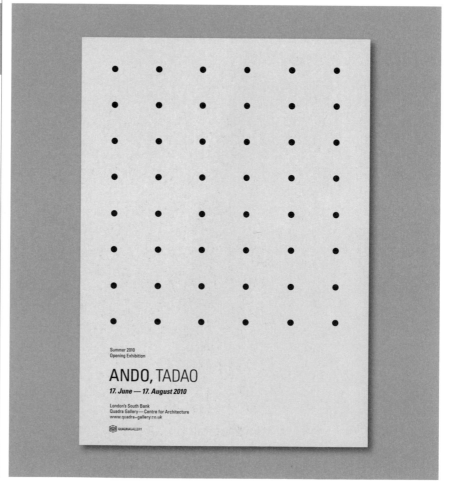

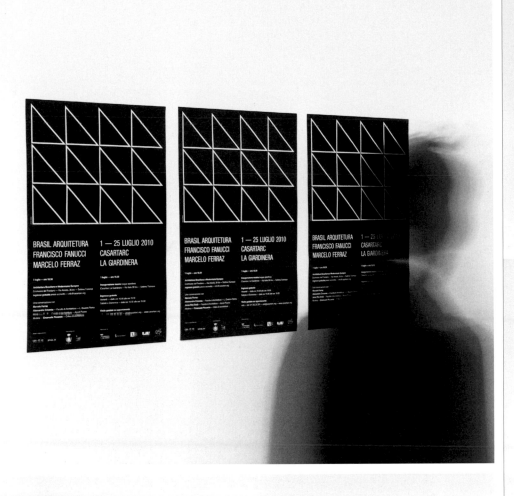

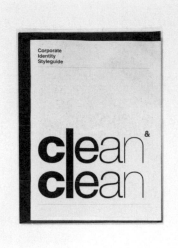

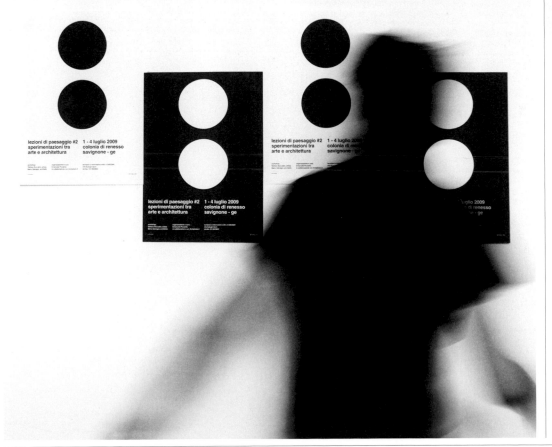

Artiva

Brasil Arquitetura
2010, Casartarc
Promotional card, poster, and infographic for an exhibition.

Lezioni di Paesaggio 2
2009, Plug_in
The comparison between the two differing points of view of art and architecture, two disciplines which are so close and also so far.

Clean & Clean
2011, Clean & Clean

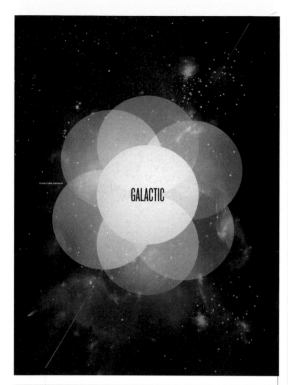

Andaur Studios

Galactic, Movement
2011, Personal Project
*Part of Sebastian Andaur's daily graphic
project "Everyday", going on since June 2011.*

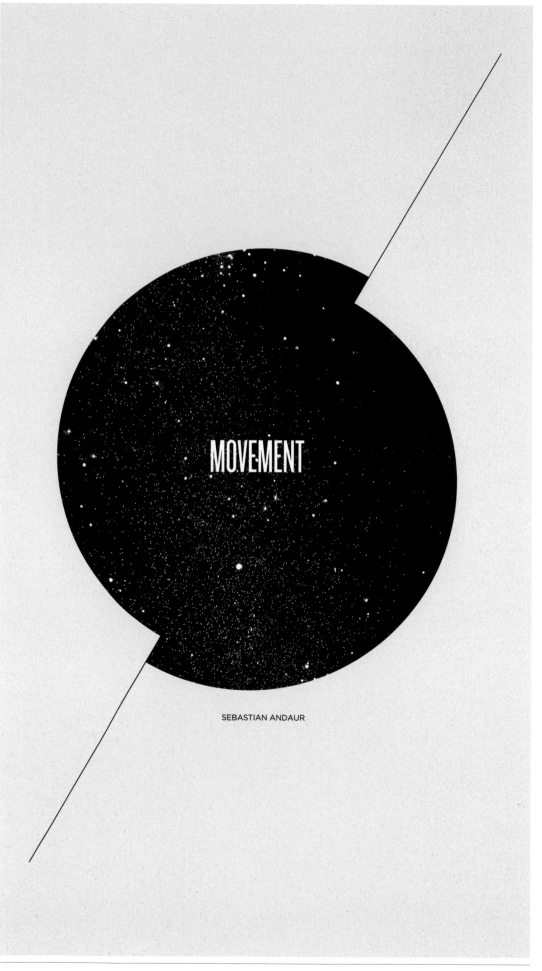

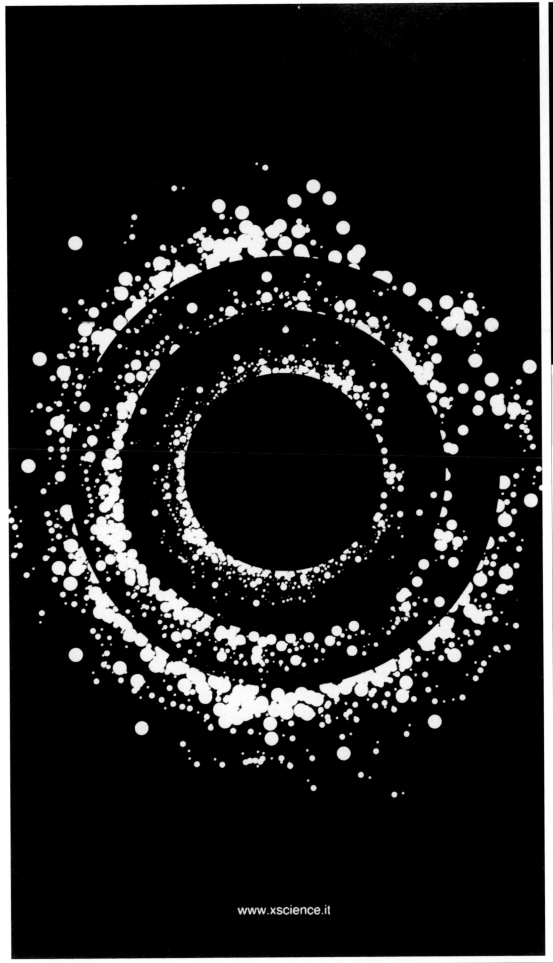

www.xscience.it

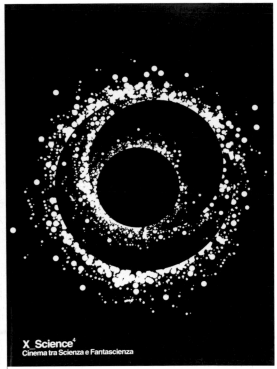

X_Science⁴
Cinema tra Scienza e Fantascienza

Artiva

X Science
2009, X Science
Identity for a movie festival

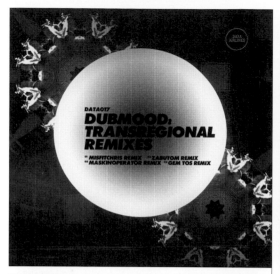

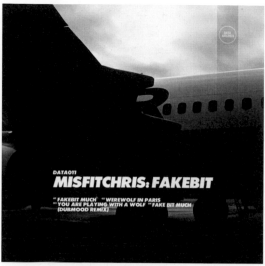

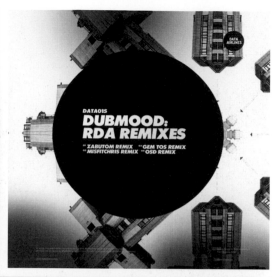

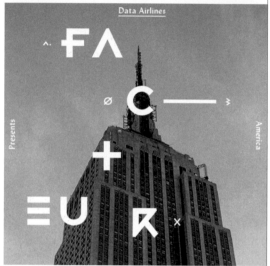

Erik Jonsson

Confipop – My HD, Misfitchris –
Fakebit, Dubmood – RDA Remixes,
Dubmood – Transregional Remixes,
Facteur – America
2010, Data Airlines Records
Digital release record covers.

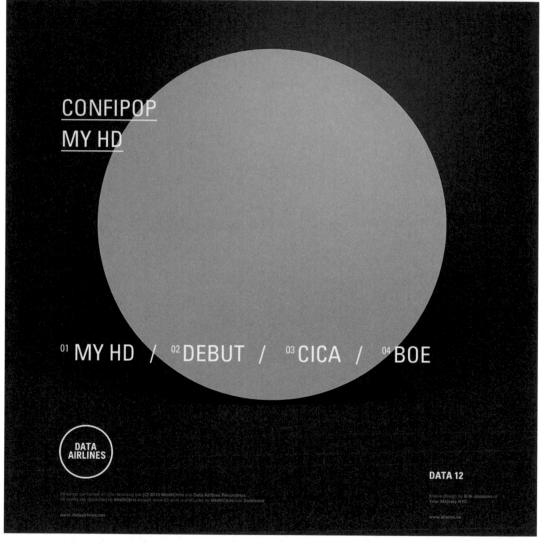

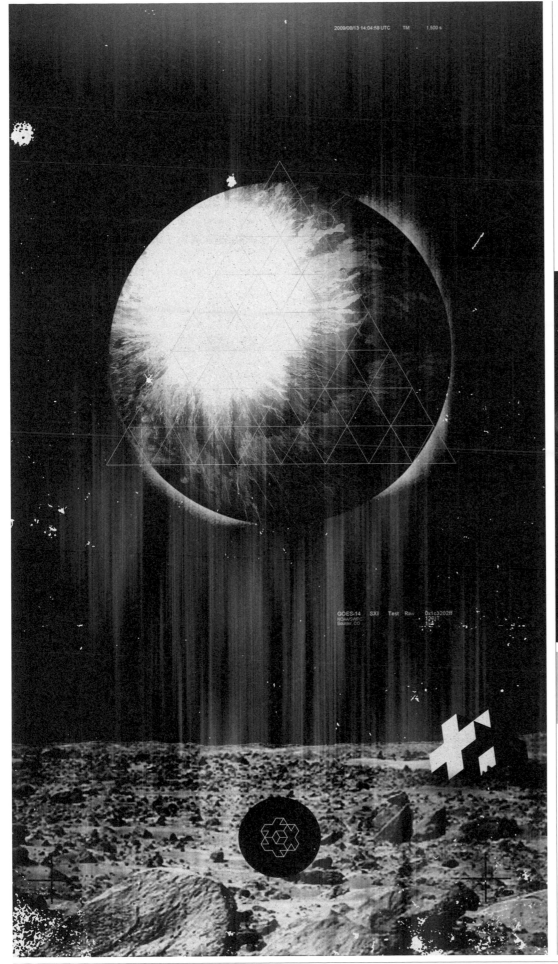

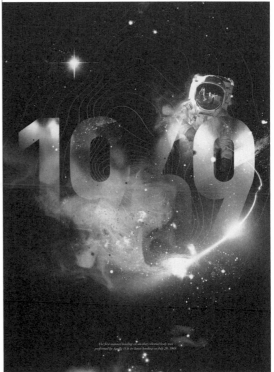

Marius Roosendaal

43, 1969
2011, Personal Project
Part of a self-initiated "make something every day" project.

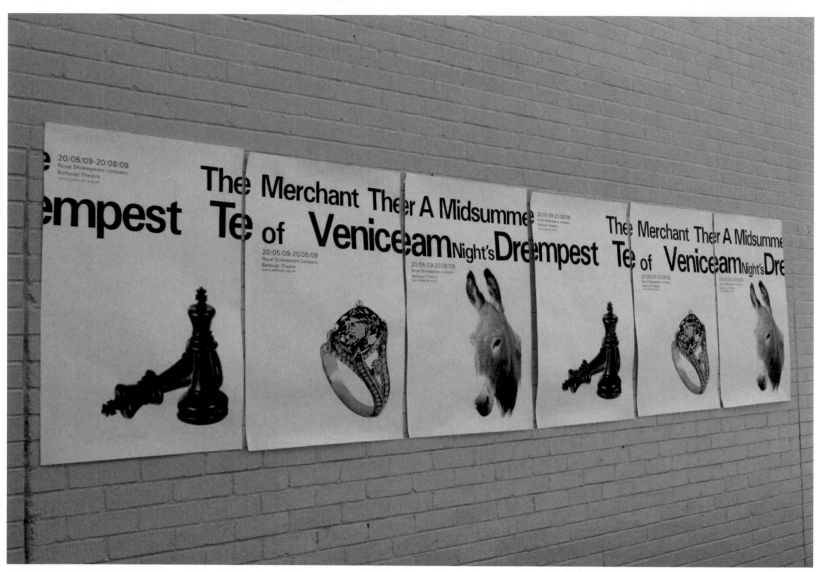

Laline Hay

Shakespeare
2009, Student Brief
Screen printed posters, 841 x 1189 mm →
The Merchant of Venice, The Tempest and
A Midsummer Night's Dream.

Tempsford Airfield Museum
2011, Tempsford Airfield
RAF Tempsford was one of the most secret air-
fields of the Second World War, as it was used by
the S.O.E (Special Operations Executive) to ferry
agents in and out of occupied Europe.

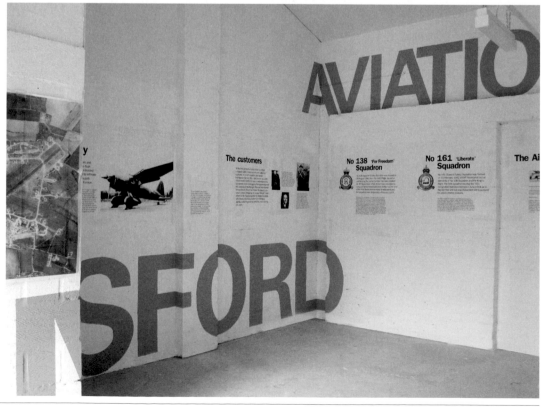

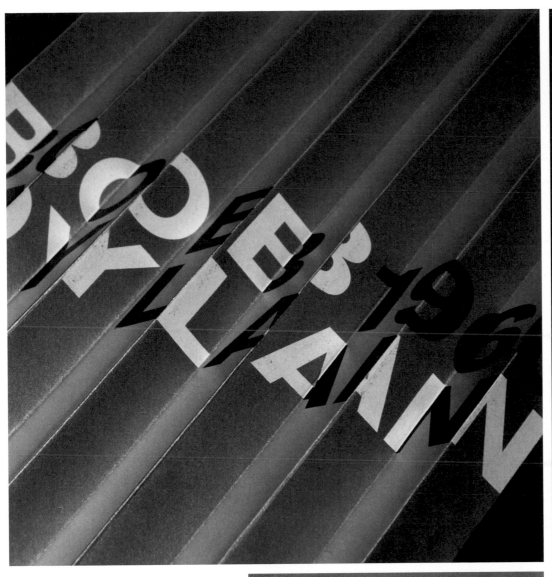

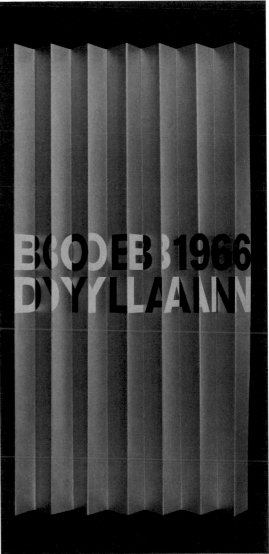

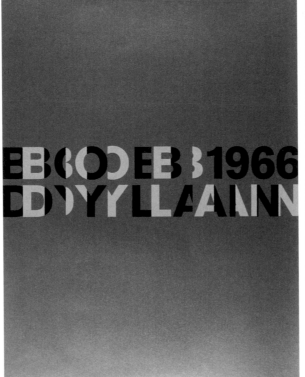

Sean Thomas

Dylan 1966

2011, Personal Project

In 1966 Bob Dylan went electric, playing a half-acoustic, half-electric set. This poster highlights the distinction between the two performances.

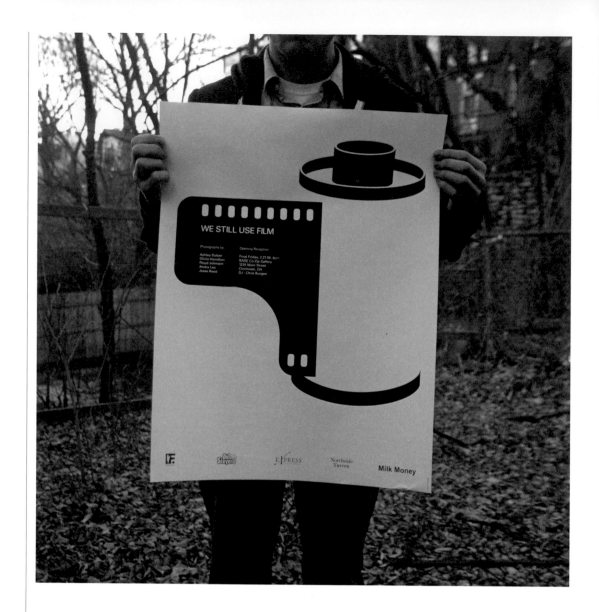

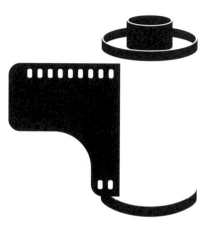

Jesse Reed

We Still Use Film

2008, Base Gallery, Cincinnati, Ohio
Identity for a photography exhibition showcasing the analog process.

Crossroads

2009, The Atlantic Magazine
Designer: Jesse Reed, Design Direction: Michael Bierut, Pentagram → Illustration for an article about Americans' conflicting views on subjects ranging from politics to socioeconomic issues.

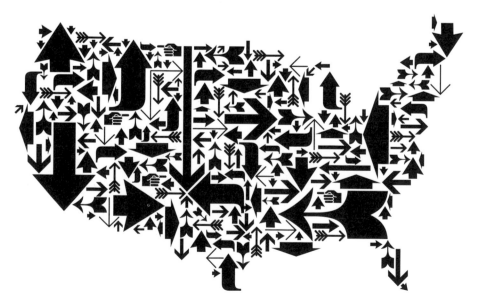

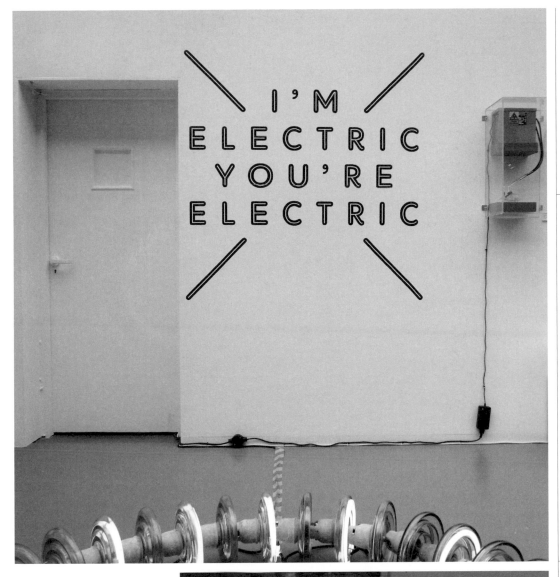

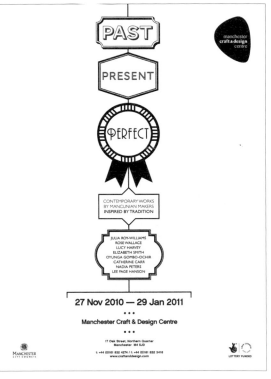

Dave Sedgwick

I'm Electric You're Electric
2011, Manchester Craft & Design Centre
Identity and marketing material for a neon-based exhibition at Manchester Craft & Design Centre.

Past Present Perfect
2010, Manchester Craft and Design Centre
Identity and poster campaign for Past Present Perfect, an exhibition at MCDC.

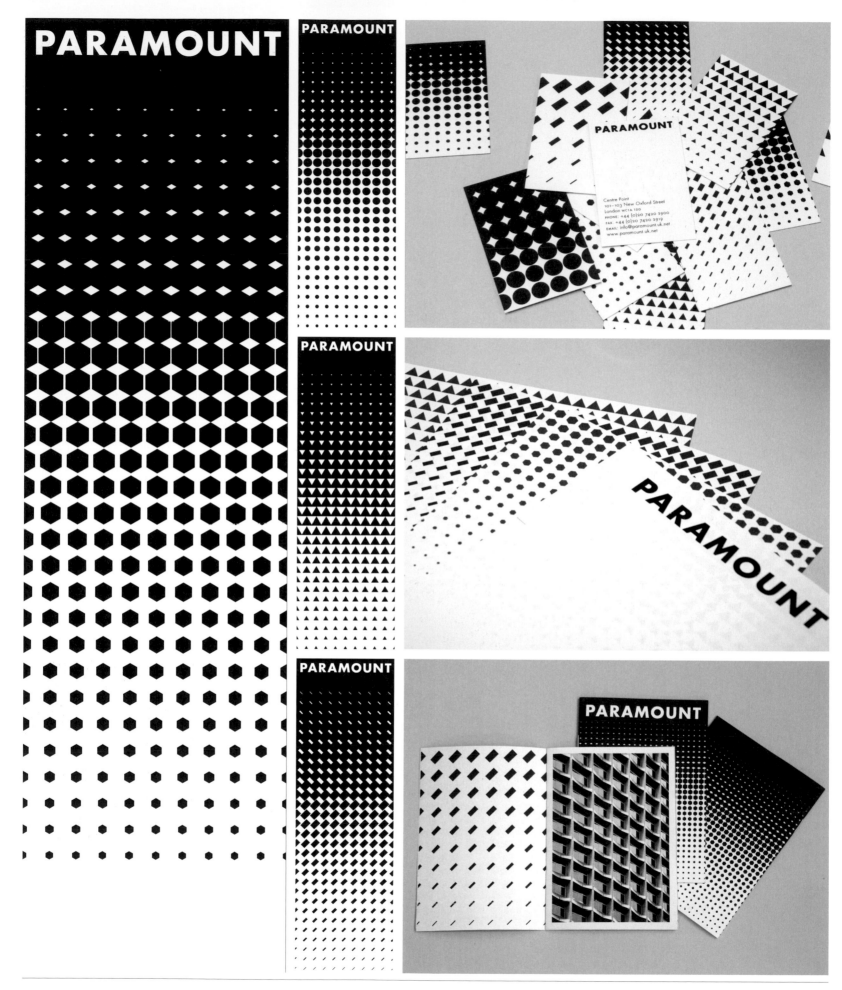

ECHOES OF THE FUTURE

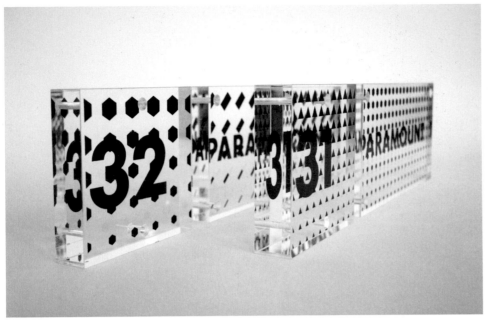

Paramount Interior Design

2009, Paramount

The Paramount identity consists of graduation patterns which express an upwards movement. Sections of the pattern are printed on the front of all signage.

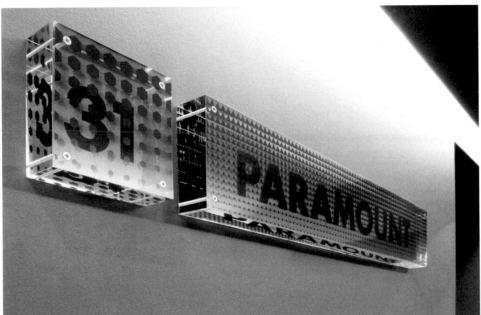

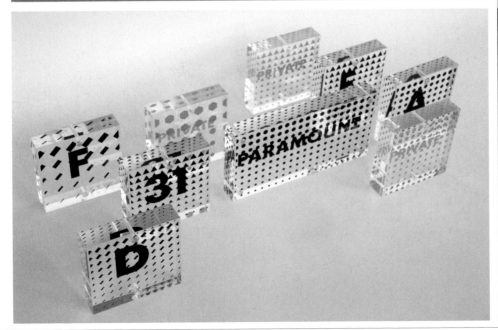

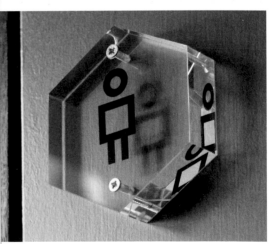

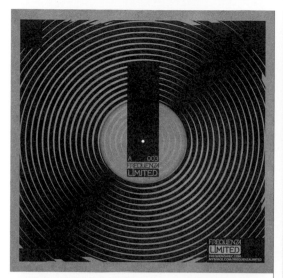

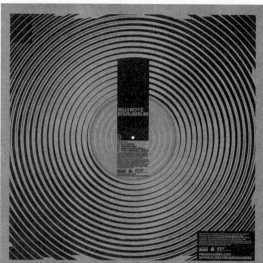

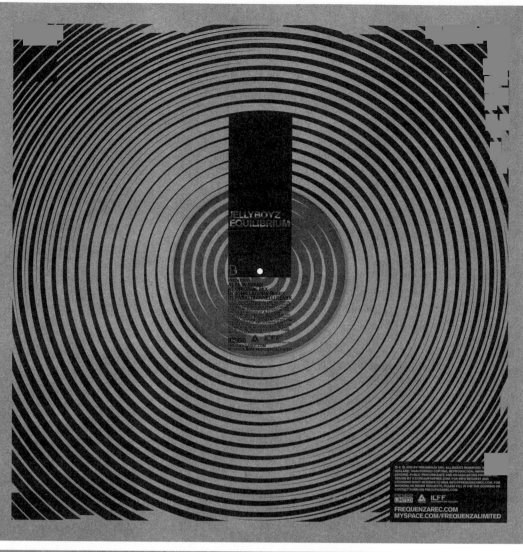

Oliver Wiegner

Frequenza Limited
2009, Frequenza Recordings
Standard sleeve artwork for upcoming label
Frequenza Limited of Italy based DJ and
producer Alex D'elia

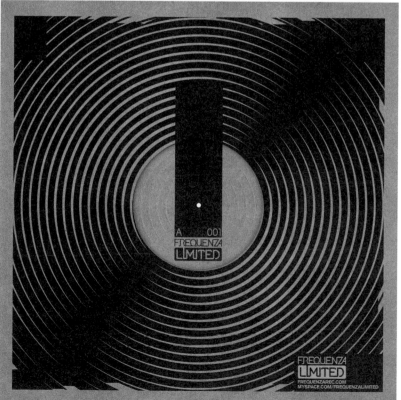

ECHOES OF THE FUTURE

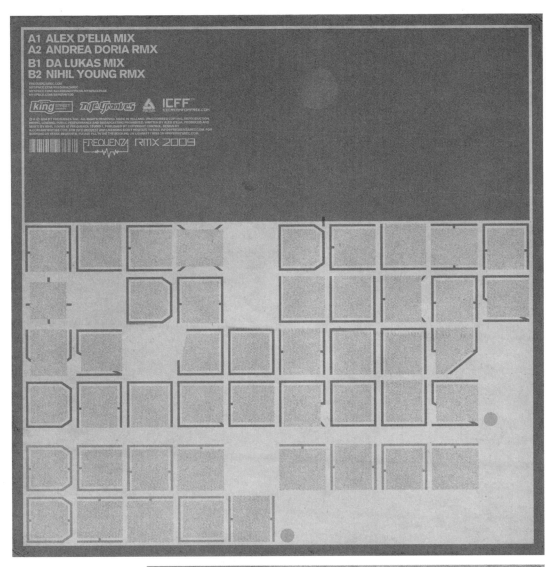

A1 ALEX D'ELIA MIX
A2 ANDREA DORIA RMX
B1 DA LUKAS MIX
B2 NIHIL YOUNG RMX

Oliver Wiegner

Alex D'elia / Beat that Bitch
2009, Frequenza Recordings
Sleeve artwork for the first of a special series of classic remix releases by Italian techno label Frequenza Limited run by DJ and producer Alex D'elia.

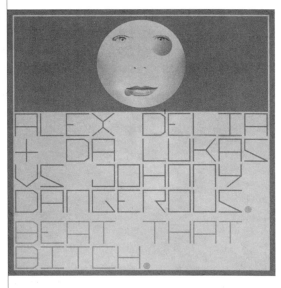

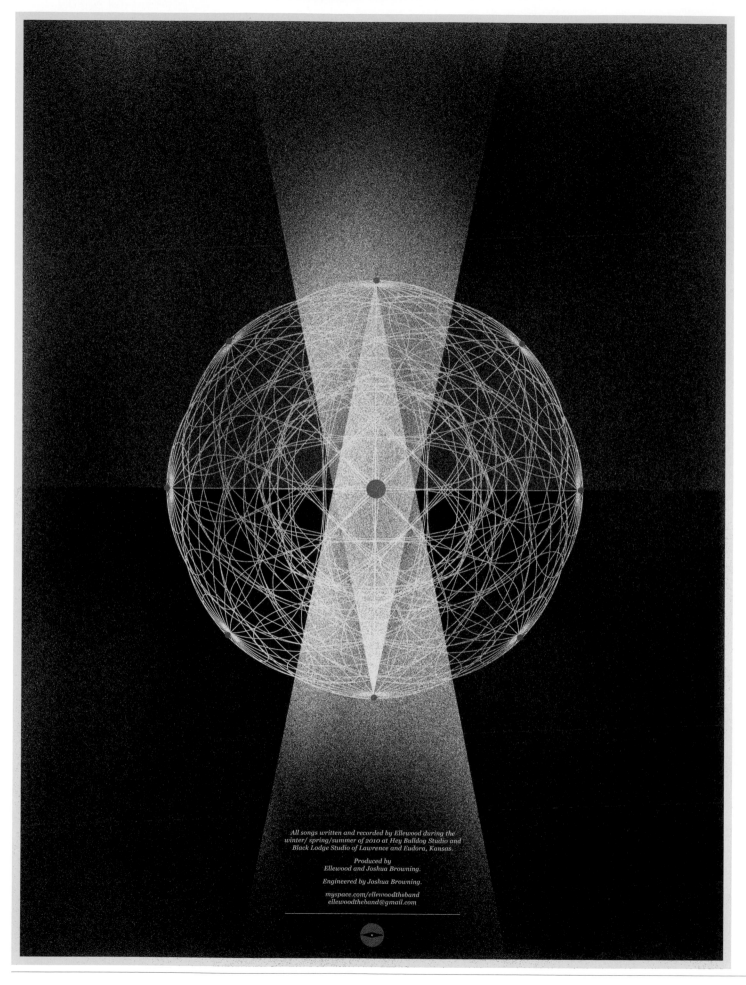

All songs written and recorded by Ellewood during the
winter/ spring/summer of 2010 at Hey Bulldog Studio and
Black Lodge Studio of Lawrence and Eudora, Kansas.

Produced by
Ellewood and Joshua Browning.

Engineered by Joshua Browning.

myspace.com/ellewoodtheband
ellewoodtheband@gmail.com

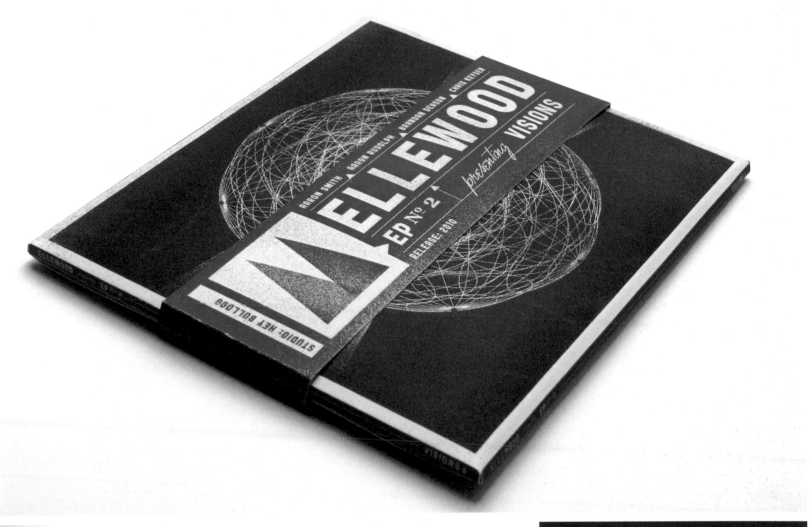

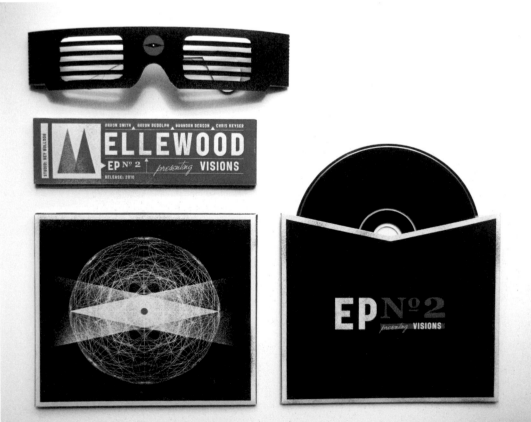

Brandan Deason

Visions
2010, Ellewood
Promotional poster and CD sleeves for Visions E.P. by Kansas City indie rock band Ellewood.

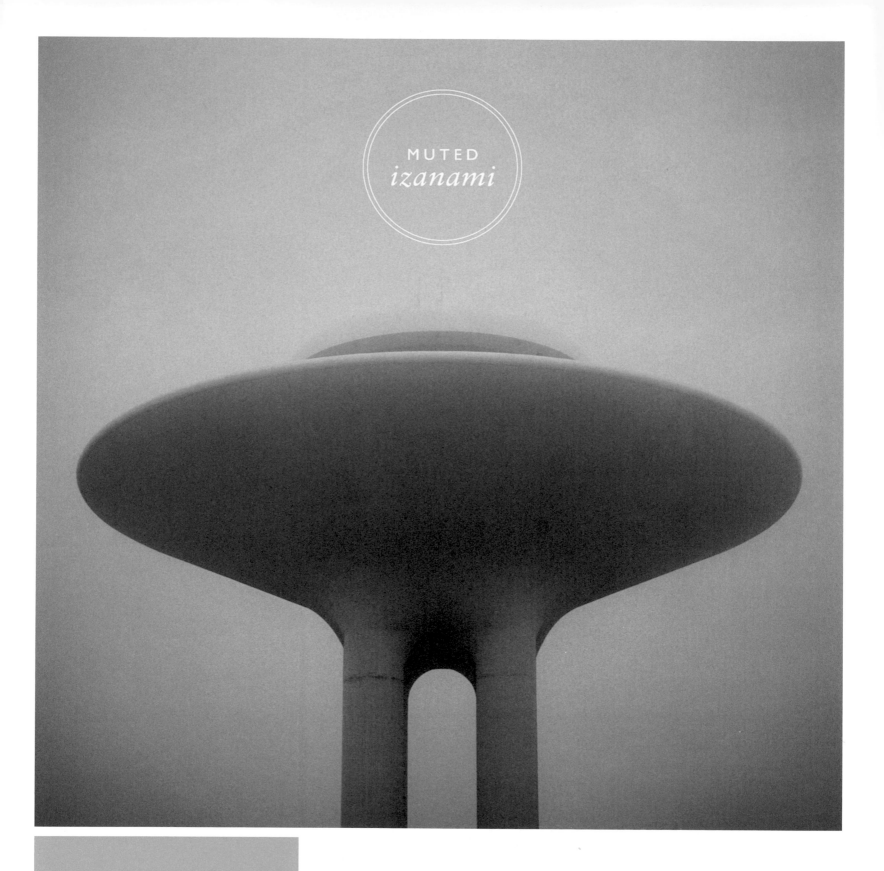

Ross Gunter

Muted – Izanami E.P.
2010, Manifesto Music
Designer: Ross Gunter, Photography by Kim Høltermand → Record sleeve.

08201 1

ALSK

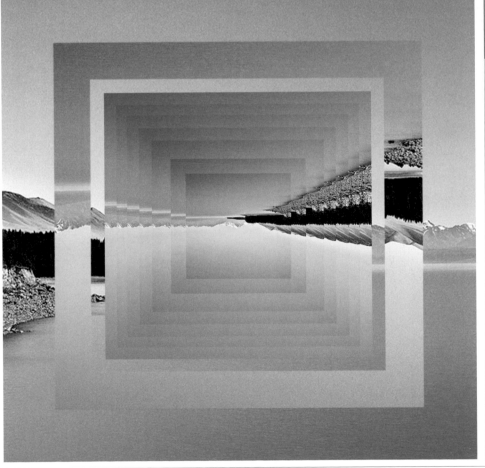

ChristianConlh

ALSK
2010, Personal Project

ROSS GUNTER, CHRISTIANCONLH

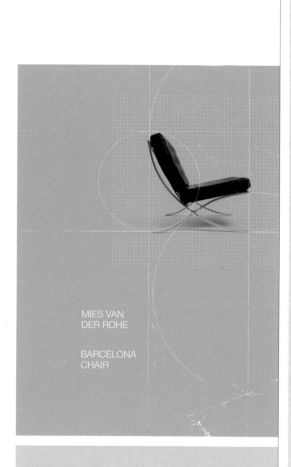

MIES VAN
DER ROHE

BARCELONA
CHAIR

Marius Roosendaal

Barcelona Chair, Diamonds Are Forever,
Form and Colour Study

2011, Personal Project

Part of a self-initiated "make something every day" project.

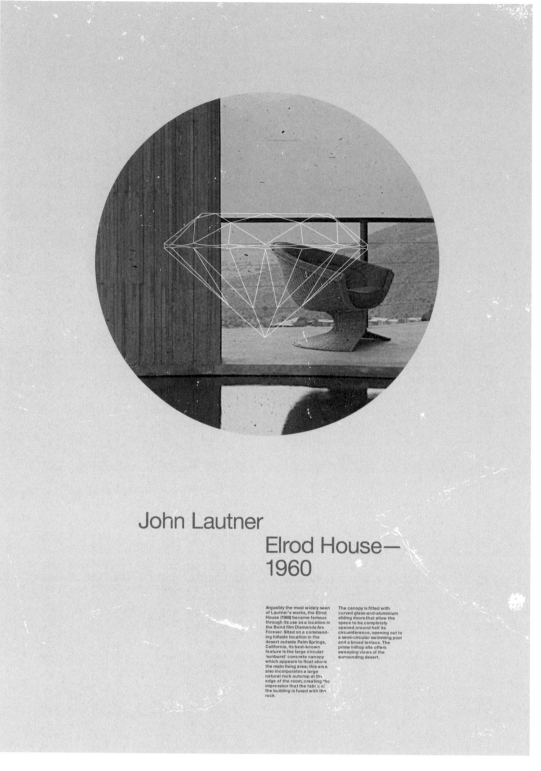

John Lautner

Elrod House—
1960

Arguably the most widely seen of Lautner's works, the Elrod House (1968) became famous through its use as a location in the Bond film Diamonds Are Forever. Sited on a commanding hillside location in the desert outside Palm Springs, California, its best-known feature is the large circular 'sunburst' concrete canopy which appears to float above the main living area; this area also incorporates a large natural rock outcrop at the edge of the room, creating 'the impression that the fabric of the building is fused with the rock.

The canopy is fitted with curved glass-and-aluminium sliding doors that allow the space to be completely opened around half its circumference, opening out to a semi-circular swimming pool and a broad terrace. The prime hilltop site offers sweeping views of the surrounding desert.

ECHOES OF THE FUTURE

 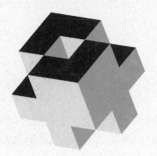 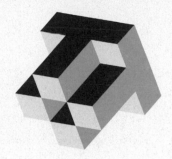

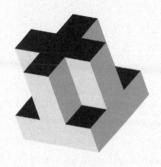 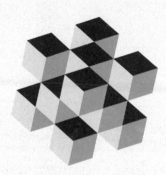 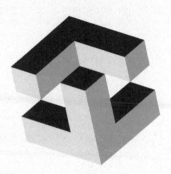

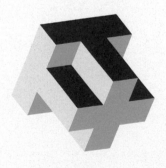 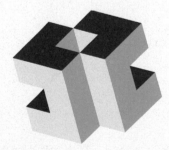 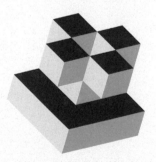

Form and colour study

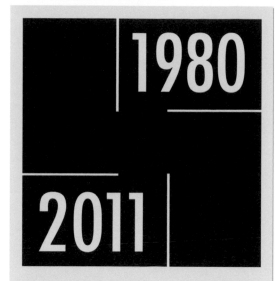

Ausstellung
Laibach Kunst
1980–2011

3.5 — 26.5.11
Dom HDLU
Bacva+Prsten+PM
Trg Žrtava Fašizma bb

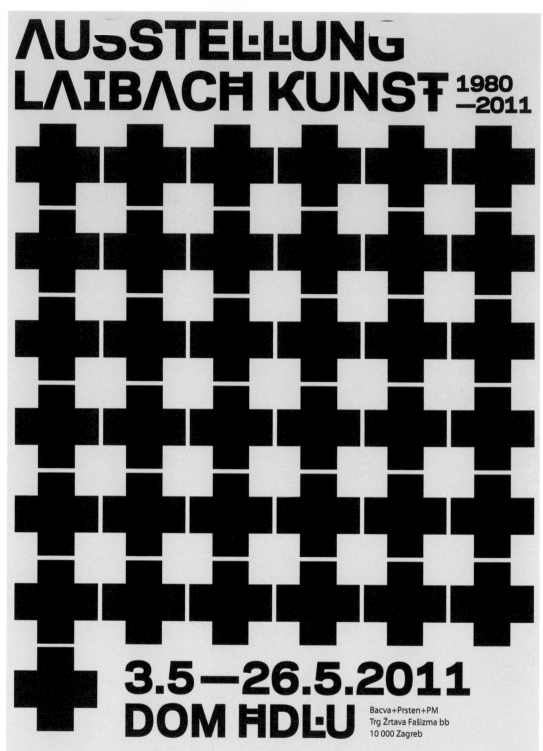

Bunch

Laibach

2011, Croatian Association of Artists
Designer: Denis Kovac → Proposal for Laibach's
31-year retrospective exhibition, which took
place at Zagreb's HDLU in May 2011.

Marius Roosendaal

37
2011, Personal Project
Part of a self-initiated "make something every day" project.

Experiment with grid
and certain constraints
in placing type within.

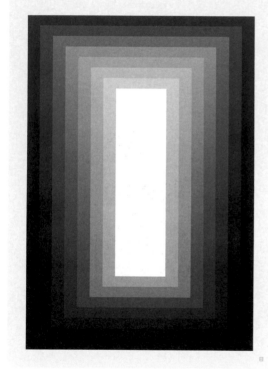

Barta Balazs

Composition, Layers
2010, Personal Project

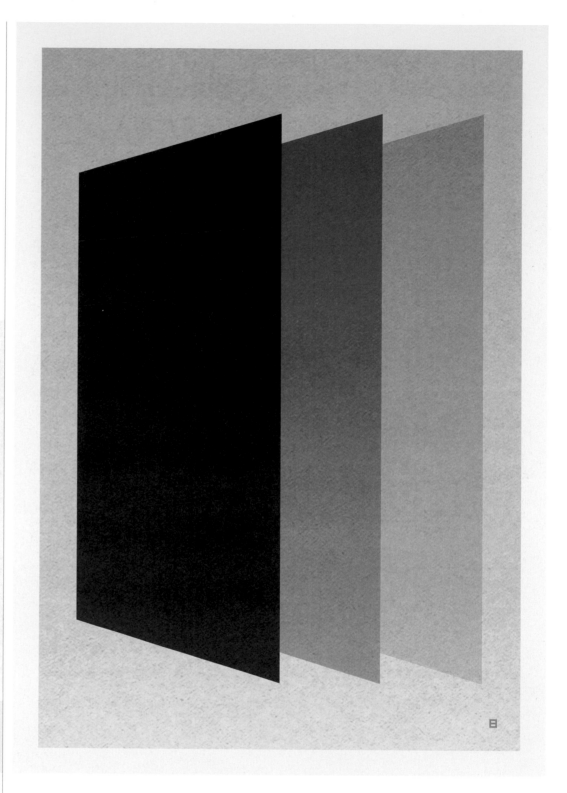

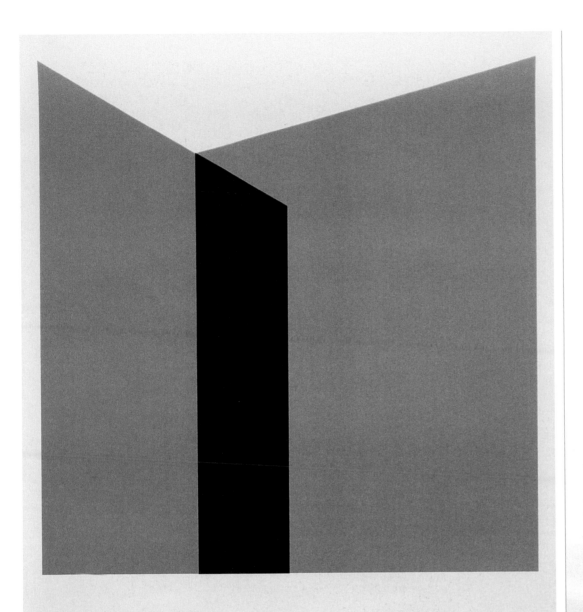

l'isola
degli artisti
2010

pietro lingeri
architetto
della tremezzina

11 sett. — 31 ott.
villa carlotta
tremezzo (co)

www.villacarlotta.it

11 sett. — 17 ott. . ore 09 — 18
18 ott. — 31 ott. . ore 10 — 17

sala esposizioni
piano ammezzato

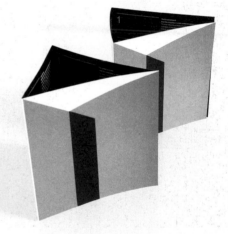

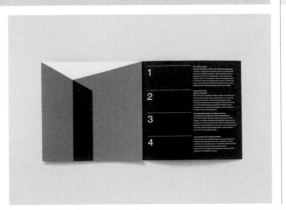

Artiva

Pietro Lingeri architetto della
Tramezzina

2010, The city of Como / Plug in
The brochure and poster illustration is a synthesis of Lingeri's architecture, "Villino per artisti" (the artist's house). The image's trasparency underlines the connection between inside and outside in Lingeri's architecture.

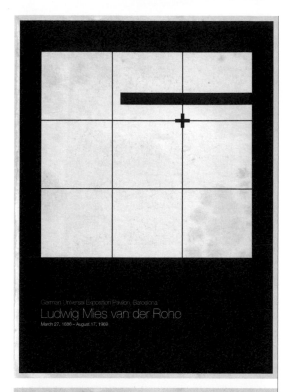

German Universal Exposition Pavilion, Barcelona
Ludwig Mies van der Rohe
March 27, 1886 – August 17, 1969

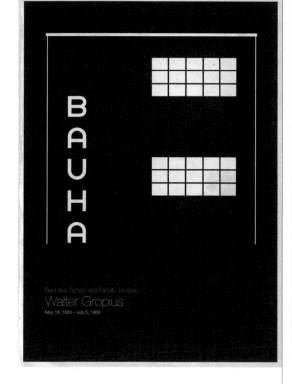

BAUHA

Bauhaus School and Faculty, Dessau
Walter Gropius
May 18, 1883 – July 5, 1969

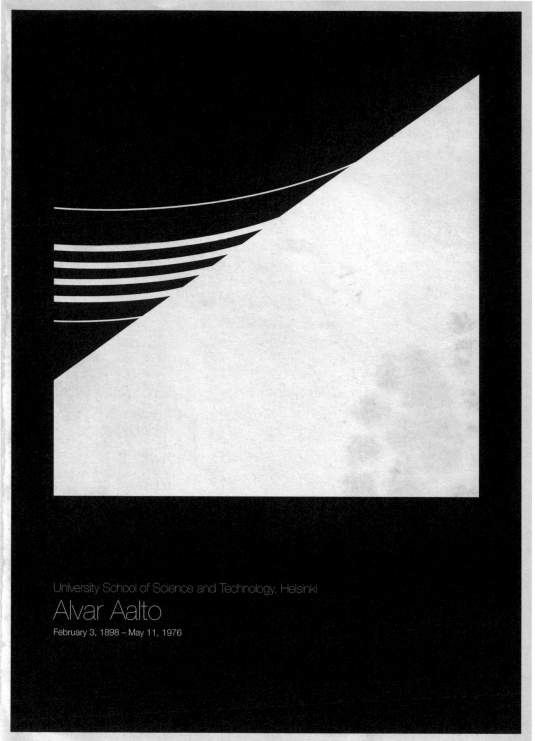

University School of Science and Technology, Helsinki
Alvar Aalto
February 3, 1898 – May 11, 1976

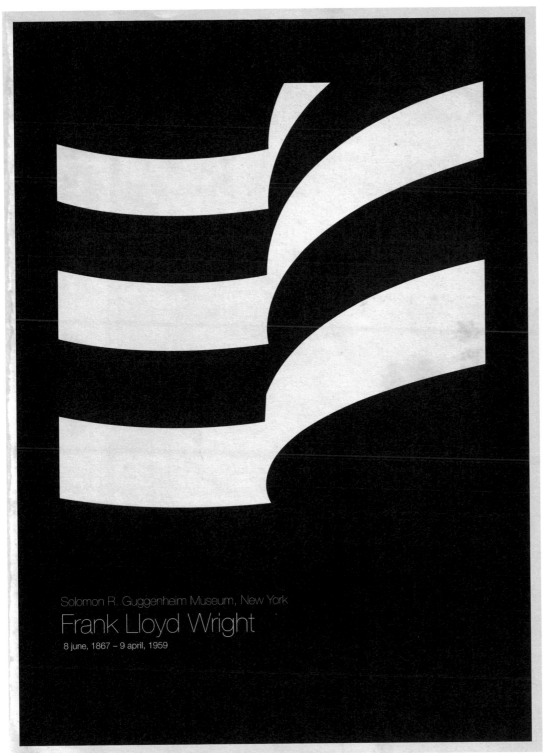

Solomon R. Guggenheim Museum, New York
Frank Lloyd Wright
8 june, 1867 – 9 april, 1959

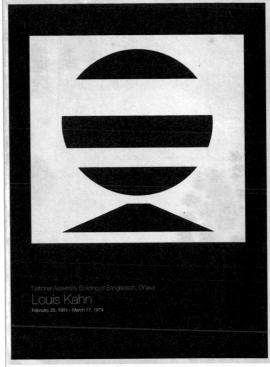

National Assembly Building of Bangladesh, Dhaka
Louis Kahn
February 20, 1901 – March 17, 1974

Andrea Gallo

Ludwig Mies van der Rohe | German Universal Exposition Pavilion, Barcelona
2011, Personal Project
Detail of Mies Pavilion's travertine paving, cross pillar and wall.

Walter Gropius | Bauhaus School and Faculty, Dessau
2011, Personal Project
Detail of the front of the Bauhaus School, using its original font.

Alvar Aalto | University School of Science and Technology, Helsinki
2011, Personal Project
Detail of the side view of the university's auditorium.

Frank Lloyd Wright | Solomon R. Guggenheim Museum, New York
2011, Personal Project
Detail of the Guggenheim's three spirals.

Louis Kahn | National Assembly Building of Bangladesh, Dhaka
2011, Personal Project
Detail of one of the building's facades, recognizable by the rounded and triangular cuts on the wall.

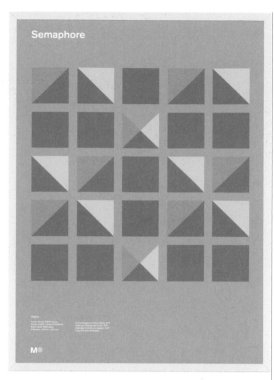

Semaphore

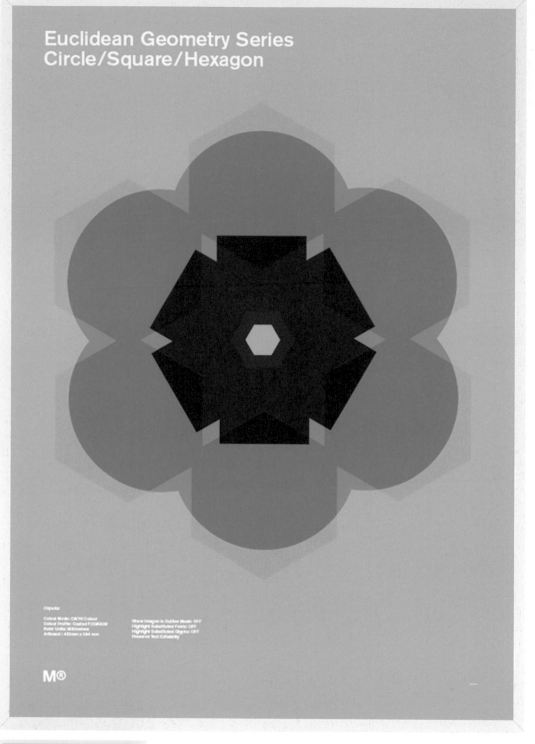

Euclidean Geometry Series
Circle/Square/Hexagon

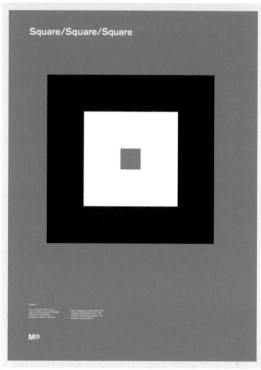

Square/Square/Square

Studio Mister

A Series of 1950/60's-inspired posters
2011, Mister
*Designer: Mike Sullivan → A series of five limited
screenprint editions.*

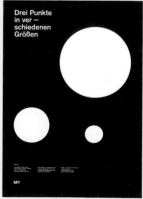

Drei Punkte
in ver —
schiedenen
Größen

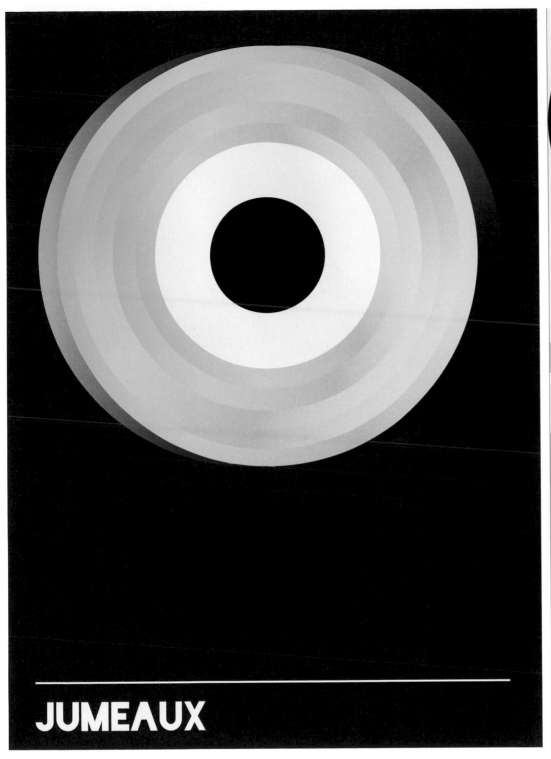

JUMEAUX

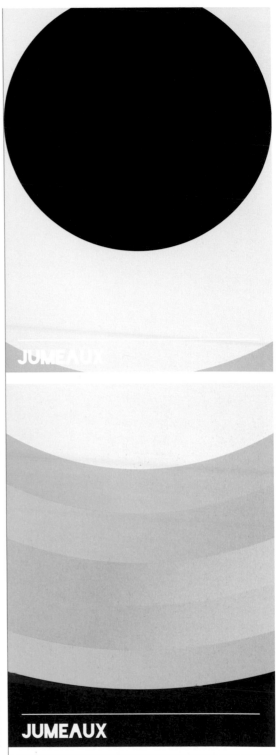

JUMEAUX

James Kirkup

Jumeaux
2009, Jumeaux

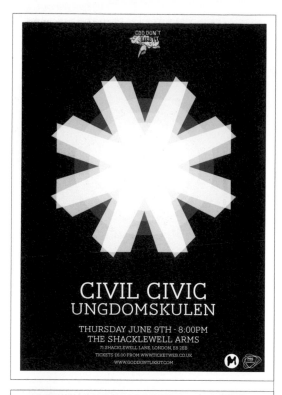

CIVIL CIVIC
UNGDOMSKULEN

THURSDAY JUNE 9TH - 8:00PM
THE SHACKLEWELL ARMS
71 SHACKLEWELL LANE, LONDON, E8 2EB
TICKETS £6.00 FROM WWW.TICKETWEB.CO.UK
WWW.GODDONTLIKEIT.COM

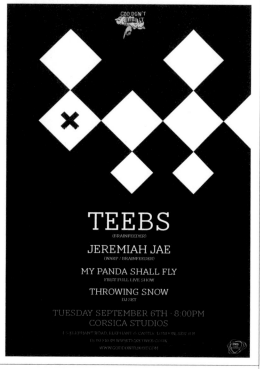

TEEBS
(BRAINFEEDER)

JEREMIAH JAE
(WARP / BRAINFEEDER)

MY PANDA SHALL FLY
FIRST FULL LIVE SHOW

THROWING SNOW
DJ SET

TUESDAY SEPTEMBER 6TH - 8:00PM
CORSICA STUDIOS
4-5 ELEPHANT ROAD, ELEPHANT & CASTLE, LONDON, SE17 1LB
£6.00 FROM WWW.TICKETWEB.CO.UK
WWW.GODDONTLIKEIT.COM

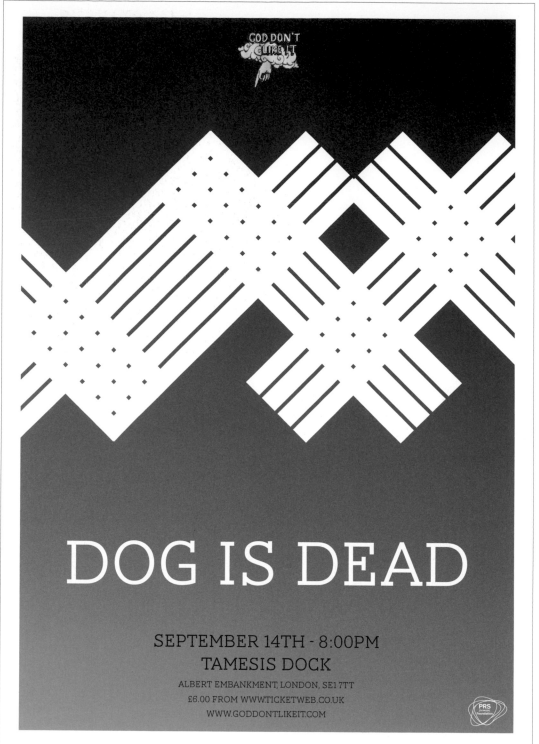

DOG IS DEAD

SEPTEMBER 14TH - 8:00PM

TAMESIS DOCK

ALBERT EMBANKMENT, LONDON, SE1 7TT
£6.00 FROM WWW.TICKETWEB.CO.UK
WWW.GODDONTLIKEIT.COM

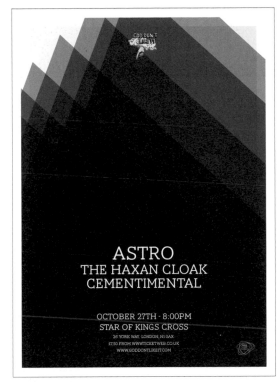

ASTRO
THE HAXAN CLOAK
CEMENTIMENTAL

OCTOBER 27TH · 8:00PM
STAR OF KINGS CROSS
26 YORK WAY, LONDON, N1 0AX
£7.50 FROM WWW.TICKETWEB.CO.UK
WWW.GODDONTLIKEIT.COM

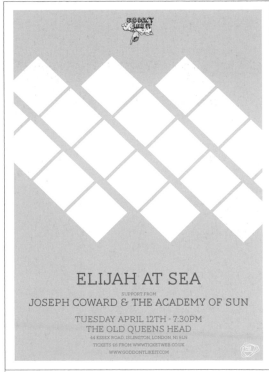

ELIJAH AT SEA
SUPPORT FROM
JOSEPH COWARD & THE ACADEMY OF SUN

TUESDAY APRIL 12TH · 7:30PM
THE OLD QUEENS HEAD
44 ESSEX ROAD, ISLINGTON, LONDON, N1 8LN
TICKETS £6 FROM WWW.TICKETWEB.CO.UK
WWW.GODDONTLIKEIT.COM

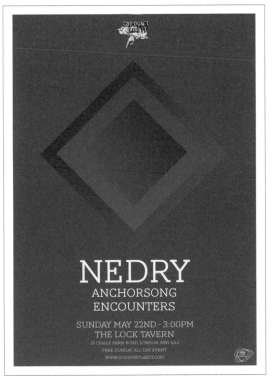

NEDRY
ANCHORSONG
ENCOUNTERS

SUNDAY MAY 22ND · 3:00PM
THE LOCK TAVERN
35 CHALK FARM ROAD, LONDON, NW1 8AJ
FREE SUNDAY ALL DAY EVENT
WWW.GODDONTLIKEIT.COM

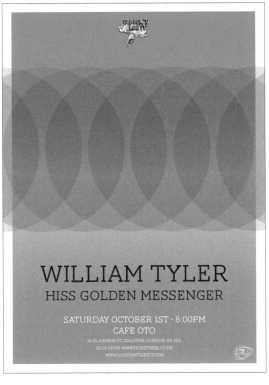

WILLIAM TYLER
HISS GOLDEN MESSENGER

SATURDAY OCTOBER 1ST · 8:00PM
CAFE OTO
18-22 ASHWIN ST, DALSTON, LONDON, E8 3DL
£8.00 FROM WWW.TICKETWEB.CO.UK
WWW.GODDONTLIKEIT.COM

James Kirkup

Civil Civic, Teebs, Dog is Dead, Astro, Elijah at Sea, Nedry 2, William Tyler, Ghosting Season
2011, God Don't Like It
Several show posters for God Don't Like It.

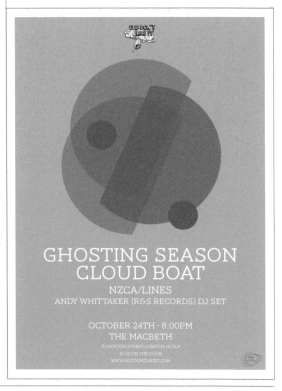

GHOSTING SEASON
CLOUD BOAT
NZCA/LINES
ANDY WHITTAKER (R&S RECORDS) DJ SET

OCTOBER 24TH · 8:00PM
THE MACBETH
70 HOXTON STREET, LONDON, N1 6LP
£5.00 ON THE DOOR
WWW.GODDONTLIKEIT.COM

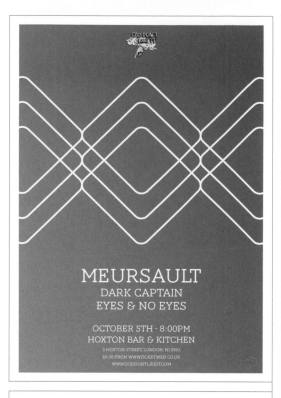

MEURSAULT
DARK CAPTAIN
EYES & NO EYES

OCTOBER 5TH · 8:00PM
HOXTON BAR & KITCHEN
2 HOXTON STREET, LONDON, N1 6NU
£8.00 FROM WWW.TICKETWEB.CO.UK
WWW.GODDONTLIKEIT.COM

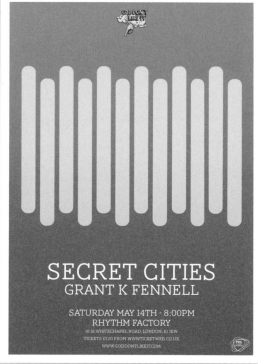

SECRET CITIES
GRANT K FENNELL

SATURDAY MAY 14TH · 8:00PM
RHYTHM FACTORY
16-18 WHITECHAPEL ROAD, LONDON, E1 1EW
TICKETS £7.00 FROM WWW.TICKETWEB.CO.UK
WWW.GODDONTLIKEIT.COM

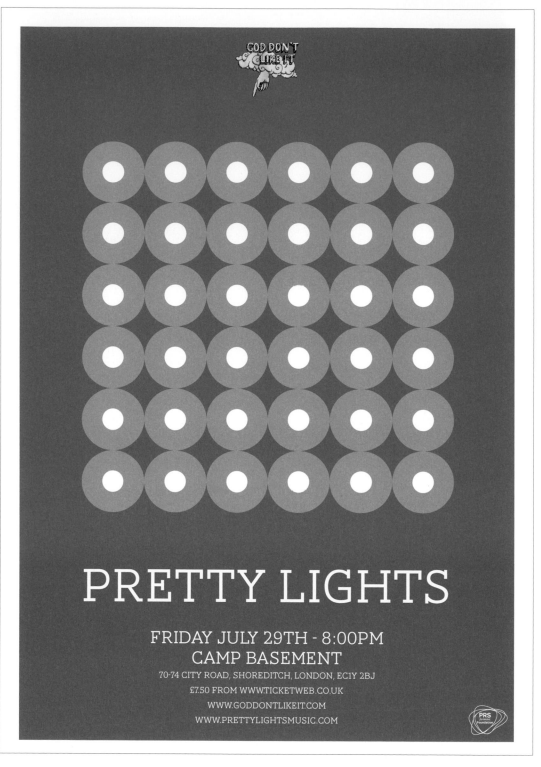

PRETTY LIGHTS

FRIDAY JULY 29TH · 8:00PM
CAMP BASEMENT
70-74 CITY ROAD, SHOREDITCH, LONDON, EC1Y 2BJ
£7.50 FROM WWW.TICKETWEB.CO.UK
WWW.GODDONTLIKEIT.COM
WWW.PRETTYLIGHTSMUSIC.COM

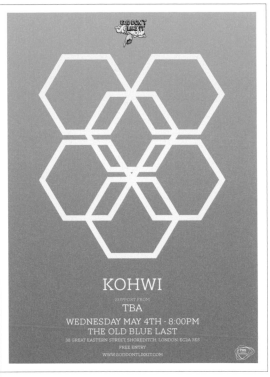

KOHWI

SUPPORT FROM
TBA

WEDNESDAY MAY 4TH - 8:00PM
THE OLD BLUE LAST

38 GREAT EASTERN STREET, SHOREDITCH, LONDON, EC2A 3ES
FREE ENTRY
WWW.GODDONTLIKEIT.COM

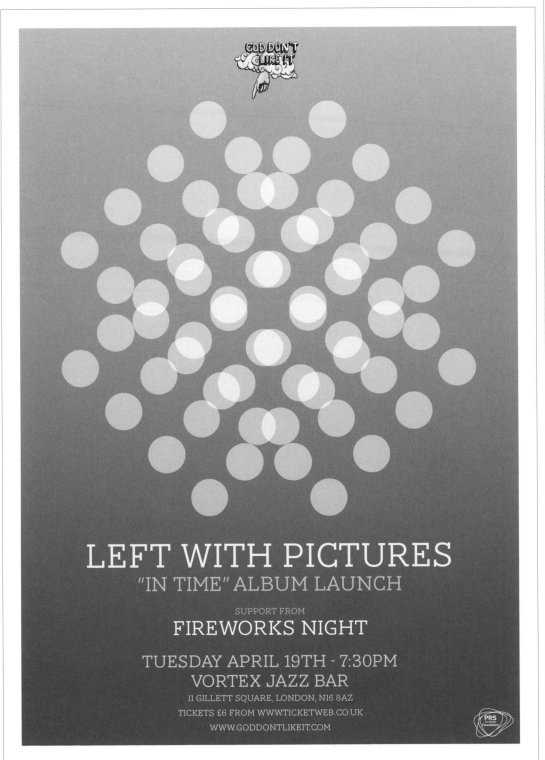

LEFT WITH PICTURES
"IN TIME" ALBUM LAUNCH

SUPPORT FROM
FIREWORKS NIGHT

TUESDAY APRIL 19TH - 7:30PM
VORTEX JAZZ BAR

11 GILLETT SQUARE, LONDON, N16 8AZ

TICKETS £6 FROM WWW.TICKETWEB.CO.UK

WWW.GODDONTLIKEIT.COM

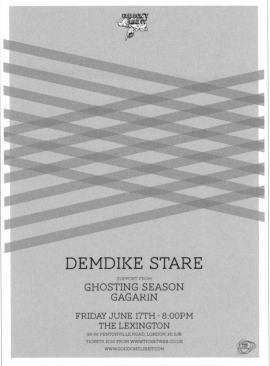

DEMDIKE STARE

SUPPORT FROM
GHOSTING SEASON
GAGARIN

FRIDAY JUNE 17TH - 8:00PM
THE LEXINGTON

96-98 PENTONVILLE ROAD, LONDON, N1 9JB
TICKETS £7.50 FROM WWW.TICKETWEB.CO.UK
WWW.GODDONTLIKEIT.COM

James Kirkup

Meursault, Secret Cities, Pretty Lights,
Left with Pictures, KOHWI, Demdike
Stare
 2011, God Don't Like It
Several show posters for God Don't Like It.

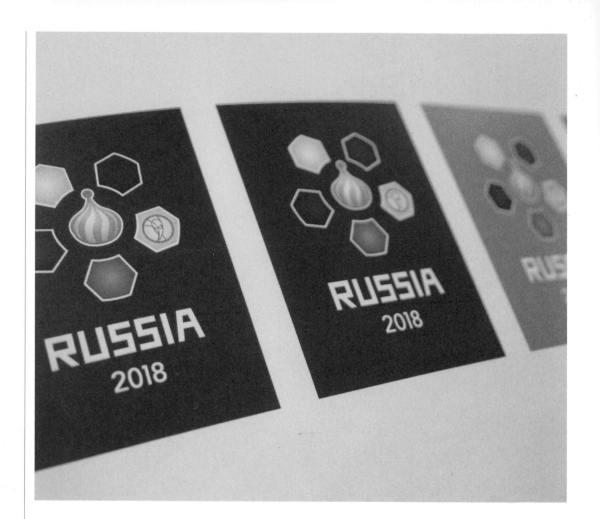

Michelle Berki

Russia World Cup Branding
2010, Personal Project

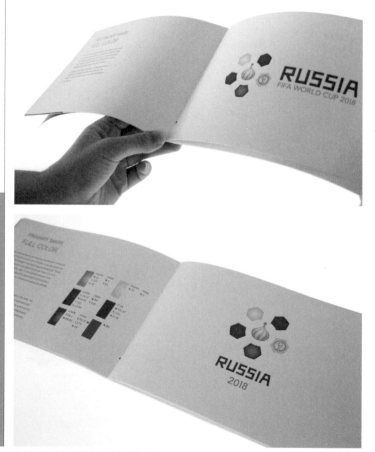

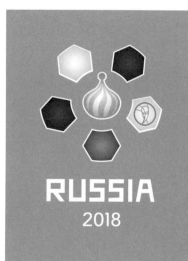

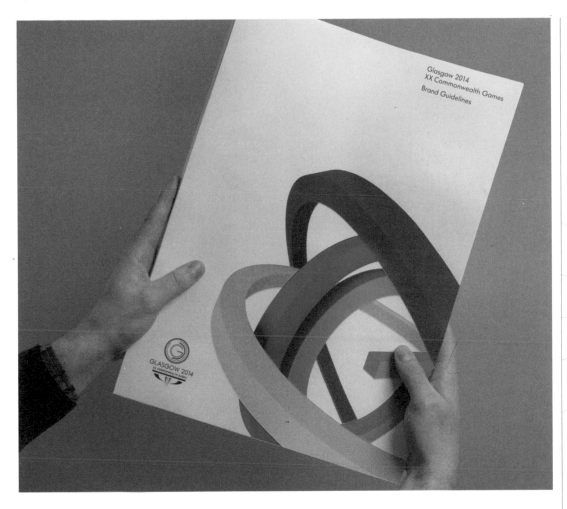

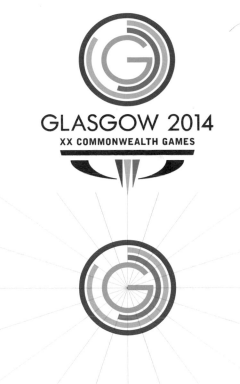

Marque

Glasgow 2014 Commonwealth Games
2010, Glasgow 2014 Limited
*Identity for the 20th Commonwealth Games,
17 Sports, 11 Days of Competition, 1 Host City —
Glasgow.*

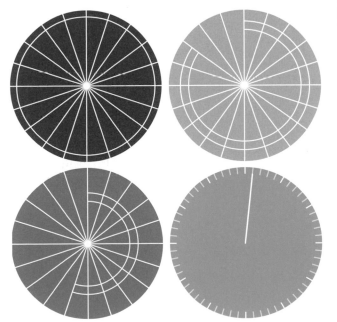

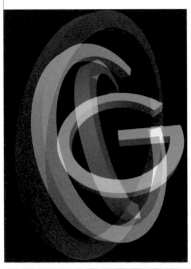

MICHELLE BERKI, MARQUE

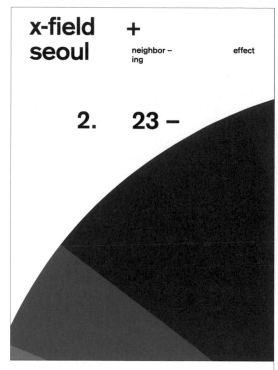

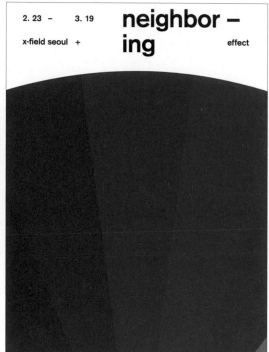

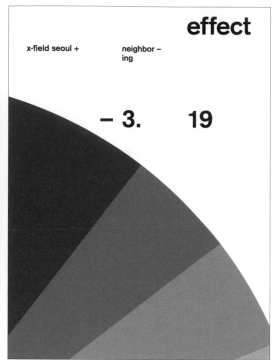

x-field + seoul neighbor– ing effect

2. 23 –

2. 23 – 3. 19 x-field seoul + neighbor– ing effect

effect x-field seoul + neighbor– ing

– 3. 19

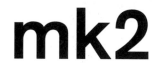

mk2

opening hour / 11:00-23:00

address / 122-2 changseong-dong jongro-gu, seoul, korea

telephone / 82-2-730-6420 email / designmk2@gmail.com

mk2

opening hour / 11:00-23:00

address / 122-2 changseong-dong jongro-gu, seoul, korea

telephone / 82-2-730-6420 email / designmk2@gmail.com

Workroom

X Field Seoul: Neighboring Effect
2011, Gallery Factory
Designer: Kim Hyung-jin → Gallery Factory, mk2,
Workroom, and Gagarin exhibition posters.

Mk2
2009, Cafe mk2
Designer: Kim Hyung-jin → Postcard

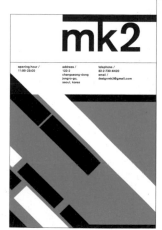

mk2

opening hour / 11:00-23:00

address / 122-2 changseong-dong jongro-gu, seoul, korea

telephone / 82-2-730-6420 email / designmk2@gmail.com

NEW RAVE / GHETTO / TECHNO / 8BIT / ITALO
BOWIE SAID DANCE + **MARK NOX**
13.06 WAGON CLUB

VISUAL
PEAK21.NET

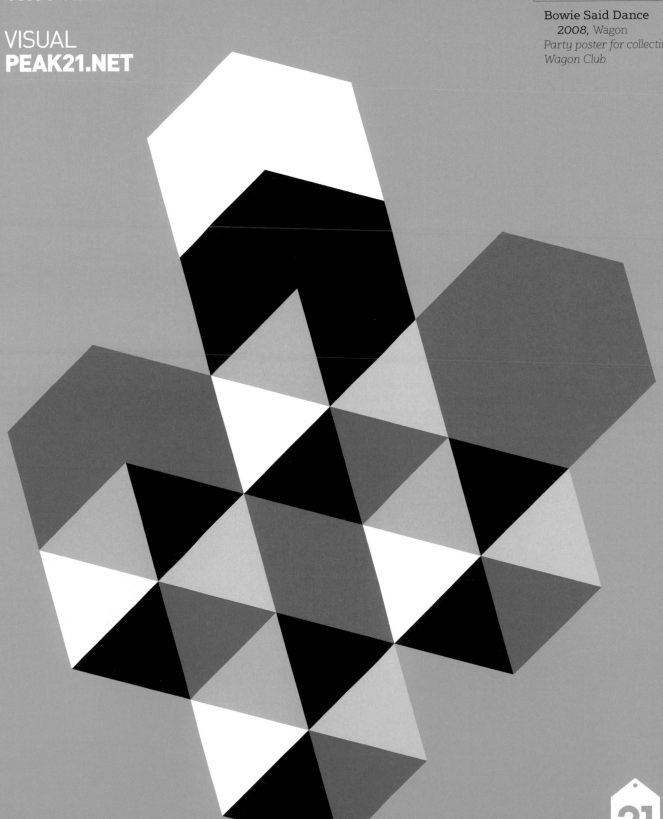

Peak 21

Bowie Said Dance
2008, Wagon
Party poster for collective Bowie Said Dance in Wagon Club.

21

Ad 1 (top left)

Smarter business for a Smarter Planet:

What if foresight were 20/20?

Today, CFOs are under more pressure than ever before to use information to fuel better business decisions. But is the information at their fingertips actually helping them do that? Many companies find themselves accessing information through management processes that can be slow, disconnected, error prone or all of the above. IBM Cognos® solutions give your finance team information they can trust, when and how they need it. Allowing them to use analytics to anticipate performance gaps, prioritize resources, gain insight into profit and growth—and make better decisions, faster. Companies have already used IBM Cognos solutions to reduce financial planning cycles by 77% and reporting cycles from days to minutes.

A smarter business needs smarter software, systems and services.
Let's build a smarter planet. ibm.com/cognoscfo

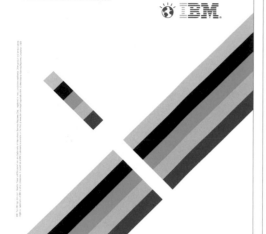

Ad 2 (middle left)

Smarter business for a Smarter Planet:

Your data is trying to tell you something. Is your business built to hear it?

Businesses can't do away with risk. But on a smarter planet, can that risk be reduced? IBM is doing this with ORX, a consortium of 52 leading financial institutions that are pooling their anonymous data and using statistical modeling to more accurately assess their risk exposure. And the IBM Fraud and Abuse Management System is helping industries as diverse as insurance, healthcare and government sort through tens of millions of records in minutes, so they can identify, analyze and, ultimately, prevent fraudulent behavior. With more than 4,000 consultants and over 450 researchers and mathematicians who have deep expertise in business analytics, IBM is uniquely positioned to help companies use data to make better decisions and mitigate risk.

A smarter business needs smarter thinking.
Let's build a smarter planet. ibm.com/riskmanagement

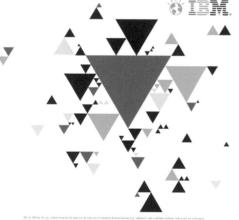

Ad 5 (bottom left)

Smarter business for a Smarter Planet:

Where does a hospital go when it needs a checkup?

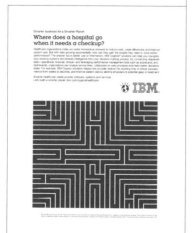

Ad 4 (main, right)

Smarter business for a Smarter Planet:

Insights by the numbers.

How exactly do you draw meaningful financial insights out of information that can sit in different departments, in different countries, in different formats? By the time information reaches decision makers, how much meaning is actually left? IBM helps companies in industries as far ranging as shipping, electronics, financial services and retail to optimize their financial management processes and enable real transparency in their information. Allowing them to integrate their data so they can move the conversation from "Are these numbers right?" to "What can we do with them to grow the business?" Perhaps that's why, last year, 80% of the top 20 Global Fortune 500 companies used IBM for its financial management expertise.

A smarter business needs smarter thinking.
Let's build a smarter planet. ibm.com/financialmanagement

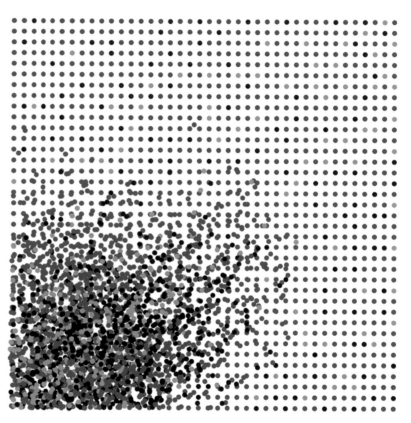

Ad 3 (bottom right)

Smarter technology for a Smarter Planet:

Service in the age of smart assets.

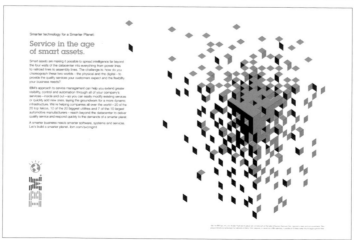

ECHOES OF THE FUTURE

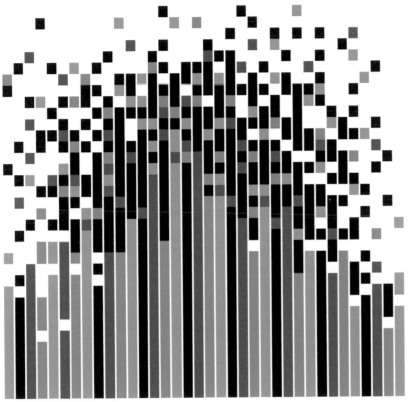

Smarter technology for a Smarter Planet:

Making accountability more accountable.

The current state of the economy and the ever-tightening budgets that come with it have put governments under tremendous pressure to justify and track every program they initiate and every dollar they spend. Faced with an endless sea of information, how will government agencies do this? With years of government experience and best-practice accelerators, IBM Cognos® helps government agencies quickly make the most of their information—giving them insight into their programs while enabling accountability and transparency. So agencies can see the interdependencies between programs, between departments, between budgets. Over 2,000 agencies worldwide are already maximizing their performance by using IBM Cognos to monitor and track their programs.

A smarter organization needs smarter software, systems and services.
Let's build a smarter planet. ibm.com/cognosgovernment

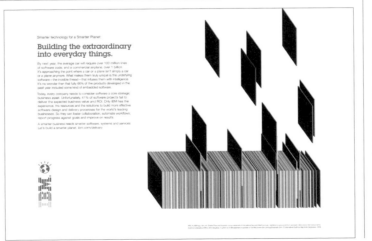

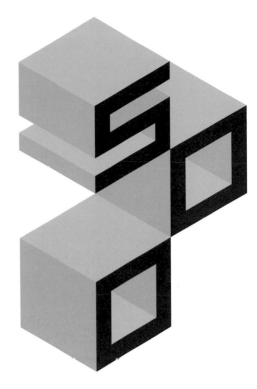

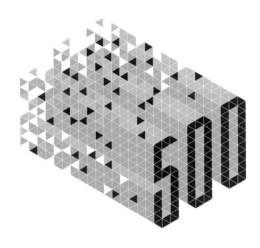

Carl DeTorres

Smarter Planet
2010, IBM
Designer: Carl DeTorres, Agency: Ogilvy & Mather, New York → Series of artworks created to represent technical innovations at IBM.

Fortune 500
2010, Fortune
Designer: Carl DeTorres, Design Direction: Robert Festino → 500 design for an article for the Fortune 500 companies.

MEDIATION
VOOR
STUDENTEN EN
MEDEWERKERS

INSTITUUT VOOR
NATUUR EN TECHNIEK
HOGESCHOOL
UTRECHT

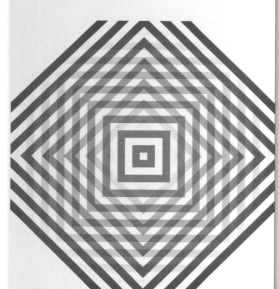

MEDIATION
VOOR
STUDENTEN EN
MEDEWERKERS

INSTITUUT VOOR
NATUUR EN TECHNIEK
HOGESCHOOL
UTRECHT

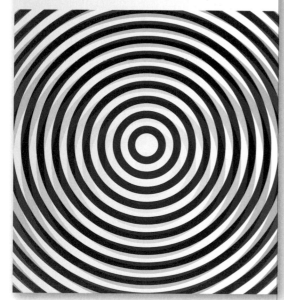

MEDIATION
VOOR
STUDENTEN EN
MEDEWERKERS

INSTITUUT VOOR
NATUUR EN TECHNIEK
HOGESCHOOL
UTRECHT

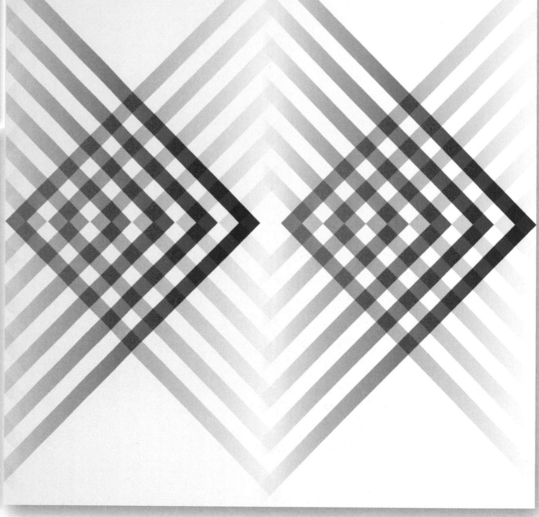

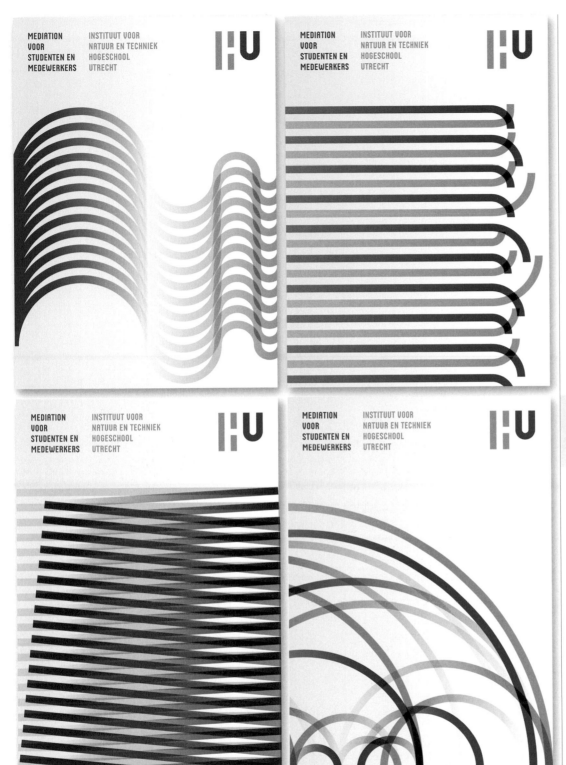

Dietwee

Brochure Covers
2011, HU University of Applied Sciences,
Utrecht

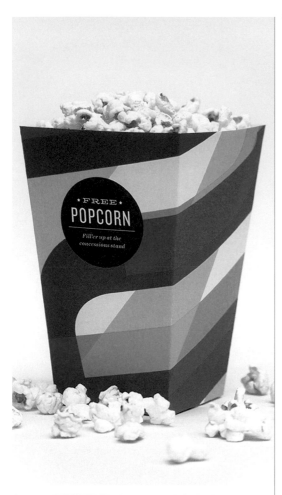

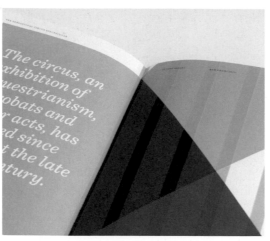

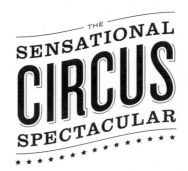

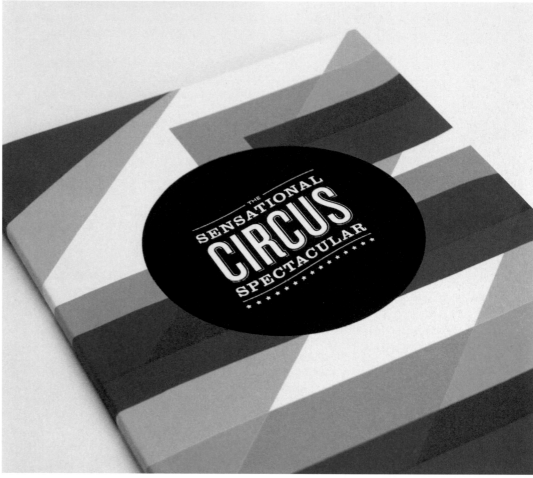

Nathan Godding

The Sensational Circus Spectacular
2010, School Project
Designer: Nathan Godding, Art Direction: Nicole Flores → Identity and environmental design for a modern traveling circus and carnival, spreading this identity across a number of items ranging from tickets and buttons to giant posters, a program and a popcorn box.

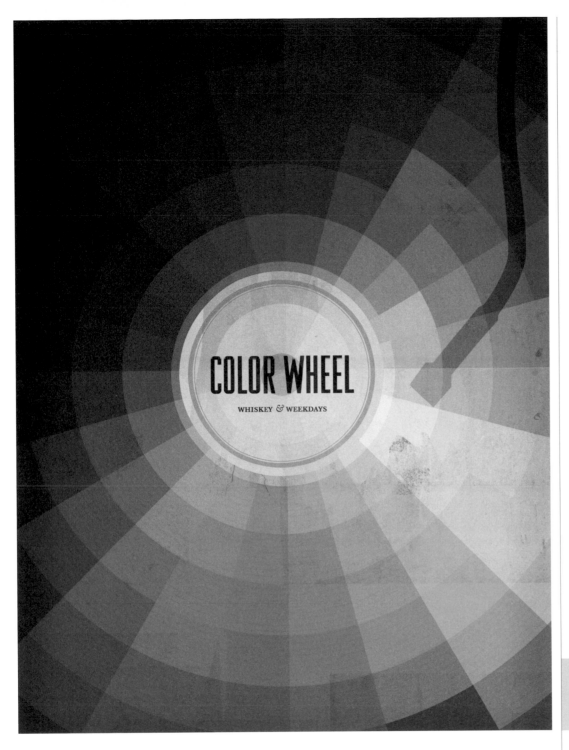

Dev Gupta

Color Wheel
2010, Color Wheel
Poster and CD artwork for indie band Color Wheel.

NATHAN GODDING, DEV GUPTA

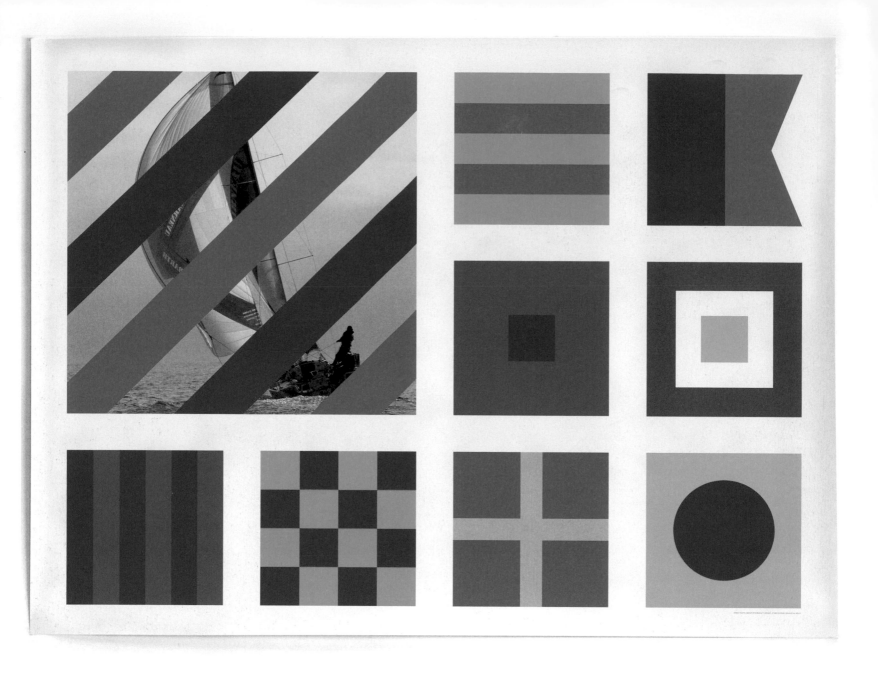

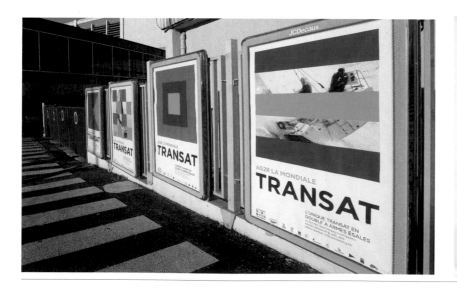
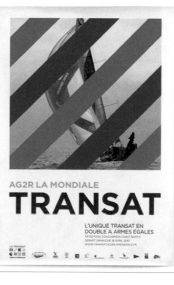
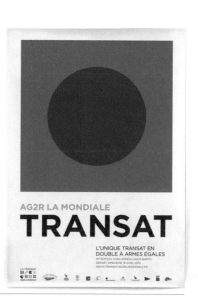

ECHOES OF THE FUTURE

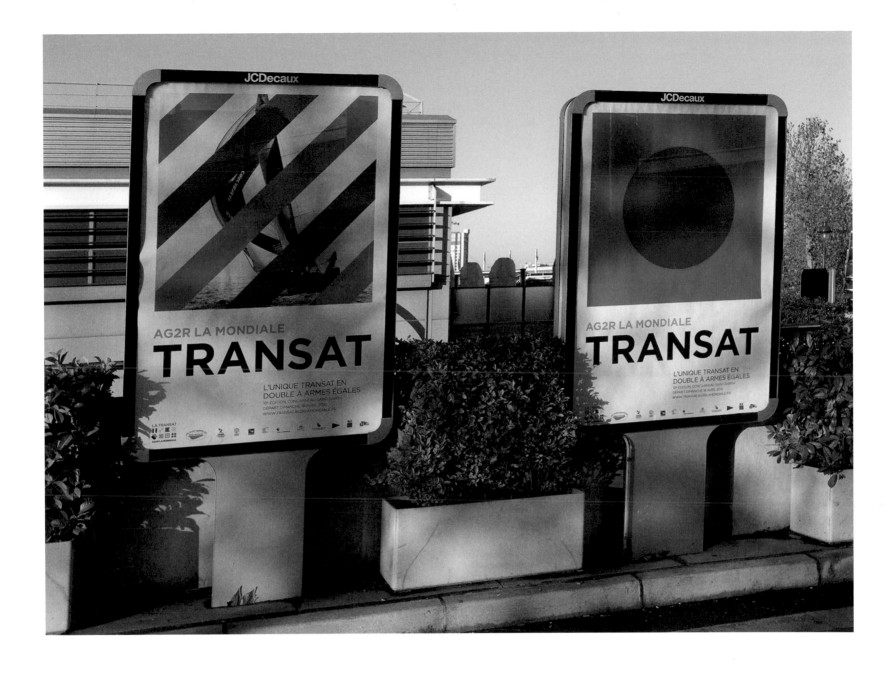

Rejane Dal Bello

Ag2r La Mondiale
2010, La Transat

Designed at Studio Dunbar → Visual identity for the international yacht race La Transat AG2R LA MONDIALE in collaboration with Danny Kreeft. This new style was launched in Paris with an extensive campaign that included 125 posters measuring up to 4 x 3 m. The design is a further evolution of the visual identity that Studio Dunbar created earlier this year for the French insurance company.

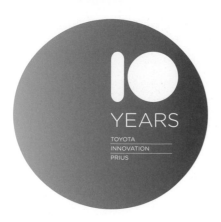

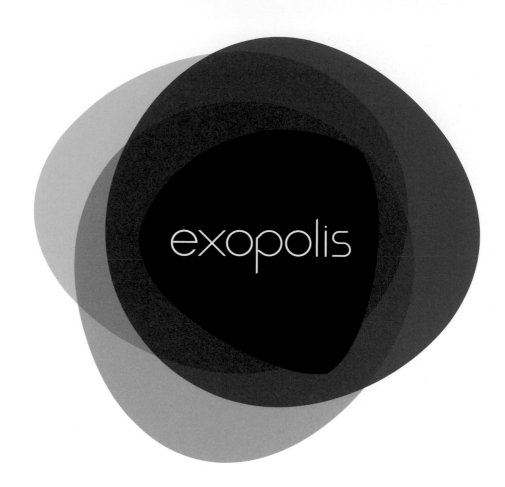

Stopbreathing

Prius 10 Year Anniversary
2010, Toyota
Designer: Ron Thompson, Associate Creative Director: Ron Thompson → Identity for an event celebrating 10 years of Toyota's Pius.

Exopolis Logo Exploration
2008, Exopolis
Designer: Ron Thompson, Creative Director: Ron Thompson → Logo exploration for Exopolis, a motion and digital design studio in Los Angeles.

K·SWISS Campaign Pitch *(right page)*
2009, K·SWISS
Designer: Ron Thompson, Associate Creative Director: Ron Thompson → K·SWISS brand relaunch pitch campaign.

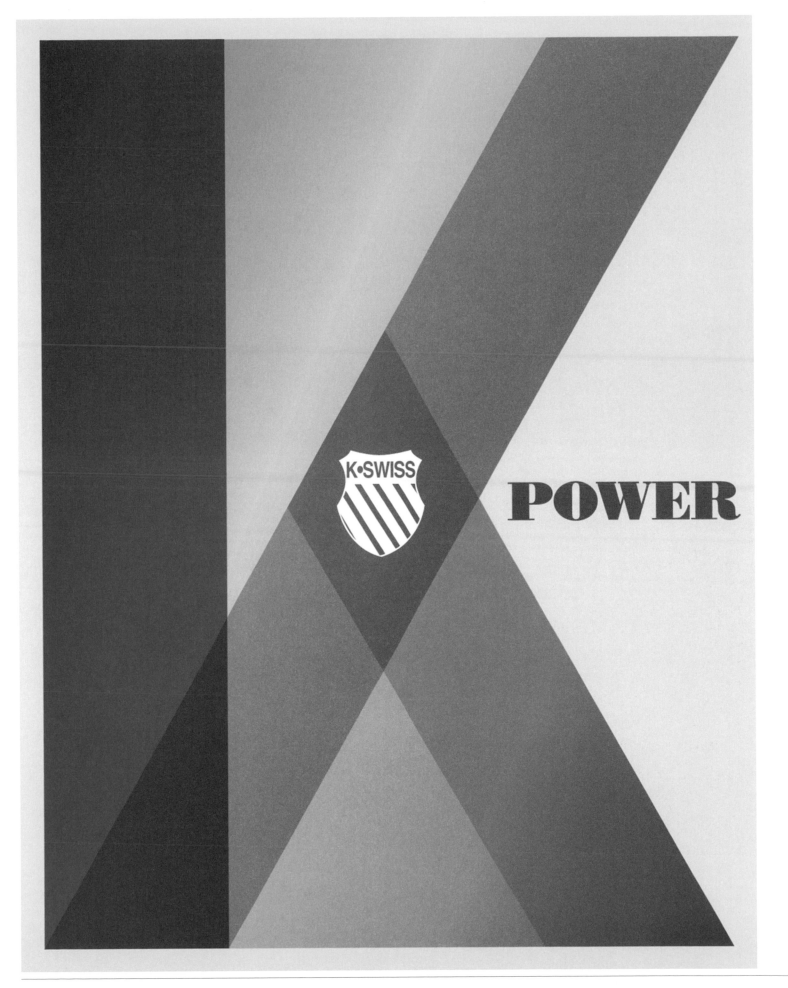

STOPBREATHING

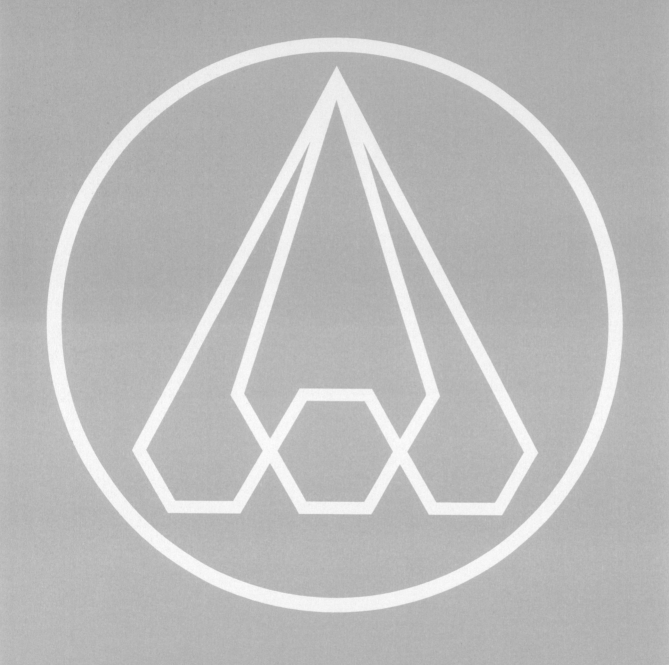

Moon Safari
1998

La Femme D'argent	7:10
Sexy Boy	4:57
All I Need	4:28
Kelly Watch the Stars	3:44
Talisman	4:16
Remember	2:34
You Make It Easy	4:00
Ce Matin-Là	3:38
New Star In the Sky	5:38
Lo Voyage de Pénélope	3:10

Talking Heads 3838

Little
Creatures
1985

And She Was	3:36
Give Me Back My Name	3:20
Creatures of Love	4:12
The Lady Don't Mind	4:03
Perfect World	4:26
Stay Up Late	3:51
Walk It Down	4:42
Television Man	6:10
Road to Nowhere	4:19

Metronomy 4504

The English
Riviera
2011

The English Riviera	0:37
We Broke Free	4:06
Everything Goes My Way	3:30
The Look	4:38
She Wants	3:51
Trouble	4:46
The Bay	4:50
Loving Arm	3:31
Corinne	3:16
Some Written	6:03
Love Underlined	5:58

Soulwax 5027

Nite
Versions
2005

Teachers	2:09
Miserable Girl	4:11
E Talking	3:59
Accidents and Compliments	5:03
Compute	5:32
Slowdance	5:15
I Love Techno	4:04
Krack	5:03
NY Lipps	4:11
Another Excuse	7:02

Duane Dalton

Favourite Records

2011, Personal Project

Posters designed as personal response to certain favorite records.

blondie

thursday
july 17 1975
all ages

with ramones
talking heads

cbgb and omfug
315 bowery
new york city

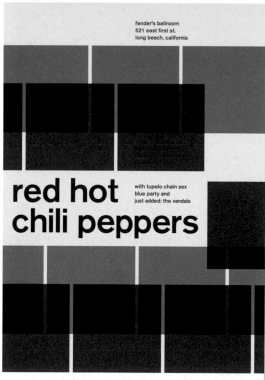

fender's ballroom
521 east first st.
long beach, california

red hot
chili peppers

with tupelo chain sex
blue party and
just added: the vandals

Stereotype Design

Swissted Poster Project

2011, Personal Project
Redesigned hardcore and punk flyers from the 1970s, 80s, and 90s.

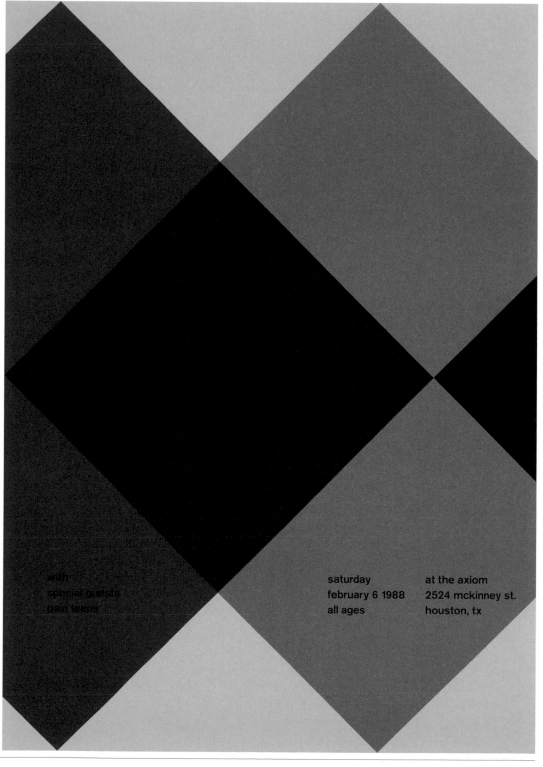

with
special guests
pain teens

saturday
february 6 1988
all ages

at the axiom
2524 mckinney st.
houston, tx

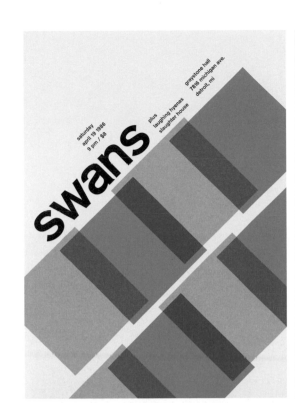

swans

saturday
april 19 1986
9 pm / $8

plus
laughing hyenas
slaughter house

greystone hall
7816 michigan ave.
detroit, mi

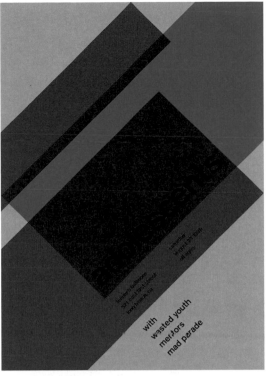

with
wasted youth
mentors
mad parade

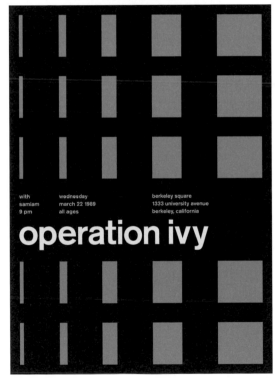

with
samiam
9 pm

wednesday
march 22 1989
all ages

berkeley square
1333 university avenue
berkeley, california

operation ivy

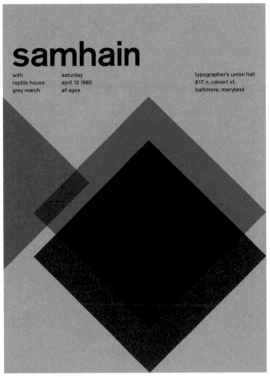

samhain

with
reptile house
grey march

saturday
april 13 1985
all ages

typographer's union hall
817 n. calvert st.
baltimore, maryland

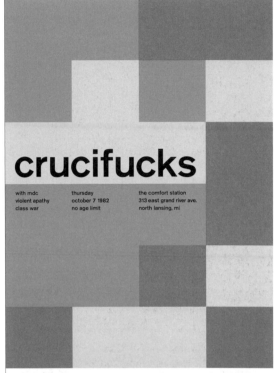

crucifucks

with mdc
violent apathy
class war

thursday
october 7 1982
no age limit

the comfort station
313 east grand river ave.
north lansing, mi

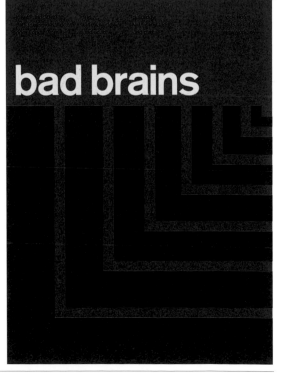

bad brains

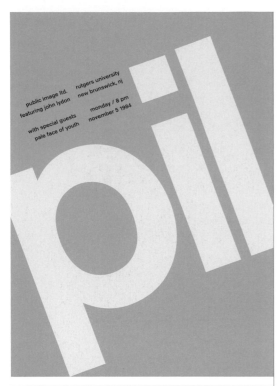

public image ltd.
featuring john lydon

rutgers university
new brunswick, nj

with special guests
pale face of youth

monday / 8 pm
november 5 1984

pil

friday
october 22 1982

with big boys

the gun club

at hot klub
4350 maple avenue
dallas, texas

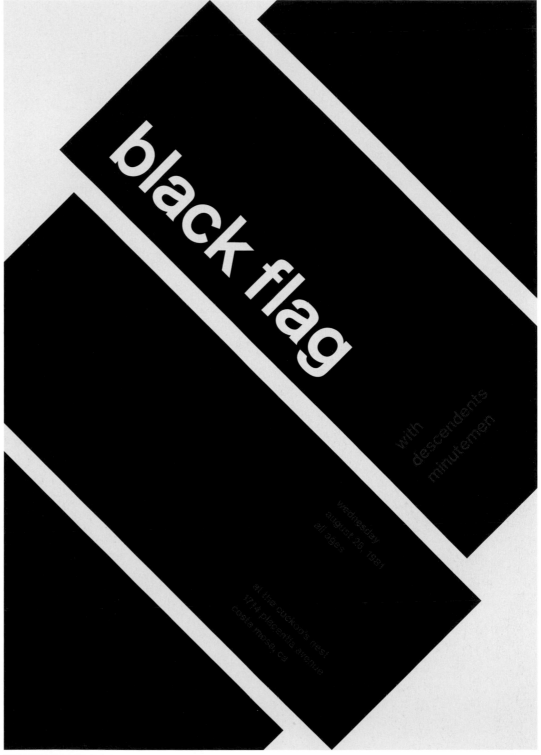

black flag

with
descendents
minutemen

wednesday
august 26, 1981
all ages

at the cuckoo's nest
1714 placentia avenue
costa mesa, ca

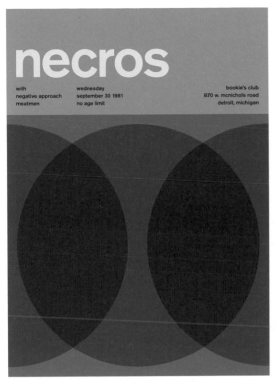

necros

with
negative approach
meatmen

wednesday
september 30 1981
no age limit

bookie's club
870 w. mcnichols road
detroit, michigan

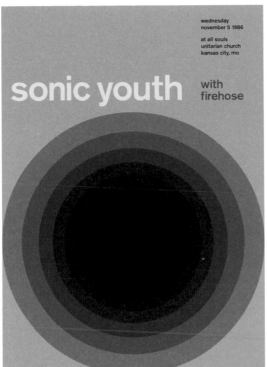

wednesday
november 5 1986

at all souls
unitarian church
kansas city, mo

sonic youth

with
firehose

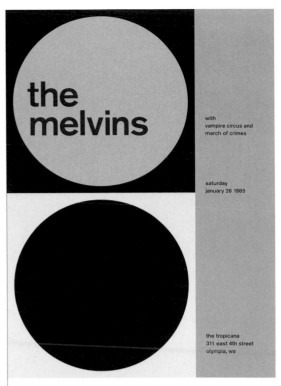

the
melvins

with
vampire circus and
march of crimes

saturday
january 26 1985

the tropicana
311 east 4th street
olympia, wa

the
crowd

friday & saturday
march 13/14 1981

with the dickies

whisky a go go
8901 west sunset blvd.
hollywood, ca

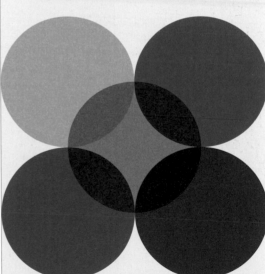

flipper

ruthie's inn
2618 san pablo avenue
berkely, california

with
sleeping dogs
the farmers

saturday
august 6 1983
all ages

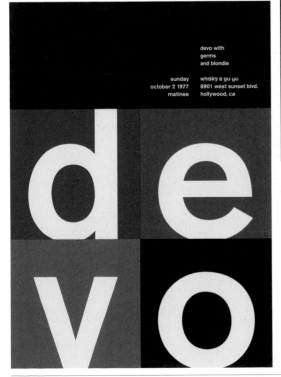

devo with
germs
and blondie

sunday
october 2 1977
matinee

whisky a go go
8901 west sunset blvd.
hollywood, ca

de
vo

Stereotype Design

Swissted Poster Project
2011, Personal Project
*Redesigned hardcore and punk flyers from the
1970s, 80s, and 90s.*

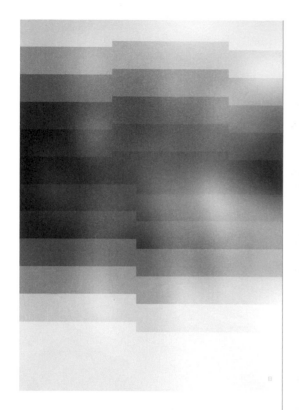

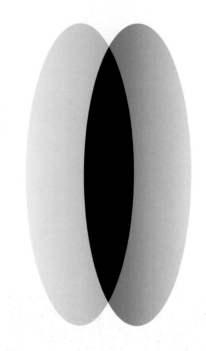

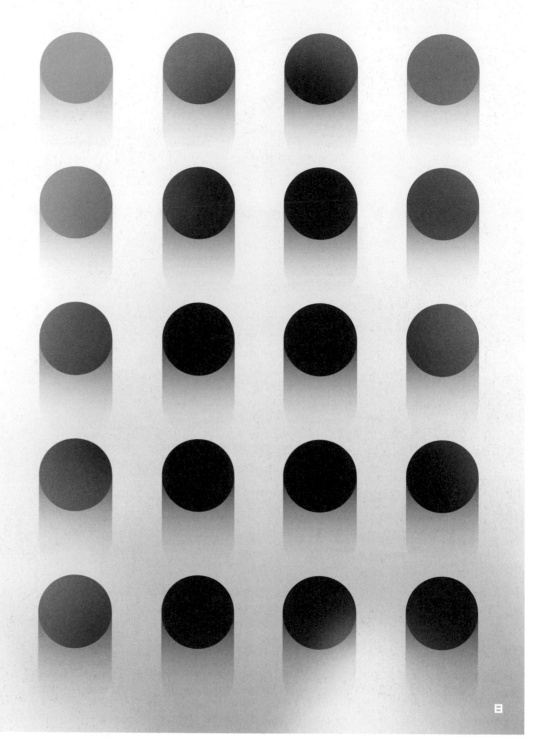

Barta Balazs

Diver, Seed, Composition
2011, Personal Project

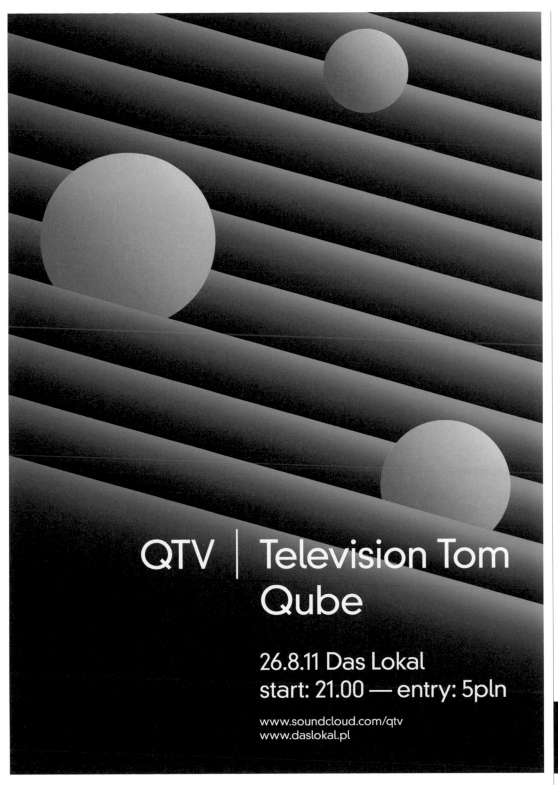

Peak 21

QTV
2011, QTV / Das Lokal
Party poster for a series of events called QTV.

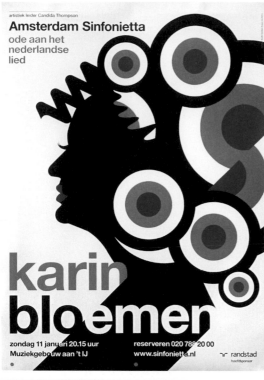

artistiek leider Candida Thompson

Amsterdam Sinfonietta
ode aan het
nederlandse
lied

karin
bloemen

zondag 11 januari 20.15 uur reserveren 020 788 20 00
Muziekgebouw aan 't IJ www.sinfonietta.nl

⌐⌐ randstad
hoofdsponsor

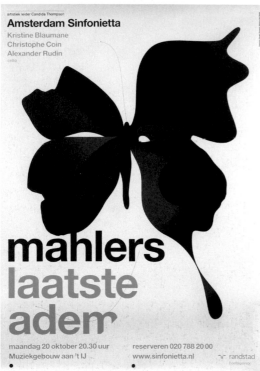

artistiek leider Candida Thompson

Amsterdam Sinfonietta

Kristine Blaumane
Christophe Coin
Alexander Rudin
cello

mahlers
laatste
adem

maandag 20 oktober 20.30 uur reserveren 020 788 20 00
Muziekgebouw aan 't IJ www.sinfonietta.nl

⌐⌐ randstad
hoofdsponsor

Rejane Dal Bello

Concert Posters

2011, Amsterdam Sinfonietta
*Amsterdam Sinfonietta, an independent musical
ensemble, mostly consists of young musicians.
The two-season poster series was developed
during a period of two years.*

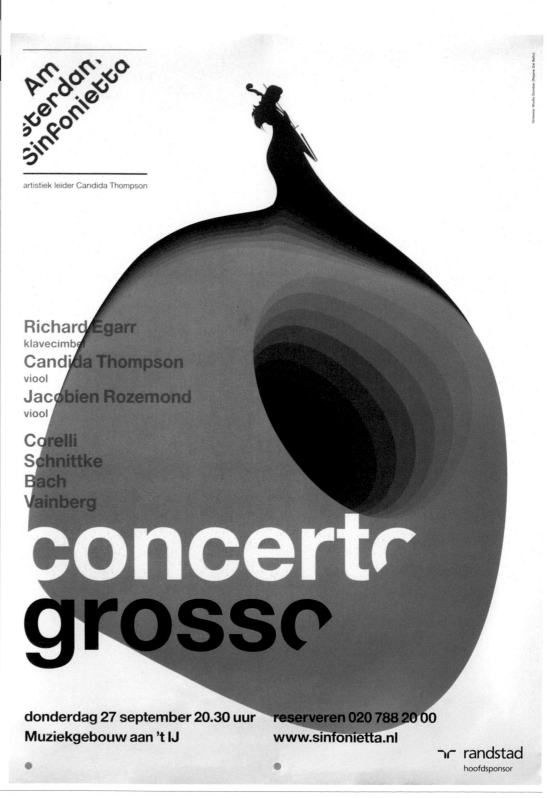

Am
sterdam
Sinfonietta

artistiek leider Candida Thompson

Richard Egarr
klavecimbel
Candida Thompson
viool
Jacobien Rozemond
viool

Corelli
Schnittke
Bach
Vainberg

concerto
grosso

donderdag 27 september 20.30 uur reserveren 020 788 20 00
Muziekgebouw aan 't IJ www.sinfonietta.nl

⌐⌐ randstad
hoofdsponsor

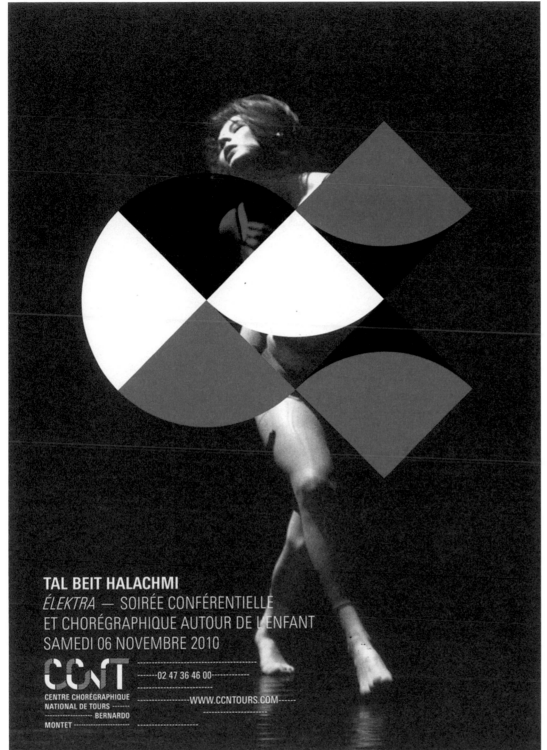

TAL BEIT HALACHMI
ÉLEKTRA — SOIRÉE CONFÉRENTIELLE
ET CHORÉGRAPHIQUE AUTOUR DE L'ENFANT
SAMEDI 06 NOVEMBRE 2010

------02 47 36 46 00------

CENTRE CHORÉGRAPHIQUE
NATIONAL DE TOURS ------
------ BERNARDO ------
MONTET ------ ------WWW.CCNTOURS.COM------

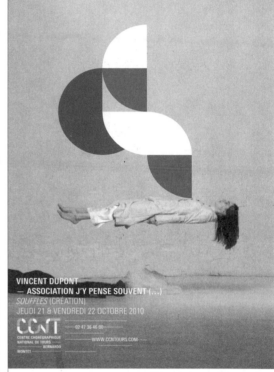

VINCENT DUPONT
— ASSOCIATION J'Y PENSE SOUVENT (...)
SOUFFLES (CREATION)
JEUDI 21 & VENDREDI 22 OCTOBRE 2010

02 47 36 46 00
CENTRE CHORÉGRAPHIQUE
NATIONAL DE TOURS ------
------ BERNARDO ------ WWW.CCNTOURS.COM
MONTET

Atelier Müesli

Season 2010–11
2010, National Choreographic Center in
Tours (Directed by Bernardo Montet)
*Graphic identity card for the 2010/2011 Season
of Dance.*

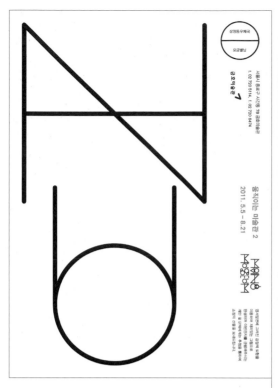

Workroom

Moving museum
2011, Kumho Museum of Art
*Designer: Kim Hyung-jin → Moving museum
exhibition postcard series.*

21 & their times
2010, Kumho museum of art
*Designer: Kim Hyung-jin → 21st young artist
exhibition invitation card.*

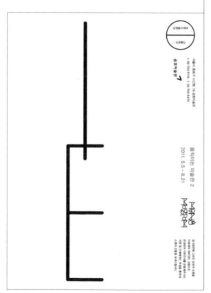

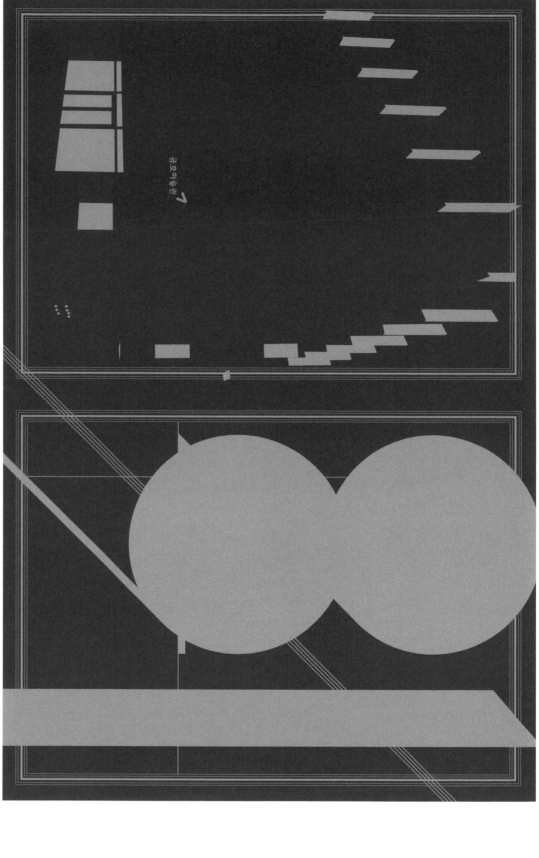

사유의 악보　　　　　　　　　　　　　최정우

1

이론의 교배와 창궐을 위한
불협화음의 비평들　　　　　　자음과모음

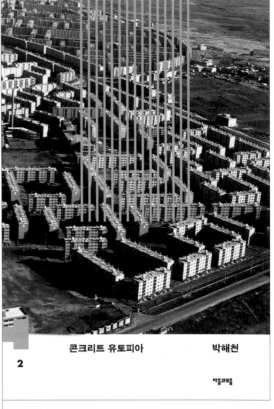

콘크리트 유토피아　　　　　　박해천

2

자음과모음

Workroom

Hybrid series: Score of Thoughts,
Concrete Utopia, Masculinity and Gender
2011, Jaeum & Moeum Publishing
Designer: Kim Hyung-jin.

남성성과 젠더　　　권김현영　루인　정희진
　　　　　　　　　나영정　엄기호　한채윤

3

자음과모음

Chromatologies
2010, Snd
Fold-out brochure and poster for Chromatologies festival of digital art and music–curated and organised by Snd.

Unitxt
2010, Snd
Poster for Carsten Nicolai's audiovisual installation "unitxt" exhibited at the Chromatologies Festival in Rotherham (UK).

International Festival of
Digital Art and Music

4 Sept — 2 Oct 2010
Rotherham, UK

chromatologies

24/09

frank bretschneider de
cm von hausswolff se
oval de

25/09

evol es
mark fell uk
grischa lichtenberger de

04/09 – 02/10

carsten nicolai de

21 – 25/09

ernest edmonds uk
paul emery uk
joe gilmore uk
kayleigh morris uk
richard sides uk
rian treanor uk

17/09 – 01/10

theo burt uk
william rose uk
chris watson uk

www.chromatologies.com

4 Sept — 2 Oct 2010
Rotherham Art Gallery

Central Library
& Arts Centre
Walker Place
Rotherham S65 1JH

Admission free
Mon to Fri: 9am – 4.45pm
Sat: 9am – 3.30pm
Sun: Closed

Tel: 01709 336633
www.rotherham.gov.uk

carsten nicolai.unitxt

An audio visual installation. Part of Chromatologies Festival of Digital Art and Music. www.chromatologies.com

Redscale Guide

Redscale is the name given to a technique of shooting photographic film where the film is exposed from the wrong side. The emulsion is exposed through the base of the film. Normally, this is done by winding the film upside-down into an empty film canister.

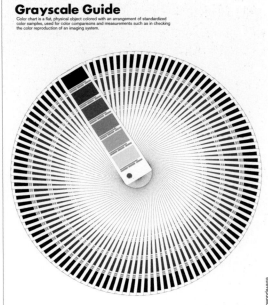

Grayscale Guide

Color chart is a flat, physical object colored with an arrangement of standardized color samples, used for color comparisons and measurements such as in checking the color reproduction of an imaging system.

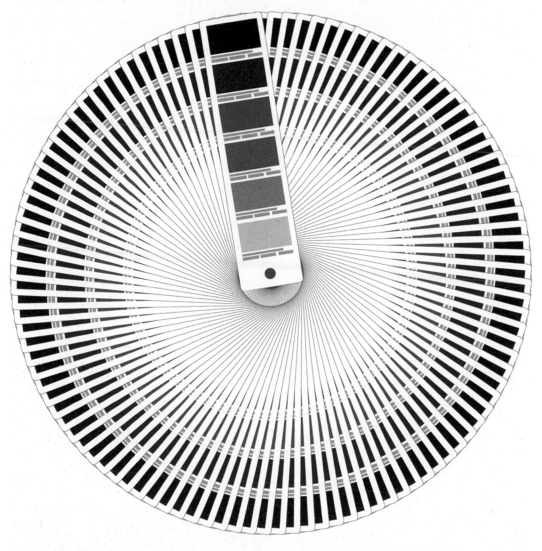

Esteve Padilla

Redscale & Greyscale
2011, Personal Project

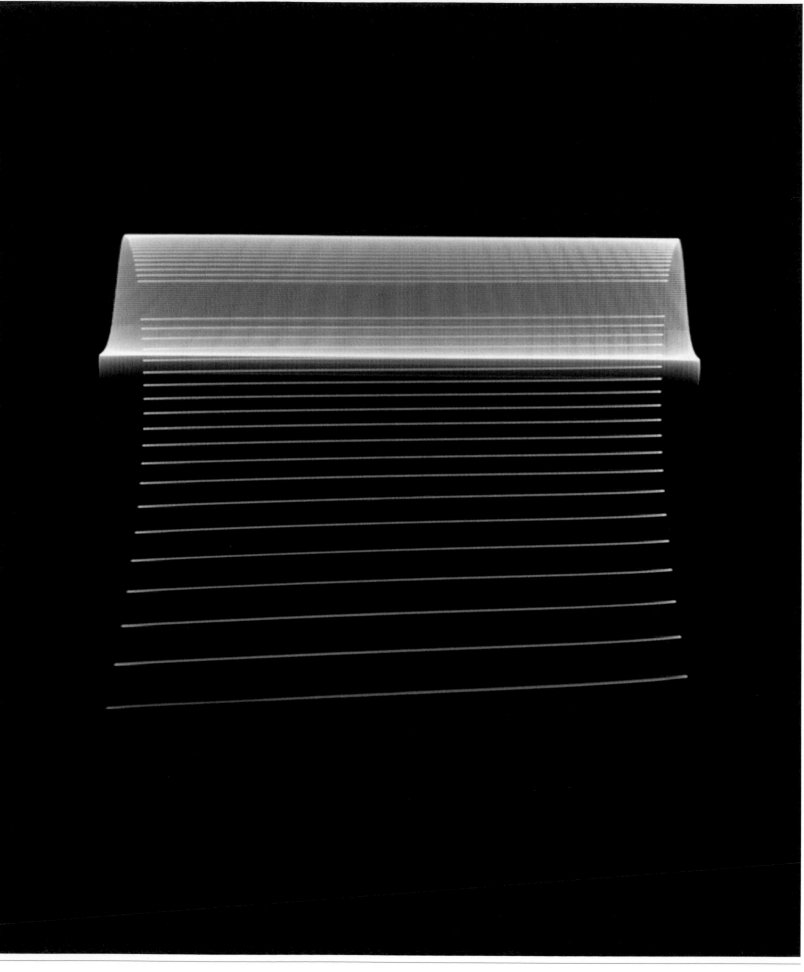

ECHOES OF THE FUTURE

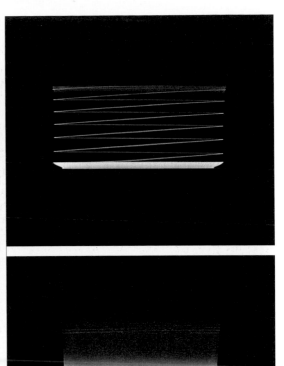

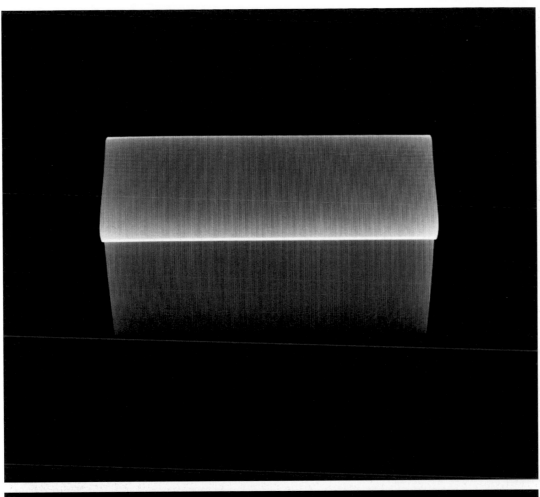

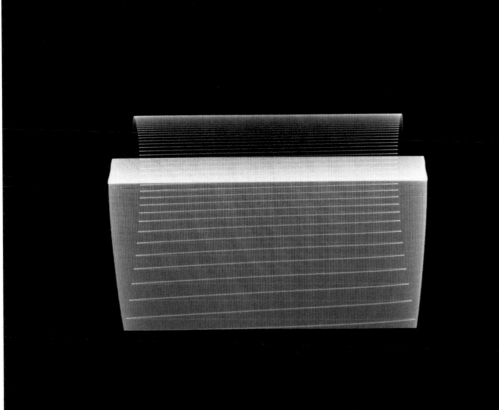

Stephan Tillmans

Luminant Point Arrays
2010, Personal Project

Photos: 100 x 100 cm | 40 x 40 cm → Luminant Point Arrays is a photographic series of old tube televisions, photographed at the very moment they are switched off. The TV picture breaks down and is abstracted to its essential element: light. This abstraction also results in the collapse of the external reference. Each of these photographs is from a different TV, but it is also the length of exposure, timing, and time the TV has been running before the photo is taken that accounts for the difference in results.

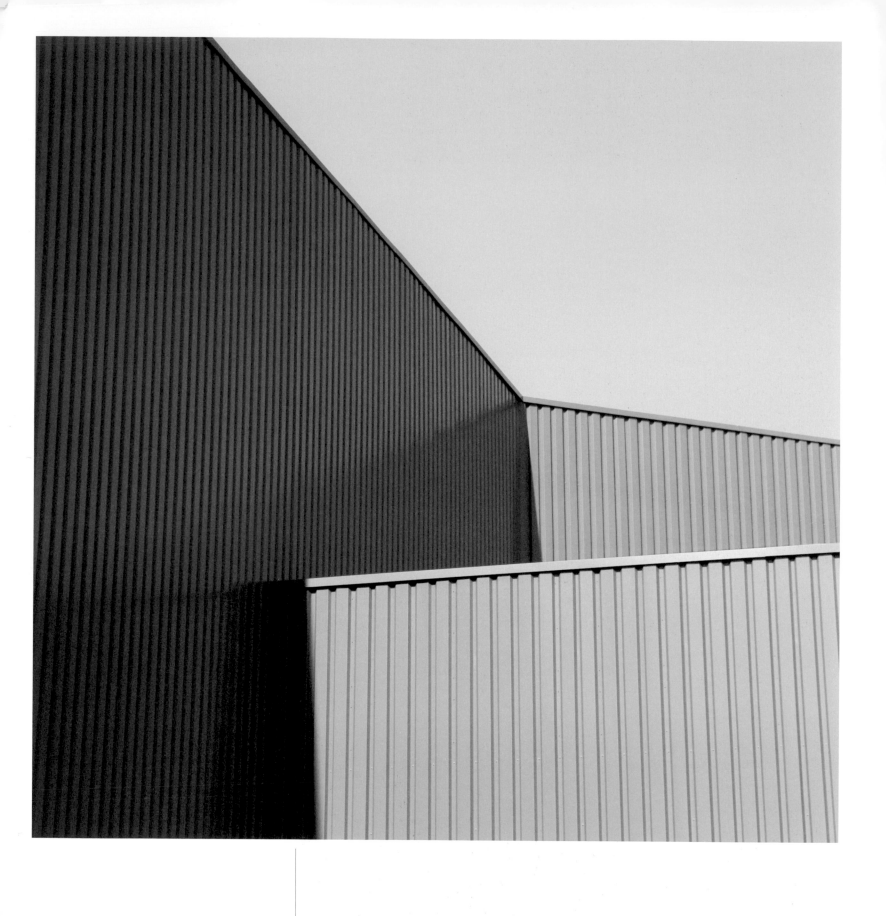

ECHOES OF THE FUTURE

Matthias Heiderich

Untitled
2010/11, Personal Project
Projects: Studie Eins, Studie Zwei, Studie Drei,
Color Berlin and unreleased so far.

Index

Albin Holmqvist 81–84
Sweden
albinholmqvist.com

Andaur Studios 28, 85, 112
Chile
work.andaurstudios.cl

Andrea Gallo 134–135
Spain
flickr: roosterization

Andy Penny 10–11
United Kingdom
andypenny.co.uk

Artiva 108–109, 111, 113, 133
Italy
artiva.it

Astronaut Design 2–3, 29
Kazakhstan
astronautdesign.com

Atelier Müesli 71, 76, 165
France
ateliermuesli.com

Barta Balazs 132, 162
Hungary
bbalazs.com

Blok Design 102–105
Canada
blokdesign.com

Brandan Deason 124–125
USA
cargocollective.com/brandandeason

Brandon Schaefer 18, 34–35
USA
seekandspeak.com

Bunch 130
United Kingdom
bunchdesign.com

Carl DeTorres 146–147
USA
carldetorres.com

ChristianConlh 127
Italy
cargocollective.com/christianconlh

Chyrum Lambert 44–45
USA
chyrumlambert.com

Cody Haltom 66–67
USA
codyhaltom.com

Concrete Design Communications 21
Canada
concrete.ca

Dave Sedgwick 119
United Kingdom
designbydave.co.uk

Dev Gupta 52–53, 151
USA
devgupta.com

Dietwee 148–149
Netherlands
dietwee.nl

Donna Wearmouth 110
United Kingdom
donnawearmouth.co.uk

Doublenaut 48–49, 63
Canada
doublenaut.com

Duane Dalton 4–7, 156–157
Ireland
cargocollective.com/duanedalton

Erik Jonsson 114
USA
erikjonsson.se

Esteve Padilla 40–41, 169
Spain
estevepadilla.info

Foreign Policy Design Group 22–23
Singapore
foreignpolicydesign.com

Graphical House 74
United Kingdom
graphicalhouse.co.uk

Heath Killen 9, 20, 32–33
Australia
madebyhk.com

Ian Walsh 100–101
Ireland
cargocollective.com/ianwalsh

James Kirkup 137–141
United Kingdom
cargocollective.com/jameskirkup

Jason Hill 60–62
USA
jasonhilldesign.com

Jesse Reed 118
USA
jessereedfromohio.com

Jonathan Mutch 8, 26–27
Canada
jonmutch.com

Jung Min 78
USA
jungmindesign.com

Kelli Anderson 50, 55, 77, 79
USA
kellianderson.com

Laline Hay 116
United Kingdom
lalinehay.com

Marius Roosendaal 38–39, 42–43, 115,
Netherlands 128–129, 131
mariusroosendaal.com

Mark Brooks . 72, 75
Spain
markbrooksgraphikdesign.com

Marque . 143
United Kingdom
marquecreative.com

Mash Creative 96–97
United Kingdom
mashcreative.co.uk

Matthias Heiderich 172–173
Germany
matthias-heiderich.de

Metric72 . 30–31
Spain
metric72.com

Michelle Berki . 142
USA
michelleberki.com

Mikey Burton 54, 65
USA
mikeyburton.com

Mind Design 120–121
United Kingdom
minddesign.co.uk

Nathan Godding 150
USA
nathangodding.com

Neuarmy 24–25, 90–91
USA
neuarmy.com

Nick Brue . 56–57
USA
nickbrue.com

Oliver Wiegner 122–123
Germany
icecreamforfree.com

Peak 21 51, 145, 163
Poland
peak21.net

Qubik Design . 168
United Kingdom
qubik.com

Rejane Dal Bello 106–107, 152–153, 164
Netherlands
rejanedalbello.com

Riley Cran . 64
Canada
rileycran.com

Ross Gunter . 126
United Kingdom
rossgunter.com

Ryan Atkinson 94–95
United Arab Emirates
behance.net/RyanAtkinson

Scott Campbell 16–17, 19, 36–37
USA
scttcmpbll.com

Sean Thomas . 117
United Kingdom
whatarogue.com

Silence Television 73, 86–89
Peru
silencetv.com

Simon Walker 68–69
USA
flickr: 32125239@N00

Soulseven . 58–59
USA
soulseven.com

Steph Davlantes 70
USA
stephdavl.com

Stephan Tillmans 170–171
Germany
stephantillmans.com

Stereotype Design 158–161
USA
stereotype-design.com

Stopbreathing 154–155
USA
stopbreathing.com

Studio Laucke Siebein 98–99
Germany
studio-laucke-siebein.com

Studio Mister . 136
United Kingdom
studiomister.com

Tenfold Collective 46–47
USA
tenfoldcollective.com

Tom Hingston Studio 12–15
United Kingdom
hingston.net

Workroom 92–93, 144, 166–167
South Korea
workroom.kr

ECHOES
OF THE FUTURE

RATIONAL GRAPHIC DESIGN & ILLUSTRATION

Edited by Robert Klanten & Hendrik Hellige

Cover and layout by Hendrik Hellige for Gestalten
Cover image *13 Wives* by Foreign Policy Design Group
Typeface: Treza by Benjamin Gomez, Nautinger by Moritz Esser
Foundry: www.gestaltenfonts.com

Project management by Julian Sorge for Gestalten
Project management assistance by Andres Ramirez for Gestalten
Production management by Janine Milstrey for Gestalten
Proofreading by Elvia Pyburn-Wilk
Printed by Graphicom Slr
Made in Europe

Published by Gestalten, Berlin 2012
ISBN 978-3-89955-413-7

Respect copyrights, encourage creativity!

For more information, please visit www.gestalten.com.

Bibliographic information published by the Deutsche Nationalbibliothek.
The Deutsche Nationalbibliothek lists this publication in the Deutsche National-
bibliografie; detailed bibliographic data are available online at http://dnb.d-nb.de.

None of the content in this book was published in exchange for payment by
commercial parties or designers; Gestalten selected all included work based solely
on its artistic merit.

This book was printed on paper certified by the FSC®.

FSC
www.fsc.org

MIX
Paper from
responsible sources
FSC® C013123

Gestalten is a climate-neutral company. We collaborate with the non-profit
carbon offset provider myclimate (www.myclimate.org) to neutralize the company's
carbon footprint produced through our worldwide business activities by investing
in projects that reduce CO_2 emissions (www.gestalten.com/myclimate).

myclimate
Protect our planet